Praise for *Portraits of Peace: Searching for Hope in a Divided America*

"Getting to know each other's personal stories is one of the best ways to bridge our deep divides and reclaim the power of 'We the People'; this book gives us that chance. *Portraits of Peace* also gives us a chance to correct the lenses through which we look at others, and get back in touch with our shared humanity."

—Parker J. Palmer, author of *Healing the Heart of Democracy*, *Let Your Life Speak*, and *On the Brink of Everything*

"John Noltner artfully weaves his own story and experiences with those of hundreds of people he has encountered or interviewed, and, perhaps most importantly, whose stories he has helped tell. These stories challenge us, expand us, surprise us, and push all of us to become more human."

—Rev. Dr. Liz Theoharis, co-chair of the Poor People's Campaign: A National Call for Moral Revival, and director of the Kairos Center for Religions, Rights, and Social Justice at Union Theological Seminary

"John Noltner knows three things about stories: people have them; people need to be heard; people need to listen. In this latest collection of stories, he comforts and challenges, he shows the fractured stories and the flourishing ones, he shares stories that contract and stories that expand. In this, he is a curator of the thing that might save us: our capacity to tell; our capacity to listen; our capacity to change."

—Pádraig Ó Tuama, host of "Poetry Unbound" from *On Being*, and author of *In the Shelter* and *Borders and Belonging*

"*Portraits of Peace* offers so much hope for our weary hearts. I can't imagine a better book for our fractured time."

—Jennifer Louden, author of *Why Bother?* and *The Woman's Comfort Book*

"At a time when our world is filled with both kindness and cruelty, *Portraits of Peace* provides us with a mirror to witness the world as it is, and also a lens to imagine what the world can become."

—The Rev. Dr. Brian E. Konkol, Dean of Hendricks Chapel and Professor of Practice, Syracuse University

"John Noltner's art is rich without being extractive; it's morally clear without being preachy. This stems from John himself, who walks through the world with a discerning wide-eyedness and deep compassion."

—Barry Yeoman, journalist

"The book skillfully succeeds in constructing a narrative of hope by revealing the lives and faces of those dedicated to breaking the cycle of conflict. John Noltner's work offers a profound awareness of what it means to be human."

—Marina Cantacuzino, founder of The Forgiveness Project

"John Noltner's elegant exploration of the many dimensions of peace is balm for the soul, especially in our contentious times. This book inspires all of us to look for the dignity and light in every person we meet."

—Rabbi Amy Eilberg, spiritual director, kindness coach, peace and justice educator, and author of *From Enemy to Friend: Jewish Wisdom and the Pursuit of Peace*

"Nolter's *Portraits of Peace* provides a new, life-giving lens. Read its words, rest your eyes on the faces portrayed on its pages, and let it lead your heart on a powerful journey from polarization to peace."

—Jacqueline A. Bussie, author of *Love Without Limits* and *Outlaw Christian*

"This book is for those who care about people and their stories and those who want to do the work of 'storycatching' themselves."

—Howard Zehr, director emeritus of the Zehr Institute for Restorative Justice

"*Portraits of Peace* vividly illustrates the power of personal story, unlocked by a courageous commitment to listen. Each chapter left me asking John Noltner's favorite question: 'Tell me more.' The future of our families, communities, and country depends on pursuing the life-giving path of listening, which begins with inspiration."

—Pearce Godwin, founder of the Listen First Project and the #ListenFirst Coalition of 250+ organizations cultivating peace across differences

"John Noltner offers us a gift—a way to listen to others, to honor their humanity, and to stay at the table even when it is difficult. He brings us with him on his journey of discovery and change. This book belongs in every household in our country."

—Martha McCoy, executive director of Everyday Democracy and president of the Paul J. Aicher Foundation

PORTRAITS

OF **PEACE**

PORTRAITS
OF **PEACE**

SEARCHING FOR HOPE IN A DIVIDED AMERICA

JOHN NOLTNER

BROADLEAF BOOKS

MINNEAPOLIS

Dedicated to all the peacemakers, great and small,
who believe that something better is possible

CONTENTS

AUTHOR'S NOTE

A Peace of My Mind is a storytelling project that began as a personal exploration more than a decade ago and has now become my life's work.

The first interview I did for *A Peace of My Mind* was in Minneapolis, just a few months after Barack Obama took office as the forty-fourth president of the United States. Unsubstantiated questions arose about his birth certificate, his faith, his citizenship, and his loyalties. Political rhetoric was heated, and lines of division were sharpened. It felt like a polarized season, and I wondered if I could use my storytelling and photography to rediscover what connects us as Americans and as human beings.

The division that was the genesis of this project has continued to grow. Over the past decade, our social landscape has been fraught with culture wars, racial turmoil, and political rancor. We have grappled uncomfortably with same-sex marriage, gun rights, religious freedom, gender equality, and more.

In 2014, as I interviewed people for our second book, *American Stories*, Michael Brown was killed by police in Ferguson, Missouri. In 2015, Bree Newsome pulled the Confederate flag from the South Carolina State House. Also that year, the US Supreme Court upheld same-sex marriage in all fifty states, but in the summer of 2016, a shooting at Pulse, a gay nightclub in Orlando, killed forty-nine people and injured dozens more.

We released *American Stories* in the fall of 2016, just before our country went to the polls and elected Donald Trump as president.

I started writing this book, *Portraits of Peace*, a few months after white supremacists marched in Charlottesville to keep a statue of Confederate general Robert E. Lee standing. In the tension, a car rammed into a crowd of counter-protesters, and Heather Heyer, a thirty-two-year-old paralegal who grew up in rural Virginia, was struck and killed.

I wanted to write *Portraits of Peace* because after a decade of quietly sharing other people's stories, I felt like I had something to say as well about encountering difference, navigating conflict, and finding a better path forward.

I connected with Broadleaf Books as our country went into lockdown because of the coronavirus, and I found myself working through edits and revisions in the shadow of protests in my hometown of Minneapolis after George Floyd was killed by police. Our final manuscript was submitted to the publisher as we were just weeks away from the 2020 election.

With some certainty, by the time you hold this book in your hands, we will be living in a different world.

The headlines will change. The rhetoric will evolve, and the tensions of the day will shift. But the fundamentals of dignity, justice, and peace will remain the same. The stories in this book are unique to each individual person who shared them, but the stories are also timeless and their lessons universal.

If we are going to find a path forward, we will have to choose it. We will need to acknowledge the deep divides that exist in our social landscape and reckon honestly with them. As a nation and as individuals, we will have to develop and enhance our ability to see the humanity in all those around us, not just the ones we agree with. And we will need to bridge divides and build healing with intention.

May these stories be a beacon and a compass to guide our journey.

INTRODUCTION

I had driven early that morning from Brooklyn toward New Jersey to interview Hashim Garrett for my ongoing project called *A Peace of My Mind*. A publisher friend had seen Hashim speak to a group of high school students, thought I might be interested, and put us in touch.

My four-door Chevy pickup was a mobile office: cameras, lighting, and recording gear in the back seat; stands and reflectors in the covered bed; and empty paper coffee cups strewn across the passenger-seat floor. I was alone and felt the weight of the 1,500 miles I'd already driven for this trip. I'd stayed with the friend of a friend in Brooklyn the night before. I met him briefly at the café where he worked, and he offered a key to his flat with instructions for which bedroom to use. I was asleep before he returned home that evening, and he had left again before I woke. In the shower that morning, I noticed a shampoo bottle for controlling head lice and wondered if I had made a huge tactical error in my effort to be frugal.

Traffic had been lighter than expected going through Manhattan, so I pulled into a convenience-store parking lot, set an alarm, reclined my seat, and closed my eyes until it was time to drive the remaining few blocks to Hashim's house. I rang the bell of the two-story duplex, knowing it might be a long wait. In our email exchange leading up to that day, Hashim told me he used a wheelchair. He could get around with crutches as well, but it was a slow process to navigate from his second-floor apartment, down the stairs, and to the entry.

Hashim unlocked the door. A young Black man, he wore a crisp white button-down shirt, gray dress pants, and freshly polished black shoes. His long, tight dreads were tied in a knot behind his head. He shifted his weight onto his left crutch, leaned the other against the door frame, and shook my hand. Hashim invited me in and asked me to climb the stairs ahead of him. *"It takes me a while,"* he said. *"Just make yourself comfortable."*

The dining room was flooded with natural light. A large wooden table was pushed up against a window, and we decided to do the interview there, with

Hashim seated on the long side of the table, facing the window, while I settled on the adjacent short side, with the window to my left. After a few minutes of small talk, I explained my interview process and asked if he was ready to begin. Hashim said yes.

"If I didn't know anything about you, what would you want me to know?" I asked.

"I am a father of two small children," Hashim replied. "I am a husband. I go into schools and educate students on the importance of using forgiveness as a tool to resolve conflicts."

"Tell me more."

Hashim Garrett grew up in Brooklyn, New York. As a young boy, he changed schools and was frequently picked on and bullied. Eventually, it occurred to him that he could possibly avoid the torment if he befriended his tormentors, and for a little while, that worked. But then things turned.

"It wasn't just like one day I became this terrible kid," he said. "It was a slow process. Sixth grade, cutting school a little bit. Seventh grade, cutting school and smoking. Eighth grade, jumping people. Ninth grade, getting arrested. By the time I was fifteen, I was carrying guns."

Hashim found himself in a gang, but even that was better than the alternative. It was a place to belong. He told me there was something powerful about having others fear him for a change. He said that when he was good, nobody noticed him, but when he was bad, everybody knew his name. There was glory in being tough. But it all caught up with him.

At fifteen, Hashim was in conflict with some of the other gang members. They called him out of his apartment and onto the street, where he was ambushed. Hashim was shot in the back and paralyzed from the waist down. As he lay on the ground wondering if he would live or die, his eyes were opened, and he knew he wanted to change. He says nothing but tragedy could have broken the intoxicating spell of being bad.

As Hashim told his story, he gazed straight ahead out the window, pausing from time to time as he searched for just the right words. His crutches leaned in the corner beside the table, and his wheelchair was over my shoulder in the next room. I was silent. My only job was to listen as Hashim unwrapped the story of his life.

"Getting paralyzed, there's no glory in that. While you all get up and run, I can't move. I don't want tough. I want to walk. I don't want tough. I want to

live. Getting shot and getting paralyzed was humbling. But I'm grateful for the experience."

I cocked my head a little. I was pretty sure I knew what Hashim meant, but I wanted to hear it in his own words. I wanted to hear the way he understood his own transformation. *"Tell me more,"* I said again. It's one of my favorite questions when I interview people, even though it's not really a question.

"My peace comes from me being at peace within my own self and saying, OK, there are things I can change. There are things I can't change—things that I have to just rule as outside of my control. Don't stress over it. Let it go. Keep things in the right perspective. That's key. I can't change the world. Peace starts from within me. If I'm at peace, then everything else is going to be well."

Hashim works with students and offers his own story as a cautionary tale. He wants young people to understand that choices have consequences. He wants people to know that we can find purpose through lifting others up instead of tearing them down.

"Helping and showing love to people, that's rewarding for me. That's important to me. We're all imperfect. I want people to love me with my flaws, so I have to love them with their flaws."

And then he said a few words that have stayed with me to this day: *"I want to love those who haven't shown me love. I want to be kind to those who may not have deserved my kindness."*

And there's the key. It's easy to love the loveable. It's easy to be kind to the ones who treat you well. It's nice to be nice when others are nice. But how do we find it in ourselves to be kind to others when they are not? How do we love the unlovable? When we challenge ourselves to expand our compassion to include all people, when we find ways to love the ones we struggle with, then we are standing on holy ground.

It's an uncommon approach. Un-American, almost. We take care of number one. We stand our ground. We take no shit. We won't tolerate being disrespected. How dare you talk to me that way? These are the ways we choose to respond to the world when we encounter challenges.

Yet Hashim chose love.

We finished the interview, and when it was time to make a portrait to accompany his story, Hashim had a clear idea in mind. He wanted to stand in his living room, wearing his suitcoat. I understood the request. He wanted to

show himself as a professional and demonstrate his strength and independence through standing. I liked it. There was something proud and compelling in his posture, and we made that photo, but I had something else in mind as well. There was another image tugging at me, and I asked for Hashim's help.

The entire time I interviewed Hashim, I had watched him looking out the window. Seated at the table, his rich, dark skin stood in contrast to his white shirt, the white walls of the room, and the white light streaming in through the window. There was something powerful in the setting. Something reflective. I asked if he would be willing to try that as an option, and he agreed.

We each sat where we had been for the interview, and this time I had my camera instead of a recorder. We returned his crutches to the corner where they had rested. For the first time, I noticed a pull-up bar hanging in the doorway to the kitchen, and his green chair offered just a small accent of color in the otherwise black-and-white scene.

"There was a moment," I said, *"when you were telling me about being shot— when you were laying on the ground—and you paused and just looked out the window. Try to remember that moment again."*

We made the portrait. Hashim liked it. I liked it. And then it was time to go. I packed my gear, moved it to the truck, and then returned to say a proper good-bye. I lingered for a little bit, reluctant to leave a good conversation the way I am reluctant to turn away from a beautiful sunset, thinking perhaps there is just one more drop of magic to squeeze out of it.

Make a circle with your thumb and forefinger. Imagine all the knowledge that you've ever acquired is held inside that circle. Every fact. Every experience. Every memory. Now imagine a second circle that holds all the knowledge that has ever existed in the entire universe. How big would that circle be?

This is the image I visualized as I sat in the driver's seat of my truck, waiting to meet Hashim that day, and it's the image I'd like you to create for yourself.

I've asked students in classrooms and workshops to show me how big that second circle would be. They spread their arms into a wide arc, laugh, and claim it isn't possible to make a circle that large with their arms.

Each time I encounter someone new, I recognize their circle holds knowledge and experiences that are different from mine. If I let curiosity and compassion

guide me—if I truly listen—I might learn something new, and my circle will expand.

That's what I did. I traveled the country, interviewing and photographing people, gathering stories of grace, forgiveness, and reconciliation in search of common ground. I went outside of my own experience in the hope that my circle might grow bigger and I could come to understand the world in new ways.

So as I drove away from Hashim's home, I was reminded of why I had started this journey. There is beauty and wisdom all around us if we take the time to see it—if we take the time to hear it. My circle had just gotten bigger through encountering Hashim, and his words would stay with me.

"I want to love those who haven't shown me love. I want to be kind to those who may not have deserved my kindness."

I wonder how it would change the world if we could do more of that.

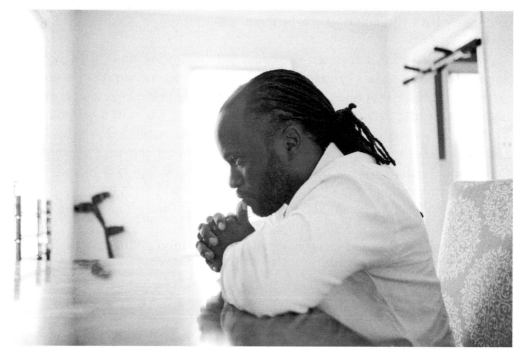
Hashim Garrett

CHAPTER 1

THE SPARK

I like to say the economy handed me some free time.

For two decades, I worked as a freelance photographer for national magazines, Fortune 500 companies, and nonprofit organizations. I had the good luck to shoot travel assignments across the country and around the world.

It was fascinating work. I never knew my schedule more than a few weeks in advance. I might photograph farmers one day, artists the next, and new immigrants the day after that. Projects took me to pediatric intensive care units, rainforest research stations, and luxury spas. When work slowed, I would stare down the empty pages on my calendar and make a few calls, and magically, the phone would ring, sending me off to work a new story filled with fascinating people or beautiful landscapes.

Of course, not every job was glamorous. There were plenty of days photographing standard headshots or the corporate gigs we used to call "guys in ties." But the mix was always interesting, and in our home—a suburban 1960s split-level, with my wife, 2.0 kids, and a cocker spaniel—we embraced the adage "Some jobs feed the belly and some jobs feed the soul." Which is to say, the most interesting jobs generally didn't pay top dollar, and the slightly more boring assignments might offer a better budget. So in the end, you pursued a balance, and it all added up to a living.

Every once in a while, the stars would align and a job would feed both belly and soul. That convergence was magical, and the goal throughout the years was to shift the balance of my work toward those sorts of projects. As I traveled and encountered people from so many different backgrounds, I found all of it interesting. The further I moved away from my own experiences, the more

fascinating the assignments became. In fact, I came to understand that it was my job to discover the good in a place—to find beauty in unexpected settings—and to recognize something worth seeing that others might struggle to notice. I felt fortunate, and business was good—until it wasn't.

The recession of 2008 and 2009 hit the world of freelance photography hard and fast, and my workload plummeted. It didn't dry up completely, but over the course of twelve months, 70 percent of my work just disappeared.

If I were a better businessperson, I probably would have used that open space in my schedule to pursue new clients, but not every decision is based on dollars and cents. There are other ways to measure success. And while the assignment world had been doing a good job of feeding my belly, as the years went on, I found that my soul was getting hungry.

I was increasingly frustrated with the quality of our national dialogue. I was concerned about the rise of angry voices. We were heading into the election cycle with Barack Obama running against John McCain, and it was getting ugly. In hindsight, as I write these words in the midst of the 2020 election cycle, things back then were pretty tame. But at the time, all of the restlessness I felt in my own life overflowed into overt frustration with the political polarization I saw in the news and sensed in my own day-to-day life. There are some media outlets that aim to rile us up, and I was tuning in and following their lead.

Upon reflection, I realized that I had been restless for a while. When the assignment work failed to feed my soul, I would look elsewhere. When possible, I would donate my photography to international projects to reignite my passion and exercise my passport. For example, I would offer to travel with a non-profit and document their work abroad so they could use the images to promote their mission. I went to Honduras on a dental mission in remote villages, where we set up in one-room schoolhouses, chased out the stray dogs, and pulled bad teeth from villagers who had walked miles to receive the only dental services they might ever have access to. When I wasn't taking pictures, I held heads still as the two dentists did their work. I flew to India to document an education program where I photographed boarding home routines, wandered through Hindu temples, and drank more tea and coconut milk than any one person should.

Eventually, I reached a point where it wasn't enough. I had something to say for myself, even if I wasn't sure what that was. I needed a project that would last longer than the days or weeks I was used to. But the phone kept ringing,

my schedule was full, and as a freelancer, I wasn't in the habit of turning work away. So I forged ahead. I pushed aside the nagging voice inside that called me to other things, and instead of feeding my soul, I filled my schedule.

I would self-assign projects that interested me, hoping to find a magazine that would publish the story later in exchange for a paycheck. I rode the length of the Mississippi on barges, where I chose to lose seventy dollars in a late-night poker game with a crabby crew in an effort to build some sort of rapport. I documented the process of steelmaking from the iron mines in northern Minnesota, across the Great Lakes on a freighter, to the steel mills in Detroit. I helped crew the 135-foot traditional schooner S/V *Denis Sullivan* for a week, sailing out of Key West, climbing the 90-foot mast, hoisting the five-hundred-pound anchor by hand winch, and watching dolphins play in the bow wave and the lights of Havana glide past to our south.

Then it happened. My mom got sick. My dad called to tell me that she was in the hospital. She was only seventy and had always been healthy and full of energy. She still worked as a kindergarten teacher's aide, walked miles each day, and could outwork me in the garden or around the house.

"Should I come?" I asked.

"No," he said. *"I'll let you know how it goes."*

But I could hear the worry in his voice, and I had to go. I grabbed a few things and drove the five hours from Minneapolis to Beaver Dam, Wisconsin, the town where I grew up and the place where my parents still lived.

It was cancer. It probably started in her lungs and then moved to her brain. The doctors started radiation and steroids right away to shrink the brain tumors and planned to use chemo for her lungs, but she never made it that far.

There were thirty days between her diagnosis and her death. Leading up to her illness, I had been running a hundred miles an hour for work, and it didn't feel like I had time to breathe between projects, but when things needed to stop, everything that had seemed urgent a few weeks earlier was set on a shelf and quickly faded away. We focused all our energy on her care, and then she was gone.

The busy work of preparing the funeral, making decisions about flowers and music, and informing friends of the sad news helps move you along in the immediate hours and days after a death. But when the service is over and the fellow mourners have gone home, you are left to confront an uneasy quiet and consider how to fill the new void in your life.

I suppose it is a normal process, but it was the first time I had been through it. I immediately recognized how poorly I had supported my wife, Karen, when she lost her own mom. I did the best I could, but I simply didn't understand. How could I? I had never been through that sort of loss before, and I had no real way to relate until now.

I turned my attention to reviving my sputtering business. Our cash flow had reduced to a trickle and then simply stopped. The bills kept coming, and I found myself balancing the grief of family loss with the anxiety of economic distress. I focused my days on filling my schedule again and actually welcomed the distraction. I made the phone calls and sent the emails to let people know I was back in the game and slowly primed the pump that fueled our personal economy. There were interesting projects in the mix, but the whole process had lost its shine. I showed up for my assignments, but my heart wasn't in it, and I worried the lack of enthusiasm was reflected in my images.

Weeks turned into months, and a numbness persisted. Joy was muted, grief was pushed aside, and my restlessness grew. The painful process of losing my mom had pulled back a curtain to reveal the basic building blocks of relationship—of deep conversations and human connection—but as the routine of daily life returned, the curtain fell back into place. The busyness of business seemed hollow. I wanted to pull that cloth back again, but I wasn't sure how, so I sat—stuck—for months, possibly years. If there was a midlife crisis looming, this had all the makings. Luckily, I couldn't afford a sports car, and I didn't want to have an affair. But I had stalled out. I tried all the old tricks to ignite my own spark, but none of them took hold.

Eventually, Karen and I decided to get away. It was 2008. We had been married seventeen years by then. Money was tight, so I did what I always did: I hustled and built a story pitch around a trip, hoping to find a publication that would pick it up and fund it. Someone bit.

The *New York Daily News* agreed to do a travel piece about Sedona, Arizona, called "Earth, Wind and Fire." My idea was to illustrate the concept of earth through hiking, wind through a hot air balloon ride over the red-rock landscape at sunrise, and fire through a spiritual quest in the high desert that was known for its vortex energy.

Karen is an easy traveler, and we spent our days wandering through the stunning landscape and photographing the story. Any time I have fretted about

the logistics of life, Karen has replied with a simple *"It will be OK."* Any time I have stressed about financials, Karen has said, *"We'll figure it out."* She is a patient partner and has always left room for me to chase whimsy, dreams, and early morning light.

For the spiritual quest, we hired a man named Rahelio to lead Karen on a dream journey that I photographed for the article. Offering a combination of Eastern, Western, and traditional shamanistic practices, Rahelio led us to Airport Mesa just before sunset. Karen sat and then laid down on the red-rock formation overlooking the expansive desert valley below while Rahelio played the flute and then the drum and led her through a series of guided meditations.

It photographed beautifully, even if the experience didn't feel particularly focused for Karen. There were dozens of tourists gathered in our midst to watch the setting sun, and as it turns out, Karen's dream journey was also pretty fascinating to them. Spiritual quests don't prefer an audience, I suppose. So even though the session was visually striking, it did very little to transform Karen's spiritual life.

Rahelio spoke as he knelt above Karen, holding the drum just a few inches above her. He passed the drum from her head to her toes, striking it between statements, and the sound reverberated down through Karen and into the rock.

I was focused on light, composition, and exposure, but at times, I tuned in to Rahelio's words as well. His voice was soothing, low, soft. I paused as I waited for a cloud to pass and the dusk light to return. *"Don't work against what you hate,"* he said. *"Work for what you love."*

I suppose I had heard those words before. Maybe everyone has. But something about this place and this time—that dusky, magical hour in a stunning landscape—and something about the way Rahelio said those words on that day made them resonate in a new way. Those words made sense to me, and I could see that I was spending my time working against what I hated. And it was more dramatic than that: I was being eaten up by the news cycle.

I was desperate to find a more positive way to engage with the world, and those few words from Rahelio gave me the nudge I needed. I took the words in and turned them over in my mind. I began to recognize how that simple phrase could change the way I saw everything. That evening in Sedona, Arizona, Karen was on a dream journey, but I found my vision.

CHAPTER 2

WHY PEACE?

Maybe I was born a little too late. I like to believe I would have made a pretty good hippie, but I was just two years old when Jimi Hendrix performed on the stage at Woodstock. I was three when National Guard troops opened fire on students protesting the Vietnam War at Kent State. I like to believe I would have stood with Dr. King during the civil rights movement, but he led his march from Selma to Montgomery in support of voting rights two years before I was born. He was assassinated at the Lorraine Motel in Memphis, Tennessee, just fifty-four days after my first birthday.

Peace was a notion I thought about from an early age, but not in the sense of rainbows, daisies, and unicorns. I am an idealist for sure, but first and foremost, I am a pragmatist. I am interested in the sort of peace that leads us to live better together—the kind of peace that seeks real solutions to complex problems, acknowledges difficult realities, bridges divides, and builds new understanding between people who once were adversaries.

In all my travels, most people I have encountered would welcome a little more peace into their lives—in their personal relationships and immediate families, in their neighborhoods and communities, or in the bigger world. Even my friends who serve in the US military, I suspect, would prefer to stay home with their families whenever possible.

But here's the thing about peace. We say that we want it, but we're not very good at getting it. We're certainly not good at making it.

So you'll see middle school students who flash the peace sign as they walk down the hallway or frame up their selfies but then form into cliques and bully their own classmates. You'll find peace activists on the street holding signs that

say, "Give peace a chance!" even though they can't get along with their immediate family members. You'll find two countries that claim they want to find a peaceful resolution to a conflict, but they can't agree on the shape of the negotiating table to sit at, and at my own church in Bloomington, Minnesota (called, ironically, Peace Lutheran Church), you'll have people who nod up and down on Sunday morning as they listen to the story of the Good Samaritan—a story about helping someone in need no matter who they are—and Monday, they'll walk right by someone in need like it isn't their problem.

That isn't a critique of my church, by the way. It's a critique of the human condition because it happens all the time. There is a disconnect between what we say we value and how we live out our day-to-day lives in the world.

That disconnect was both deeply disappointing and profoundly fascinating to me.

How could we all recognize the need for change and not acknowledge our own role in it? Most of the commentary I encountered focused on how other people had to change or we would face certain doom. Rush Limbaugh rails against the bleeding-heart liberals who are ruining the world while the *Huffington Post* blames Republicans for greed and exploitation.

Don't get me wrong. I have my opinions and they are strong, but I saw a wealth of resources that were invested in driving us apart and precious few that were working to bind us together. Follow that path far enough and it leads you to an ugly future. Spend your days with negative people and that negativity will rub off on you. Surround yourself with folks who believe something better is possible and that contagion will spread as well.

My mom collected refrigerator magnets. She had felt frogs and family pictures attached to our avocado-green Frigidaire. An insurance salesman's business card. A little grid chart to track the progress of her macular degeneration. And there was one magnet with a cutout quote shellacked to a square piece of wood. It proclaimed, *"Your talent is God's gift to you. What you do with it is your gift back to God."*

In my high school days, I applied that saying to my music and volunteered to play trumpet in nursing homes and for church services. I played "Taps" at funeral services for veterans. In my photography, I gave back through personal projects, donating time and talent to try to make a difference for others.

The world's swirling anger needed someone's help. Plenty of people were talking about it, but I didn't see many solutions to the problem. Our social fabric was increasingly unpeaceful, and I started playing around with the following question: *"What does peace mean to you?"*

I wondered what would happen if I interviewed people from different backgrounds and built the conversations around that simple question.

It wasn't going to change the world. That's a pretty lofty goal. But what if it changed one person? What if a collection like this could be a resource to combat the growing animosity in our society? What if it could model the beauty and wisdom of the world and encourage others to seek them in their own lives? What if it changed me in the process?

I appreciated the open-ended nature of the question. It gave people the space to interpret the word however they saw fit and held the promise to quickly get to the core of who we are as humans and what we value as a society. Over time, I found that the simple question opened the door to compelling conversations about race and gender issues, national priorities, and international policy. It provided a platform for people to share what was closest to their hearts and how that impacted the way they lived in the world.

Could something this simple actually build understanding? Could stories connect people in a fractured world? And why should I try? Was it even my responsibility? I'd heard someone break the word *responsibility* into two parts: Response. Ability. What was my ability to respond to a polarized landscape?

I wish I could say I articulated these lofty goals right out of the gates, but I didn't. My mission was a little less certain at the start. The exact process and how this might all unfold was a mystery, but I had a gnawing curiosity. I decided to follow that muse to see what might develop.

In fact, there was no reason I should have been the one to start a project about peace. I had no advanced degree, no secret answer. My temper cropped up at awkward moments, and I cultivated a pretty clear sense that some of the people who didn't see the world the way I did were probably just idiots.

Compassion was present in my life, but it was unevenly distributed. In fact, at times I was downright stingy in how I rationed empathy and care. I am no Gandhi; I am no MLK. Just ask anyone who knows me. Ask my wife, Karen; our son, Jordan; or our daughter, Brenna. I struggle as much as anyone does, but just because we struggle doesn't mean we should give up trying.

I was interested in the conversation, and what began as a whisper of discontent grew into a more persistent voice. The idea took hold of me, flexed its muscles, and started looking for a way out. While the stirring became almost impossible to ignore, I still didn't act. When pressed to name what I felt, the only label I could place on it was *a calling*.

Our folklore is filled with reluctant leaders who tried to silence the voice inside and push away their calling. It never ended well because callings can't be hushed. Callings whisper and nudge. They holler and cry out, and if that's not enough to get your attention, they will grab you by the shoulders, shake you vigorously, and scream, *"Are you going to do this thing or what?"*

A calling doesn't want a defeated partner, I argued. But maybe defeated was the perfect place to start.

All these things converged. I couldn't see it happening at the time, but in hindsight, it makes perfect sense. The recession hit and opened a space in my life for something new. Magazines that had been my bread and butter shuttered their doors. Publications that had once hired me for week-long travel projects whittled them down to a single day.

It all chipped away at my living and my own self-esteem. As a freelancer, it feels good when people desire what you offer and give you money to do it. But when the phone calls slowed down, I found that I needed a little peace for myself.

The project needed a name. I like to craft the headline for an article before I write it. I title a poem in my mind before I ever put pen to paper. It's not that the name doesn't evolve halfway through or when the piece is complete. I'm happy to shift course if the words take me in a new direction, but for me, the title is like a map. Or maybe a compass. It helps chart a course and set a tone and points me in the right direction. I wanted to do the same for this project.

I played with words. What were all the concepts that pertained to this thing I wanted to do? Peace, people, stories, voices, pictures, photos, interviews, perspectives, listening, and so on. What were all the ways we could put these words together? Peace stories. Stories of peace. Peace people. People of peace. Peace portraits. Pictures of peace. Visions of peace. The peace project. Voices of peace. Peace voice. Can you hear peace? Listen to peace.

Nothing grabbed me. A few possibilities resonated, but a quick Google search showed they had already been claimed for other uses. I added a few other

words to the mix, like *heart*, *soul*, and *mind*, and after another round of word association, I stumbled on the combination *A Peace of My Mind*. Something about this phrase stuck.

We've all heard people say, *"I'll give you a piece of my mind!"* and it's rarely the start of a peaceful exchange. It occurred to me that our entire society was leaning into that phrase and its tension. We were collectively overflowing with righteous indignation and quick to tell others about it. Our fuses had become short, and we rushed into conflict before considering any other path.

But replace the word *piece* with its homophone *peace*, and the entire meaning of the phrase shifts. I liked that play on words and settled on it quickly.

That decision has not been without its challenges. Early on in the process, I made a phone call and asked to speak to a woman named Darla. The conversation went a little like this:

Ring, ring.

"Hello, can I help you?"

"Good morning. Can I talk to Darla, please?"

"May I tell her who's calling?"

"Yes, tell her it's John with A Peace of My Mind.*"*

There was a pause. Although a hand went over the mouthpiece, I could still make out the muffled exchange.

"Oh, Darla . . . sounds like trouble. Some guy named John wants to give you a piece of his mind!"

Darla came to the phone with her defenses up. I explained the misunderstanding, and we both laughed about it, but it still placed a bump in the road that I wished hadn't been there. It took us a few minutes to overcome it. I learned to change my language and to answer the same question by saying, *"Yes, tell her it's John with a media project called* A Peace of My Mind.*"*

It made all the difference. Words matter. It's important to set the right tone for a conversation. It matters how we build expectations. Simple statements can be easily misunderstood, but with the slightest adjustment, we can communicate more clearly and avoid those obstacles.

The name was aligned with what I wanted to do, and it was time to start.

CHAPTER 3

THE FIRST STEPS

Desmond Tutu once said, *"There is only one way to eat an elephant. One bite at a time."*

I wasn't certain how to begin such an ambitious project, so I just took the first step. I crafted an email and cast a wide net. I was just looking for recommendations at the moment. The request was a little uncertain but read something like this:

"My name is John. I work as a local photographer. I'm starting a project about peace and plan to record stories and take portraits of people built around the question 'What does peace mean to you?' I'm not sure where it will lead or what I will do with the stories, but I'm hopeful they can help connect people and build understanding in a world that sometimes struggles. I'm looking to draw from a broad range of experiences, and I'm curious if you know anyone who might be willing to sit down and talk with me."

Quite a sales pitch.

To my surprise, people responded. I compiled a list of names as recommendations came in, and then I stalled. Who should be first? How would I ask? What if they said no? What if it went poorly? How many people should I interview? What if I failed?

Exploring the idea in my mind, it seemed full of potential and promise. But when it was time to put it out into the world, it carried the very real possibility of failure. My lack of work and shrinking income were a source of self-doubt, so I questioned myself, but I forged on. I sent out a few requests and hoped for the best. It really didn't matter who was interviewed first. With nothing but a blank slate in front of me, just one solitary response would be substantial progress. I crafted an invitation and explained the process like this:

"I was given your name by _____. I work as a freelance photographer, and I'm starting a project called A Peace of My Mind. *I would like to invite you to participate. We'll schedule a time for a recorded interview. We'll talk about your background and experience, and we'll build a conversation around ideas of peace. You can talk about spiritual peace, political peace, or inner peace. It's open to your own interpretation of the word, and the conversation can lead where you like, but some of the guiding questions will be*

- *What does peace mean to you?*
- *How do you work toward peace in your life?*
- *What are some of the obstacles that get in the way of peace?*
- *Tell me about a time when you saw a great example of peace in your life.*

"When we are done with the interview, we will do an informal portrait. I can't be sure how long this whole process will take, but I would think maybe two hours. I'll ask you to sign a release that says you are willing to lend your voice to this collection, and at the end, I'll send you some of the photos that you are free to use in any way."

I sent out a few of these requests, and the first to respond was a woman named Barbara Nordstrom-Loeb. I didn't know much about her, but she was recommended by Vic Rosenthal from Jewish Community Action in Saint Paul, whom I had contacted as the result of a Google search with the words *Jewish, Peace,* and *Minnesota.*

Barbara was willing, interested, and available. At this early stage, those were the three most important prerequisites. The door opened, and there was nothing left to do but walk through it. We compared schedules and picked a date two weeks later.

This quote was attached to the bottom of her email:

> Only the walker who sets out toward ultimate things is a pilgrim. In this lies the difference between tourist and pilgrim. The tourist travels just as far, sometimes with great zeal and courage, gathering up acquisitions, and returns the same person as the one who departed. The pilgrim resolves that the one who returns will not be the same person as the one who set out. The pilgrim must be prepared to shed the husk of

personality or even the body like a worn-out coat. For the pilgrim, the road is home; reaching the destination seems nearly inconsequential. (Andrew Schelling, *Meeting the Buddha*, edited by Molly Emma Aitken)

I suppose I was taking the first tentative steps on the path of a pilgrim, but I didn't know it at the time. Any joy at starting this journey was tempered by self-doubt and uncertainty about the final destination.

On the day of the interview, I parked in front of Barbara's South Minneapolis home. It was a 1912 bungalow with a stucco exterior. Maple trees lined the street. It was April 16, 2009. Taxes were due the day before, and we had pulled money from our retirement funds to cover the bill. I felt small.

It seemed easiest to meet in people's homes. It was comfortable for them. It offered a window into who they were and the things they surrounded themselves with. There was one additional, unexpected benefit that became clear over time. The conversations often became intimate and emotional. It was not uncommon for one or both of us to wind up in tears during the interview, and the privacy of their own home was a safer place for that to unfold.

I walked up the short path to the house, climbed the three steps, and knocked on Barbara's door with my arms full of equipment. We said hello, I thanked her for being open to the conversation, and I asked where she would like me to set up. We agreed on the dining room, at a round, wooden pedestal table with soft light coming through the north-facing window.

It took me twenty minutes to set up the gear, and when we began the interview, I quickly recognized a tactical error. Barbara leaned on the table as she sat across from me, and the aging joints of the woodwork let out a weary creak. Barbara's earthy bracelets clattered loudly against the dark wood surface. These were all normal sounds in the course of ordinary dialogue that would quickly fade into the background of our consciousness, but wearing headphones and wired for recording, it was clear I had much to learn about gathering quality audio. I had much to learn about the entire interview process.

Over time, I understood that providing a list of questions prior to the interviews was a mistake. At times, I offered a full battery of questions by email so the person being interviewed could feel more prepared, but it reduced the sense of spontaneity. Once, someone showed up with a notebook full of written responses and proceeded to read them back to me. It was thoughtful but felt

a bit stilted. Never again. I stopped providing that list of questions because I preferred a candid conversation. The answers were more interesting, and it simply felt less formal, more human, and more authentic. The informal and free-ranging conversation with Barbara set a high bar.

I would listen for cues and paths worth exploring to dig a little deeper. I was not shy about asking difficult questions, but I always let the person on the other end of the interview know that they had absolute veto power. They could decline at any time, although I never once had someone say, *"I don't want to talk about that."* The simple act of offering people agency over the conversation created a space for far-reaching dialogue and honest sharing.

When it was time to steer the conversations toward a more pragmatic realm, I asked people to talk about their own experiences: *"Can you tell me a time when you saw a great example of peace in your own life?"* That's when you started getting to the good stuff. That's when the conversations became deeply personal. Those personal experiences, more than any theory or idea, are what make us human. They are the threads that weave our rich fabric and get to the heart of who we have become and who we want to be.

Barbara and I stumbled through the technology, and together we learned to keep our hands off the table to reduce the ambient noise. She was patient and kind, and soon enough, the conversation fell into a rhythm and unfolded naturally. I suppose I led the interview, but mostly I just listened.

We began our exchange by getting to know one another: *"Tell me your name and where we are sitting."* *"If I didn't know anything about you, what would you want me to know?"* Simple prompts like this allow people to settle into the conversation. They offer space for the interview subject to set the agenda and let them feel like what they have to share is important—because it is.

I learned to be patient. I learned to be quiet. In return, I was rewarded with compelling stories and new insights. *A Peace of My Mind* quickly became a project about listening, and it was a skill I practiced throughout the interviews.

Barbara was a psychotherapist, an educator, and a healer involved with social justice issues, including Jewish peace work related to Israel and Palestine. Barbara viewed fear as an obstacle to peace and recalled a parable told by a Native American elder. Two wolves are engaged in a battle inside each of us. One wolf represents peace, hope, and truth, while the second wolf represents fear, anger, and lies. The elder's son asked which wolf would win the battle, and the elder replied, *"The one you feed."*

I wondered to myself if this project I was starting could be a way to feed the wolf of peace, hope, and truth.

Barbara explained that her understanding of peace didn't equate with giving up who she was in order to promote harmony.

"Sometimes when people say peace, it's sort of masking differences. A lot of stuff gets marginalized if everything's just all nice-nice. Everybody gets along, but it's at the sacrifice of the ways that people are different and sometimes do bump up against each other. For me, peace is a place where everything is represented and welcomed and present. And that's much more complicated because then you have to figure out 'How do I relate to, or accept, or be with other parts that I don't like or don't want or wish they would go away?' You have the right to your beliefs, but you don't have the right to impose them on me or on anyone else, and each one of us has to figure out how we relate to someone else's beliefs that we really disagree with."

Part of that dance could mean steering clear of certain people and recognizing that you don't have to like everybody—that didn't mean they were bad people or that you were a bad person. It was a dance that allowed her to appreciate the differences around her.

"I think about buying clothes. People say, 'Always have a beige shirt because beige goes with everything.' At some point, I thought, The last thing in the world I want to be is beige. Why would I want to get along with everybody? *If the only way I could get along with everybody in the world is by being beige, I don't want to. I want to be the rough and funky parts of me and the wonderful parts of me, and I think that is hopefully true of everybody."*

At the end of the interview, it was time to make a portrait. I always do the work in that order—an interview followed by a portrait. It takes time for both the interviewer and the subject to settle into the exchange. Leading with the photo would feel rushed and unnatural. Through the interview process, I get to know the person I am talking with. I have time to consider what might make sense for the portrait. I take the opportunity to observe the way they hold themselves and the comfortable poses they fall into as they relax. And I get to judge the tone of the exchange. If someone spends most of the conversation talking about the lessons they learned through the death of a loved one, it doesn't make sense to photograph them smiling. And if someone shares the importance of approaching life with a positive attitude and a smile for passing strangers, it would be incongruent to photograph them with a stern or stoic expression. By

the time we have moved through the interview process, we have both become comfortable with one another, and I have a better understanding of what the portrait should try to convey.

During our conversation, I had noticed some of the details of the house. Tapestries from Barbara's travels covered the walls of her home with scenes from Thailand, Morocco, and Egypt. Books overflowed their shelves onto small stacks on the floor. A guitar leaned against the wall in the corner, and a violin hung beside a window. An upright Elgin piano stood proudly against one wall. Houseplants soaked up the sunshine that spilled through every window. Each element told a little bit about who Barbara was and how she filled her time. I wanted a portrait that felt informal, like she was. I wanted an image that told us a little bit about who she was. I asked if she would sit on the piano bench, not like she was playing it, but just resting comfortably there so we could see some of the environment behind her.

She sat cross-legged on the bench and turned to the side to face me. The window light was strong from my left side and gave shape, texture, and depth to the image. I composed the portrait so a tapestry draped over a doorway framed her from behind. Houseplants softened the edges of the image. The violin was visible just over her right shoulder, and natural light flooded the room behind her. I shot some tight portraits, but the image that interested me was the one that showed the space around her, backed out far enough to see her casual stocking feet and the edge of the piano bench that she sat on, hands resting comfortably on her lap and eyes looking directly into the camera lens.

"We got it," I said. I don't always know what I want, but I do know it when I see it. So almost always, as I look through the lens, I am keenly aware of when we have gotten the shot and when it's time to stop. As I pressed the shutter button, the photo seemed to capture the rough and funky and wonderful parts of Barbara she had spoken of in the interview.

"That's it?" she asked.

"I think so."

There was no client to please. I just wanted an honest portrait that captured the moment, something that both Barbara and I could be happy with.

As I packed up my gear, something caught my eye. Sitting on top of the piano was a small woven basket, and it looked to have a swastika on the side of it. I couldn't understand why anyone would want to display a swastika in their

house. Barbara is Jewish, so it made even less sense to me. I thought about ignoring it and wrapping up our time together, but curiosity pressed me to ask.

She explained that the symbol was thousands of years old and represented good fortune. The word had its root in the Sanskrit word *svastika*, and it continued to be a sacred symbol in religions around the world. It was Hitler's regime that had twisted the beautiful symbol into a sign of hatred, and she chose to reclaim the original intent. It seemed to me a powerful statement of strength and control—of choice—and I wished I had asked the question during our recorded interview.

I walked out the door and thought to myself, *That was interesting*. And I decided to do a second interview, which was interesting as well, so I did a third. And a fourth. Each person I talked with offered suggestions for new interview subjects and helped connect me to others, so the web began growing wider.

Before long, I had gathered a dozen stories, and I wasn't sure what to do with them. My friend Chris encouraged me to launch a website to share them publicly, but I balked at his suggestion. *"I'm not even sure what I'm trying to do yet."* I resisted the idea for fear of looking foolish or unprepared.

"Just put it out there," he said. *"You'll figure the rest out later."*

It was good advice. So I built the website, www.apeaceofmymind.net, and suddenly I had a small body of work living online. Even at that early stage, looking at the individual stories as a collection, I recognized how incomplete it was. The goal was to have a series of diverse perspectives, and there were important voices missing. It was 2009, and given the politics of the day, it was important to me to include Muslim voices in the series. So far, there were none. In fact, I became quite aware of the fact that I really didn't have any Muslim friends in my circle, and I realized I would have to be intentional about inviting those voices in.

I went back to Google and this time added the word *Muslim* to my search for *peace* and *Minnesota*. The top result was the Islamic Resource Group, an organization whose mission is to *"build bridges of understanding between Minnesota Muslims and the broader Minnesota community through education."*

I reached out, explained *A Peace of My Mind*, and asked if they could recommend someone I could talk with. They introduced me to Zafar, who later introduced me to Imani, who introduced me to Odeh, and suddenly I had a whole new network in my life that hadn't existed before. In fact, all of my networks

Barbara Nordstrom-Loeb

expanded. People started reaching out to me, suggesting individuals I should interview or perspectives to explore.

The body of work grew. It started to feel like this series was gaining a life of its own, but it was a difficult juggling act. There were more people to interview than my schedule could accommodate. I was still doing as much assignment work as I could find in order to pay the bills, but this little side project became more and more interesting to me.

Typically, when I saw blank days looming on my calendar, it was my habit to put out a series of calls to my regular clients, and those days would magically fill up. But as we say in the business, when you stop shaking the trees, the jobs stop falling out. I don't think it was an act of self-sabotage as much as a shift of interest, but I spent more and more time looking for new interviews and less and less time looking for new assignment work. I would manage the editing and production on my slow days and in between family obligations. I stopped shaking the trees, the jobs stopped falling out, and pretty soon we found ourselves out on a limb.

When the Israelites went into the wilderness after their exodus from Egypt, they eventually ran out of food. They grumbled, but God provided. Just when they thought they would starve to death in the desert, God sent them manna every morning and quail each evening. They were told to gather just what they needed for the moment and trust that there would be more the next day. They lived on faith.

I started seeing the thinning stream of jobs coming in as my manna from heaven. There was just enough work to keep going, and it came in just at the last minute. We learned to live on faith. I like to believe that I grumbled less than the Israelites, but I'm not sure that's true.

CHAPTER 4

TOUGH CHOICES

Fear of starvation is a powerful motivator. Our family was never at risk of going without food, but financially, things were getting tight. I was passively unraveling the assignment photography business I had built over two decades and replacing it with work that fed my soul but didn't seem to hold any promise of paying the bills.

Just before the recession, we leveraged the equity in our home to buy eighty acres of agricultural land in western Wisconsin, where we fostered dreams of starting a Christmas tree farm, so as our expenses were going up, our revenue was going down.

We trimmed back where we could. Smaller gifts for the holidays. Fewer nights out to dinner. Less frequent vacations. When we did travel, we chose destinations that required tents rather than hotel rooms. We stopped contributing to our retirement plans. Then we started pulling cash out of them just to make ends meet. I wasn't sure where the bottom was. In hindsight, the kids say they never really noticed a difference, even though we talked about our finances openly, but this newer, leaner economy felt daunting to the grownups in the house.

There were difficult decisions to make. It was getting hard to afford the payments for both the house and the farm. My mom's ashes were buried at the farm in a cluster of maple trees we called Grandma's Grove. We had a deep love for the land, but it had no buildings or place to live, just a junky old camper jacked up on cinder blocks where we slept until the abundant mice chased us into a tent. We had less love for our suburban 1960s split-level back in Minnesota, but it was our home. It had a toilet that flushed.

In theory, we could have moved in with Karen's dad or mine if things got really tough. That carried with it all the feelings of middle-aged failure and

despair. We considered selling the farm, but it would mean leaving behind those new dreams, and as prices dropped, we would likely sell it for less than what we owed. Either way, a big hit was looming, economically and emotionally. So naturally, we did nothing. We were paralyzed, and we hoped each new month would bring a different reality, although it never did.

I nudged *A Peace of My Mind* forward. Just enough assignment work trickled in to keep us afloat as I watched some of my photographer friends abandon the business and take jobs with the TSA.

As we limped into 2010, Karen suggested we sell the big new four-door pickup truck that we bought just before the recession. I loved that truck, but it came with a four-hundred-dollars-per-month payment and a ravenous appetite for fuel in the days when gas was pushing past four dollars a gallon. I hesitated, but she was right. We posted it on Craigslist the next week. I was sad to see my truck drive away, but we used the money to pay off its loan and had enough left over to pay cash for a fifteen-year-old Honda Civic with 140,000 miles on it.

All ego set aside, debt-free driving was far better than being driven into debt. That decision removed a little bit of economic pressure and made it possible to keep working on *A Peace of My Mind*. At the very least, it helped us feel like we were making choices about our own destiny. But even so, it seemed like an admission that we were failing. In that mix of emotions, we walked even further out on that limb, chasing this new vision with no promise of a return.

When you follow your dream, there is a fine line between foolish and visionary, and you don't know which side of that line you're going to land on. We've all heard the story of Steve Jobs and Steve Wozniak, who started tech empires in their garage, but we hear less frequently about the countless others who toil away for years and never reach their goal. Failure is real, and success can be elusive. That reality was unsettling as I struggled forward with my own quest, and it kept me up at night.

Right around the time I sold my big, beautiful truck, I had the chance to interview an oil company executive. Not some middle-management guy, but the downstream director for Shell, meaning that he was the top boss for all petroleum products headed to consumers around the world.

Mark Williams was one of Carleton College's trustees. Carleton was a frequent client of mine—they made the introduction, and Mark agreed to the interview. At the time, oil companies were posting record profits every quarter. We had just sold our truck because we were going broke. As I walked into the

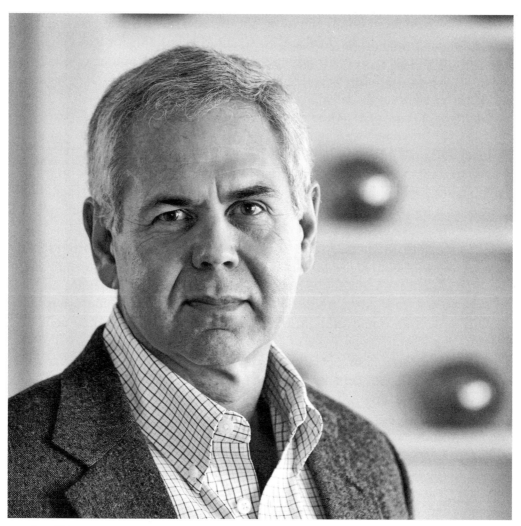
Mark Williams

room to set up, I thought to myself, *Man, this guy is making money hand over fist from people like me, and I can't even afford to keep gas in my truck.*

It was my birthday. I wore my typical lumberjack uniform to the interview: jeans, hiking boots, and a flannel shirt. Mark arrived in a crisp, checked shirt with a button-down collar and a tailored blazer. We met at the Headley House on campus, a brick and stucco home built in 1917 by a Carleton professor of philosophy, psychology, and education and now used to house guests and visiting scholars and as a hub for social and academic gatherings.

The living room had high ceilings, a hardwood floor, and formal furniture. A small dining nook to the side was lined with bookshelves and art and filled with natural light from two large windows. I set up at a heavy round table in that corner.

A rhythm slowly developed for this body of work. I became comfortable with the interview process and made little adjustments here and there to make it better. I learned to avoid interesting conversations as I walked in the door. If someone launched into good material before the recorder was turned on, I would interrupt and ask them to stop. I was afraid it would be perfect the first time and if I asked them to repeat a story once we were on the record, they would recite it in shorthand, knowing that I already had background knowledge. It was better to just talk about the weather or the commute until the interview began and save the good stuff for the recording. Eventually—perhaps reluctantly—I had to realize that I did know what I was doing. When you do one interview, you learn something. When you've completed ten interviews, you gain a level of comfort and proficiency. When you've done a hundred interviews, you've suddenly accomplished something that few others have even considered.

Despite the growing body of work, I was still uncertain. Mark seemed perfectly at ease. I felt like a country mouse in the big city. I got the sense that Mark had sat through many more interviews than I had led. He was kind and gracious, if maybe a little disinterested.

If I'm honest, I have to say that I approached this particular interview with a chip on my shoulder. I walked in with a certain expectation of what an oil company executive would be—and it wasn't positive. I wondered if my attitude showed through. I wondered if he could sense my distrust or if maybe I looked as defeated as I felt.

I grew up camping and hiking through our country's national parks. When I sat in the dentist's chair and needed to mentally retreat to my "happy

place," I inevitably envisioned an unspoiled wilderness with wildlife frolicking through it. My default narrative was consistently "Environmentalists = good. Oil companies = bad." But of course, I had driven to the interview that day. In a car. Using oil.

Much to my surprise, Mark acknowledged climate change early in the interview.

"Eighty percent of the world's energy currently is produced by fossil fuels, which are a limited resource. Further, fossil fuels—combusted in the typical way we do it—produce carbon dioxide. It has become obvious that we have to move away from them.

"We have to meet people's legitimate needs for energy while we keep the planet from going bust as a consequence."

This wasn't the caricature of an oil company executive that I had expected. I understood that his horns and pitchfork wouldn't be visible, but I fully expected him to dismiss, deflect, or at least minimize any environmental concerns I might bring up. I pressed Mark about how we could keep the planet from going bust, and he went on.

"This is one of the hardest things that humanity has ever faced. It's a global problem, and the mechanisms for adjudicating things on a global scale are not strong. Without the right governance in place to allocate resources and manage costs, we face the potential for tragedy on a global scale.

"With regard to peace, if developing people's needs aren't met, tensions will increase on a global scale. If global warming goes forward unabated, its effects will be felt unequally and create conflict. If nation-states focus on supplying their own security, when we finally pay the price for global warming, it will be much more difficult and much more expensive."

I've always aligned myself with the Sierra Club. The Nature Conservancy. Maybe even Greenpeace. From my environmental perspective, I always assumed that people in the oil industry were ignoring my concerns. I believed they didn't care. I imagined the issues weren't even on their radar.

Of course, I had never talked to "them" before—only about them. When I sat down and entered into dialogue with Mark, I began to see and hear a narrative that I wasn't expecting.

"There are no simple solutions," he continued. *"Exercising leadership, thinking about next steps, the next source of energy, and the next source of wealth and mobility are important because it takes decades to change these systems. Ideas*

about proper governance, the role of the state, individual responsibility—all of this is converging. You can point to examples where that isn't happening, but overall the pattern is quite powerful. The world is growing up, and we are thinking about the right way to underpin a peaceful society."

I walked into this conversation with certain expectations based on the "oil company executive" label I had applied to Mark. The label carried a lot of baggage, and I was happy to throw it all at him. My mind filled in all sorts of blanks about who Mark was and what he believed. In the world of "us" and "them," I was convinced Mark was one of "them" before I ever met him. But when I spent time in conversation with Mark, I began to see past that label to his humanity. I began to recognize the complexity of the situation in a new way, and perhaps most importantly, I came face-to-face with my own bias.

I started to wonder what other biases I held as fact. Where were my own blind spots? How were they affecting the way I understood the world, and how were they impacting the way I viewed others around me?

There's the funny thing about blind spots—you don't always know that you have them.

Recognizing my own biases reminded me of hunting for morel mushrooms on the forest floor or searching for sand dollars along the seashore. It's really hard to find the first one. You're not even sure what you're looking for. But as soon as you see one, you start to recognize the pattern. Morels prefer moist and loamy soils. Sand dollars become more visible when backlit on the beach. And once you find one, the others become easier to spot. Similarly, biases can be exposed through purposeful searching and honest reflection.

We attach shame and guilt to the stigma of being biased, and because of that, we work hard to believe we don't have any biases. We reserve them for the bad people, and in that way, we avoid having to face our own. I've found it helpful to set aside the stigma—to simply recognize biases and notice how they impact our thoughts and then resist them and do the work of challenging them. For me, that looks like suspending judgment. Hearing someone out. Exercising patience. Taking a breath or two before responding. Seeking clarification.

Don't get me wrong. I didn't walk away from my conversation with Mark thinking that oil companies were angels. I still believe that large corporations are guided by profit and that the drive for profit can lead to unfortunate—even disastrous—choices and results. I still believe that one reason these conversations

might even take place at an oil company is because of the ongoing work of people at the Sierra Club, the Nature Conservancy, and even Greenpeace, who keep applying pressure and pushing these issues into the public forum.

I didn't walk away from this interview believing that Mark and I agreed on everything. But I did begin to understand that these issues were not as black and white as I had imagined them to be before. I was starting to recognize some of the subtle shades of gray that defined the complexities of the debate, and the barrier between "us" and "them" faded a little bit in the process.

We all have biases. They are relatively easy to spot in other people and a little harder to recognize in ourselves—but they are there, and they get in the way of our clear understanding of the world.

CHAPTER 5

THE WORLD IN MY BACKYARD

I didn't have money to travel. As I subsidized *A Peace of My Mind* with my remaining assignment work, I needed to stay close to home in Minneapolis for the interviews. The Upper Midwest is perceived as lily white, and certainly the heavy Scandinavian immigration of the mid-to-late 1800s is still evident in the population today. But the cities of Minneapolis and Saint Paul are diverse. The first fifty interviews for *A Peace of My Mind* were done in my own backyard, but the worldview was much bigger than that because of the people I encountered along the way. Immigrants, refugees, and travelers passing through all shared their stories, expanding and enriching the collection through their varied perspectives, backgrounds, and experiences.

Jamal Hashi was born in Somalia and attending elementary school when the civil war broke out in his country. *"It sounded like thunder,"* he said of the explosions, and it came from a place between his school and his home, so he was never able to go home again. He fled with his older brother, taking shelter with family friends and making their way to the southern part of the country. Eventually, they snuck onto a ship filled with refugees who were escaping the war.

Jamal now lives in the United States, where he owns and operates a restaurant. I interviewed him in a public seating area just a few steps away from his food stand in a bustling commons called Midtown Global Market. His Safari Express sells *sambusa*, rice dishes, and roasted camel. Jamal kept his eye on the time, sensitive to the brief lull in his day where we had squeezed the interview, between the lunch rush and the evening commuters grabbing takeout to bring home.

Jamal said he has lived three lives: a stable childhood in Somalia, a season of chaos and uncertainty as he was coming of age on the move during the war, and his current life in the United States. He feels fortunate to be in America,

where he has found a life of peace, because he has experienced life without peace in a way I can never imagine.

"I have the three greatest things that a human needs," Jamal said. *"Shelter, food, and a person who loves me very dearly. I smile more than I used to."*

Jamal exuded gratitude and joy. He took daily troubles in stride knowing that he had seen much worse in his life. I asked him about the challenges of the world and about people who have the same material possessions he has now but still can't seem to find joy. I asked him to talk about some of the strife he witnessed growing up and some of the geopolitical drama unfolding after 9/11. He offered a parable of sorts.

"You know, the Bible, the Qur'an, they all give the same message," Jamal said. *"But people fight about who was the messenger. The core of the message is achieve peace, give peace, and live by peace. But what do we fight about? The difference of who was the messenger. It's like killing the mailman because he wasn't the same mailman last week. Did you get the mail? That's all that matters."*

Until I met Jamal, I had no personal connection to Somalia. What I knew came only from the headlines. Putting a name and a face to world events gave them new meaning, and that personal connection brought nuance and perspective to the stories I saw in the media.

I appreciated Jamal's buoyant and poetic enthusiasm. It resonated with my own optimism that kept rousing me out of bed each morning, even when things seemed bleak. But I also found truth in the more pragmatic responses from others.

Luyen Phan was born in Vietnam, and his family moved to the United States during the final days of the Vietnam War, when he was six years old. A Lutheran church from Redwood Falls, Minnesota, sponsored Luyen's family, and his parents made that town their home.

With a Fulbright scholarship, Luyen studied in Singapore and went on to work in Thailand. Today he works with international students and believes that student exchange programs can lay a valuable foundation for understanding and accepting different cultures. Even so, he feels the challenges are daunting.

"Peace is an absence of war. In the past thirty-five years, there have been very few periods of peace. People said that what happened in Nazi Germany wouldn't happen again, and then it did, in Cambodia and Darfur.

"The cynical side of me says peace is a dream. It's great to live for and hope for, but we don't learn from history. We get greedy. We want something we don't

have or more of what we already have. It's human nature. There are good people in the world, but sometimes there may not be enough of us to balance things out. Or we may not have enough real power—political, economic, cultural, linguistic, social—to stop these things."

This resonated with my own tension around what was possible with *A Peace of My Mind*. On the one hand, perhaps it was absurd to believe that stories could heal the many wounds of our broken world. On the other hand, perhaps it was foolish not to at least try.

In Luyen's work, he brings students together from different cultures to engage in and build relationships. He sees that over time, they develop friendships and become advocates for one another. It's a model that has potential on a large scale.

"Small exchanges can grow into deeper discussions. Hopefully, over time, those relationships continue to build. It may be years or decades later, but when we read a story about a place and whatever bad thing is happening there, we will think about our friend who is from there or about the student who went back there. I believe those small experiences will help people work toward some sort of world peace."

I've seen it a hundred times in my travels. You can do as much research as you like, but there is no substitute for being in a new country and talking with local people to deliver a perspective and understanding that simply can't be gained any other way. Here I was, able to do the very same thing in my own backyard just by being thoughtful about who I spent time with.

In all of these conversations, I learned something interesting. If I just stopped talking—if I left a big, gaping open space in the conversation—the other person might eventually fill the silence. And often they would fill it with amazing and unexpected things. We don't feel comfortable with dead air, so we speak. We dig a little deeper to find something more to say. I learned to pause in order to leave the intentional space for listening.

I've heard it said that we spend the first two years of our lives learning to speak and the rest of our lives learning to listen, but we never quite get it right. We listen in order to respond or refute. We listen so we can debate or debunk. We listen to correct, coerce, or convince. But listening with the simple goal of understanding—that is rare. Imagine how the world could change if we did more of that.

I connected with people from other countries who were passing through Minnesota. Najm Abed Askouri was a physics professor from the University of

Kufa in Iraq. He participated in research to document the effects of depleted uranium munitions used by US forces in Iraq. Designed to penetrate hardened targets, depleted uranium remains toxic for years, possibly generations, affecting military and civilian populations alike. The depleted uranium is atomized upon impact on the battlefields, picked up by dust storms, and spread into populated areas. The cancer rates in parts of Iraq are tragically high as a result.

Najm was a member of the Muslim Peacemaker Teams in Iraq. In October 2009, he traveled to Minnesota with a delegation of Iraqis who were establishing a sister city program between Minneapolis and Najaf, Iraq. When I sat with Najm for his interview, the headquarters for one of the companies that manufactured depleted uranium munitions was just outside of Minneapolis, roughly a dozen miles away.

"Peace is much cheaper than war," Najm said, *"and it is the most effective way for people."*

What was it like for Najm, I wondered, to be visiting the country that went to war with his own? How would I feel if I had gone to Iraq? When I have traveled overseas, I've been amazed at how people differentiate between people and policy. Our country had visited great harm on Najm's homeland. Without a doubt, it had affected people who were very close to him, yet he sat with me and treated me kindly. He had traveled to Minnesota in order to build connections and create peace, one person at a time.

I met people who illuminated history for me. Fred and Judy Baron were Holocaust survivors. Fred spoke at my son's middle school, and I had hoped to attend the lecture so I could invite Fred into the project. As it turned out, I had an offer for paying work that day and needed to take it. I wrote a letter to Fred and handed it to Jordan. *"Please give this to your speaker after the assembly,"* I said. Jordan was a little shy at the time, and I wasn't sure it would happen, but he passed on the note, and the next day, Fred called me to schedule a time to meet.

Going to his apartment, I was expecting to interview and photograph Fred. That was my typical model—one person at a time. I found it easier to craft a narrative arc with one person's voice, and I could make a more dramatic portrait of a single person. But when I walked in the door, both Fred and Judy greeted me. As I set up my equipment, both of them sat at the table.

I panicked a little. I thought about explaining my model for the series and that I only interviewed one person at a time, but it is impolite to uninvite

someone to an interview. I felt incredibly honored that I had been asked into their home for this conversation, and I was willing to accept what they offered. I asked, *"Will I be interviewing one of you or both today?"* They discussed it among themselves and decided to do it together.

Fred and Judy were in the Bergen-Belsen concentration camp together during World War II, but they didn't meet until after the camp was liberated and they were recovering in a Swedish hospital. They fell in love, moved to the United States, got married, and started a family. They talked of trying to find peace again after living in a place that had none. The emotion was evident in their voices, and the table we gathered around transformed into a sacred space as they related their stories with the vivid detail of a memory that would not fade.

I asked Judy to describe the community of people who were subjected to the camps, and she corrected me: *"It wasn't a community. It was a bunch of people who were afraid to be dead the next minute. There could be no peace in a place like that."*

We sat quietly for a moment, and I struggled to offer the most relevant experience I could recall. In my effort to connect, I shared that Karen and I visited Dachau, another concentration camp outside of Berlin, several years earlier and that we were deeply moved by the experience. I expected that this bit of personal history would find its way into our conversation, and this seemed like the right time to share, but I had misjudged.

Judy was hurt. She explained that she had returned just once to Bergen-Belsen, and she found it profoundly troubling that it had been turned into a tourist destination. From my perspective, I had only seen the memorials as honoring the victims, and I had never—until that moment—considered that it might be an unwelcome intrusion onto hallowed ground for those who had lived through the experience. I didn't sense that Judy was upset with me for raising the issue; she was perhaps weary that yet one more person had failed to grasp just how painful that personal history was for her.

I recognized that I had blundered. I paused and apologized. Both Judy and Fred offered grace, and the conversation continued.

Fred spoke of the guards who watched over them during the war: *"I spent almost a year in a camp in eastern Germany. The area was very quiet and tranquil because the Russians at that time were still far away and the Allies did not bomb anything in eastern Germany. So the families of some of these guards came to stay with them, or at least visit them for a long time. I was always impressed with the*

way they treated their family members—their children and their wives—normally, just like you and I would. They loved their families, and they cared for them. By all means, it looked like a normal human being, and yet when they turned toward us, they were completely animal-like.

"I could never understand that dichotomy to this day. They seemed normal human beings on one side, and when they dealt with us, it was like a different human being or no human being at all.

"There were exceptions to that, I should say. Nobody should say that there were not exceptions. I have sometimes met, even among guards, people who had a human moment and some expression of pity."

It stunned me to think of the concentration camp guards in a human capacity, spending time with their families and expressing love. On one hand, I expected it to be true, but I couldn't reconcile it with the brutality I understood in what they had done. Had they convinced one another that their behavior was justified? Had they compartmentalized their emotions enough that they had persuaded themselves that this was rational behavior? Nobody wants to perceive themselves as evil. So what sort of mental gymnastics had these guards gone through to treat human beings the way they did? What tragic behavior was our society busy defending today? And what was I guilty of justifying in my own life?

Fred's statement surprised me in another way as well. He seemed able to recognize some bit of humanity in the guards, even though they didn't return the favor. In spite of the fact that these men treated him so poorly—and were the reason his very life was in jeopardy—Fred was able to observe and acknowledge some tenderness in the interactions with their families.

We don't tend to do that. When we face an adversary, we are quick to point out their faults. We work overtime to gather all of the evidence that demonstrates how bad our enemy is and conveniently ignore any evidence that would show otherwise. It's called confirmation bias, and once we make up our mind on something, we just keep finding and focusing on the examples that prove we are right.

The fact that Fred could recognize any good at all in these guards was a remarkable display of grace. What if we could do more of that?

CHAPTER 6

SOME THINGS TAKE TIME

When I turned forty, my family asked what I wanted as a gift. I had been on the road a bit, so all I could really think of was a little time together and asked if they would treat me to breakfast at Al's Diner, a small café in Minneapolis's Dinkytown neighborhood.

When I say small, I mean Al's has one single counter with fourteen stools. That's it. Hungry patrons queue up right behind the folks who are eating, and the rest wait in a line that extends out the door and down the street.

If you are a party of three and a few single seats open at the counter, the whole row of diners in between will grab their plates and shuffle a couple of stools over to open a space where your whole party can sit together.

We had a slow start on my birthday morning, and by the time we arrived at Al's, the line was long. Even though it was February in Minnesota, the sun was bright and offered a hint of warmth. We decided to wait our turn. A man who appeared to be homeless was talking with people in the crowd. He had a marker and a coat that was covered with signatures scrawled across the fabric. He invited people to sign his coat and maybe give him a dollar or two in the process. But more than anything, he seemed to enjoy the conversations with the people in line, who seemed to enjoy his company as well.

We learned that his name was David. We signed David's coat. We gave him a few bucks. We visited and passed the time, and pretty soon we had moved up in line far enough that we could enter the front door of the diner.

I don't actually remember our entire exchange, but I am certain I had never engaged with someone who was homeless in quite that way before. I went inside the doors of the café and was aware that David couldn't really do the

same. But my mind was less focused on *"Poor David, he is homeless"* and more centered on *"What an interesting guy . . . I'd like to spend a little more time with him."*

We finished breakfast, but when we went outside, David had moved on.

A couple of years later, I started *A Peace of My Mind*, and I hoped to connect with David and invite him to share his story, but I had no idea where to find him. I drove by Al's a few times when I was in Dinkytown but never saw him. I asked around, and though others had seen him and signed his coat, nobody seemed to know where he stayed.

I tabled the idea and focused on other interviews. If it was meant to be, an opportunity would present itself. As part of my research process, I learned about an organization in Minneapolis called the Peace House Community, a day center where people who were unhoused could feel welcome for a meal, some conversation, and a little encouragement. I interviewed Marge Sullivan, one of the longtime volunteers at Peace House. After interviewing Marge, I packed up my gear and went to walk out the door at the very same time that David walked in. I said hello and followed up with, *"I think I'm supposed to talk with you."* We sat down and visited, I explained the project, and we scheduled a time to do an interview the following week.

We met back at the Peace House Community, a weathered, two-story house that sat alongside Interstate 35W just south of downtown Minneapolis. We were offered a large room upstairs that served as the Peace House supply depot, stacked high with boxes of socks and warm clothes, snacks, and personal hygiene goods. The door to the stairway was kept locked. Someone unlocked it so we could pass, and as we climbed the stairs, I heard it lock again behind us.

There were two worn-out, stuffed armchairs in the room, and I shuffled a few boxes so we could sit facing one another. The windows were thin, letting sounds from the street seep in and rattling in their frames when larger vehicles passed. David moved slowly and settled heavily into his chair. His short hair was receding to reveal a creased forehead, and his dark beard was frosted with gray.

David told me that his full name was David A. De Lampert Jr., and he had been living on the streets of Minneapolis for thirty years. A veteran, he survived on disability checks and the few dollars people offered him when they signed his coat. He had filled up more than one hundred coats with signatures over the decades as well as hats, umbrellas, and canes. He wore one of the coats as we talked.

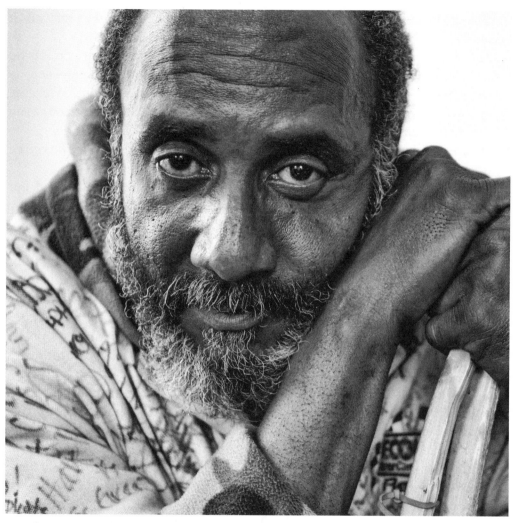

David A. De Lampert Jr.

For David, collecting signatures began as a way to survive, but eventually, it became a way for him to connect with other people.

"I feel . . . the richest thing you got going for you is your name," he said. *"As we fight in this world to obtain something for ourselves and to be somebody—nobody wants to feel like they're nobody, no matter who it is—I encourage people to believe, in my travels, that we are somebody. That everybody is somebody, regardless if you are an addict, alcoholic, or whatever. Whatever your vice is in life, I happen to believe you can be at peace with yourself. Get to know who you are. This has given me an opportunity to know me."*

David's voice was deep and gravelly. His eyes were kind. We paused our conversation from time to time to let a passing siren roll by and fade away.

I didn't know the rules of what I was supposed to ask and what I wasn't. We just talked. I asked about the things that made peace difficult in his life. Mostly, I was surprised by how much of his story resonated with my own. Though our experiences were very different, our understanding of the world was similar.

"People are so hard on each other, nitpicking and always looking for something wrong and wanting to put someone down. People don't know how to forgive. That's the one thing the world ain't caught on to yet—forgiveness. We have a problem with forgiving each other, so we gonna have a problem with being at peace with each other.

"And then you got those who like to keep up a lot of razzmatazz. They like to keep up a lot of bullshit. There are those in this world who are not satisfied unless they are jamming somebody else's life up. And to find out there are people in high places who do things like that, it kind of frustrates me because I work hard at maintaining my own peace down here. I don't get up there. I get to stay down here, and there's a great gulf between the ones at the top and we who are at the bottom."

David paused and laughed as he seemed to size me up. *"But one more day aboveground is better than one underneath, so I try to be at peace most of the time."*

David was candid, talking about his substance abuse issues through the years and the difficulties of living on the streets. But he shared an appreciation for small human moments that made life worth living.

David was easy to photograph. He stayed in his chair, and I stayed in mine. He leaned forward onto a wooden staff that he grasped with both hands. He smiled and he joked, but in the end, it was a direct, warm, if slightly tired gaze into the camera that I chose to accompany his story.

I posted David's story online. I started getting photos from friends who saw him on the street. In the photos, they stood next to David, smiling after signing his coat. David was smiling too. As my kids got older and ventured downtown by themselves, they would sometimes run into David and visit.

I don't remember who said it to me one day after encountering him—if it was Jordan or Brenna—but they said, *"Dad, David doesn't seem like a homeless guy."*

I asked, *"Well, what does he seem like to you, then?"*

"He just seems like a guy."

It was the clearest lesson I could have hoped for as a father and as an artist. We make assumptions about people's lives and their values based on what they look like and their life circumstances. In the process, we miss out on the bigger picture of their humanity.

CHAPTER 7

BUILDING A BODY OF WORK

When I started *A Peace of My Mind*, I expected to interview a few dozen people and then exhaust the topic, but I found that *peace* was just the word that allowed me to access all sorts of interesting conversations. It opened the door and invited me to walk through.

The process was fascinating to me—not only the stories people told but also the way they shared them. There is a poetry to language that sounds like music to me. We might say the same thing, but we say it with our own twist and nuance so that it can be heard in a new way.

Melvin Carter is a retired Saint Paul police officer—or, as he liked to describe it, a peace officer. He is also the father of the current mayor of Saint Paul, Melvin Whitfield Carter III. The elder Carter spoke lyrically: *"If I would just come up with my own definition [of peace] right here and now, I think it's people living harmoniously with one another. And when I think about harmoniously—maybe melodically, maybe rhythmically—[I mean] together in ways where we can accept one another's idiosyncratics. . . . And it probably wouldn't take much to figure out that you and I may have some beliefs that are just in opposition to one another. But when you think about us kind of living together symphonically . . . well, you know, in the symphony, you've got all kinds of stuff happening—rhythmically and melodically and harmoniously—at the same time. [Yet the instruments work] together in such a way that doesn't clash. You know, the bass will be the bass, and the trinkets will be the trinkets."*

If there was color and colloquialism in the response, I let it stand. I am not certain that *idiosyncratics* is a real word, but it carries plenty of meaning. As a music major, I don't recall any instruments in the symphony that were called

the trinkets, but that is beside the point. Melvin's story came out of an enthusiastic effort to explain his vision, and the image he painted with his words was rich and full of life. It was a candid, genuine, and freewheeling exchange, not a scripted response. Any effort to sanitize it would strip it of its power and soul. Any effort to criticize a technical detail loses sight of the beauty in the bigger scene.

As a photographer, I have always preferred an image with soul to one of technical perfection. Something that is slightly out of focus can move me more than a calculated execution. The unexpected twist in the lyric of a song will always reveal the world to me more effectively than a well-researched bar graph.

Kimberley Lueck is a student of Buddhist practices. Sitting in her dining room, Buddhist prayer flags and children's drawings on the wall behind her, she expressed a weariness in conversations about peace. At the outset of our exchange, she admitted a frustration that all of the historical dialogue about peace had not resulted in a peaceful world, so the prospect that one more discussion would help seemed slim. I actually worried a little bit about the trajectory of this conversation. But then her narrative took a turn, and Kimberley explained the process in a way that made more sense to both of us.

"One doesn't sit down on a cushion and suddenly attain peace. One sits down on a cushion and encounters the speedy nature of mind and the confused glut of thoughts and reactions. But if I sit down, if I just take that step, I'm practicing peace by just having the courage to interrupt the status quo. And then if I go further and actually try to accommodate what arises . . . in my case, the practice would be to bring the attention to the breath. So if my attention wanders and I start thinking of somebody I'm really mad at or sick of . . . practicing peace is noticing that with some gentleness and then gently leading myself back to a breath. So there's a process of reapplying ourselves, reapplying ourselves to peace.

"And then I can remember, well, yes, it has to be done over and over again, until we've practiced. Like practicing scales at the piano. First, your fingers bumble over it for a long time, and eventually when you practice and practice, it becomes fluid and beautiful. We're not on human lifespan time. It's a big and ancient universe, and one aspect of peace is patience. Patience with ourselves and others. Patience with our impatience, even."

Several people told me that through the process of the interview, they gained a new understanding into how they saw peace in the world. Others said

they had never really considered the concept in clear and concrete ways until we spoke.

The act of saying ideas out loud can help us clarify them. Articulating our thoughts can help us understand them in new ways. Often I let big concepts float around in my head, and I think I know what I believe. But those notions can remain nebulous and elusive. When I am required to say them out loud and articulate them to others, the ideas become slippery, and I need to think them through a little more critically until they take shape.

It's a good exercise, and going through an interview like this can help both people consider new perspectives.

Businessman Odeh Muhawesh told me he was born and raised in Jordan but now lived in Minnesota. As he put it, he was originally a Middle Easterner but was now a midwesterner. He talked about his global travels and the similarities he had seen in people everywhere.

"Imagine if Moses, Jesus, and Mohammad came today and stood in front of us. Moses would ask his followers, 'What have you done?' And Jesus would ask his followers, 'What have you done?' And Mohammad would ask his followers, 'What have you done?' They all would be ashamed of us."

There is a sense of color and nuance to language that drew me into each conversation. One interview led to another, and pretty soon I had dozens of stories. Because there are stories all around us, a project like this could never really be finished, but I started to feel like at a certain point, I would have to call it quits. Eventually, I would have to step back and say, *"There—this is done."*

I'm not a numbers person, but I started thinking about where I would draw the line. How many interviews would be enough? Random numbers floated through my head. Fifty? One hundred? I imagined a desk calendar with a single peace story for each week of the year. So maybe fifty-two. There are fifty-two cards in a deck of cards too. This is how my mind works.

In the end, it was less of a calculation and more of a gut feeling that brought things to a close. I was producing this series for myself, essentially. There was no deadline, no expectation, no contract to fulfill. It just felt like it was time to pause and step away from the project. Maybe it was time to get back to the business of running my business. I wasn't sure. But I could sense this series was mature, and I wound up with fifty-one stories. I had a sense there would be more for *A Peace of My Mind*, but at that point, I drew a line. I put a bow on it and suspended any thoughts of new interviews. It was the summer of 2010.

We received funding from the Minnesota State Arts Board to produce an exhibit, and we shifted our attention to installing the series in public spaces.

Every person I encountered had a story to tell. Every soul had wisdom to impart. At times, the most reluctant and humble individual held the biggest gift waiting to be unwrapped. Maybe my job as a journalist—or as an artist, or as a human being—was to help them share it.

CHAPTER 8

THE FIRST BOOK

I felt like I was getting my exhibit feet under me when someone innocently asked, *"Have you thought about turning this into a book?"*

My photos had been printed in magazines and books for years, but I had never produced a book of my own. It was a new world to navigate agents and book proposals. I imagined firing off a quick letter, dazzling a big agent, and rising to the top of the *New York Times* bestseller list. In reality, I compiled a stack of 113 rejection letters in pretty short order. I am stubborn, but I am not blind. The cost of producing a photo book made the prospect of a first-time author landing a publisher an unlikely proposition.

I imagined a coffee-table book with the same content as the exhibit, but in an intimate, bound format that people could bring home with them, but it was clear the traditional publishing model wasn't going to work. My circle of friends was filled with editors, designers, and printers, so we decided to self-publish. I had everything I needed except the money to pull it off.

Crowdfunding was a relatively new concept in 2011, and we chose Kickstarter as our platform to run a campaign. The goal was to bother all our friends and family for money and hope they would remain our friends and family. In the end, about one hundred people supported the project, and we got ready to print one thousand copies of the book.

I considered who might write the foreword. I aimed high and again received a small pile of rejection letters or no response at all. As our printing deadline drew closer, I still didn't have a foreword. I worried out loud to Chérif Keita, a colleague who taught at a local college. He seemed in a hurry that day, but I plodded through my story anyway. Eventually, he said, *"John, you'll have to*

excuse me. I need to head to the airport to catch a flight to South Africa. I'm speaking at a conference coordinated by Ela Gandhi."

My lightbulb lit up instantly, but his hadn't yet.

"Do you mean of the Gandhi family?" I asked. *"As in Mahatma Gandhi?"*

Then Chérif's lightbulb flickered on as well. *"Yes."* He smiled. *"Ela is that Gandhi's granddaughter."*

"Those Gandhis are pretty good peace people. Do you think you could ask if she would consider writing the foreword for this book about peace?"

He agreed and put us in touch by email. I made my best ask but heard nothing in return. I sent the full manuscript to Ms. Gandhi and still heard nothing back. Our press deadline was just weeks away, and I had received neither an acceptance nor a rejection, so I prepared to send one final note—an uncomfortable mix of begging and a desperate plea—and just before I pressed send, an email came through. From Ela Gandhi. With the gracious foreword attached. It started like this:

"John Noltner takes us on a unique journey filled with revelations of courage and commitment, resilience and hope. It is a beautiful journey that speaks to our innermost being. It touches us in a way that allows us to see the world from a different perspective."

And it ended like this:

"We need to appreciate the richness of our diverse heritage and begin to see the value of global citizenship, so that peace and social and political justice may prevail in the world. Perhaps it will inspire us to become peacemakers."

It was perfect and just in time.

Several years later, I got to meet Ela Gandhi in person. The University of Wisconsin–Eau Claire, my alma mater, hosted the exhibit, and I brainstormed with the planners about what the programming might look like. During the conversation, one of us asked, *"Wouldn't it be fun to have Ela Gandhi be a part of it?"* and we laughed. Then we looked at each other, stopped laughing, and said, *"We should ask her."*

So we asked. She accepted, and for a few glorious days, I got to visit with Ela Gandhi and thank her in person for writing the foreword. Granddaughter of Mahatma Gandhi, Ela came with all the genes of an impressive peacemaker, but she had crafted a powerful legacy of her own while working to end apartheid in South Africa. Because of her efforts, she was placed under house arrest for years but continued to resist and eventually served on the transitional task force with

Nelson Mandela. She was elected to the South African Parliament for a decade once apartheid ended.

Ela was a soft-spoken woman. She was short, with long, graying hair pulled back in a thick braid. Her deep-brown eyes sparkled, and she was exceedingly polite.

My aging father made the trip to Eau Claire to see the exhibit and—he hoped—to meet Ms. Gandhi. I worried about him. His gait was slow and unsteady, he carried an oxygen tank after a lifetime of smoking, and the programming schedule was full. I was excited he had come but concerned I wouldn't be able to offer him the attention he might need. He told me to carry on, and he would catch up. Classic Dad.

On more than one occasion, as I moved from lecture to workshop, I watched Ela slow her pace to walk with my dad. After one reception, I couldn't find him and later discovered the two of them tucked into a ballroom corner over cups of coffee, laughing and visiting like old school friends.

On our last day of programming, I asked Ela if I could interview her. I had no firm plans on how to use that interview, but both of our public schedules had been busy, and I hoped for some time to visit with her alone. She agreed, and the university offered a recording booth for the conversation. As the door closed and the noise of the busy schedule faded, I thought about how often I had asked schoolchildren to recall a name that related to peace. Without exception—no matter how young the students—someone always said the name Gandhi. It might have been intimidating for a fledgling peace activist to sit with this woman who had such a generational legacy for peace and justice if she had not been so warm and kind.

Ela grew up on the one-hundred-acre Phoenix Settlement in South Africa, where her grandfather lived in the early 1900s as he began experimenting with living simply, sustainably, and communally. It was part of Gandhi's transformation from life as a lawyer to one focused on nonviolent liberation and spirituality. Ela only remembers meeting him once as a young girl, but his spirit was pervasive in the place. The ethic of activism and the common good infused her youth and guided her path.

She spoke of the pressure that accompanied growing up with the Gandhi name and how it carried a certain level of expectation. She referred to her grandfather as Gandhiji.

"I feel very privileged that I was born in this family, the Gandhi family. It is a name of which we all are very proud, but at the same time, it is also a name that imposes a particular standard. You feel satisfied, you feel there's a motive in life because there's always something that you have to do and something that you have to do better and you keep thinking about what would Gandhiji say? What would my grandfather say about this? And you try to improve, and you try to do better, and that keeps you motivated, and I think that is very important in life. Every person on this earth should have role models. And role models keep people motivated to improve, to do something better."

She spoke of her grandfather's choice to live simply.

"One of the issues that confronted him was the idea of poverty and the exploitation of human beings by other human beings. He felt that if we cut down on our needs and live a simple life, then the resources of the world can be shared better."

When I asked about peace, Ela spoke of nonviolence as a tool for resisting injustice.

"Peace becomes synonymous to building a culture of nonviolence. It's about how you relate to each other; it's about getting to learn how to deal with issues because where there are two people, there are bound to be differences of opinion. And differences of opinion have to exist because that is the variety of life. You can't all have the same views. It's just not possible, and it's not even desirable. Everyone has different views, has different talents. You put them together and you can get a rich tapestry. You don't put them together; you have different threads and they can be at war with each other. And for me, the biggest issue is for as many people as possible to take on the responsibility of promoting nonviolent ways of dealing with conflict. You take each challenge and you begin to tackle it as it comes. It's not an easy road, but nothing is easy. Nothing that is good and that is worth conquering is easy, and so we have to take the challenge and we have to be committed to nonviolence. It's not just a strategy for a particular period, but it's a way of life."

For Ela, it was a way of life but also an ongoing process. She was seventy-three years old when I interviewed her.

"I find that even at my age, I'm learning new things all the time from different people. If you have an open mind, and if you are able to see from the eyes of other people as well, then you can learn, and it's lifelong learning. But if you close your mind and you're not prepared to listen to other people and learn from other people, then you have limited knowledge yourself; you're not growing."

Ela Gandhi

I felt I was growing through this conversation. It was a longtime dream to be connected in some way to Gandhi's legacy, and here I was in dialogue with his granddaughter. Of course, there is a risk in elevating the status of any one person. History has a way of presenting its main characters as saints or sinners. Practically speaking, humans are complex. A purity litmus test is bound to fail on most. There is a certain tension that exists in trying to reconcile the balance of good and bad that exists in each of us.

We have nearly deified Gandhi and MLK and other peace advocates as well, yet a careful look reveals that they had flaws like the rest of us. For example, it was years after my encounter with Ela that I learned some of the less admirable history of Mahatma Gandhi—thoughts and writings of racism, intolerance, and indiscretion. While I won't defend those flawed practices, I am also uncomfortable flipping the switch from deity to demon and discarding all that he brought to the table.

The complexity of this tension is an uncomfortable reality we must grapple with for a full understanding of the world. It's my hope that we can find a way to celebrate the advances while acknowledging the shortcomings in order to see a more complete picture of history.

At the end of my interview with Ela, I checked my watch. I was reluctant to bring the interview to an end, but both of our schedules required it. I wondered aloud if she could close by sharing something that perhaps people misunderstood about her grandfather, and Ela smiled. She said, *"People thought Gandhiji was born a leader, but he wasn't. It took him years of work, learning to lead in South Africa, before he ever went on to do his work in India."*

CHAPTER 9

AMERICAN STORIES

There was a part of me that thought *A Peace of My Mind* had run its course. Perhaps the journey had come full circle. We had gathered dozens of stories on a website, we produced a book, and we toured with two exhibits. It felt like I had done what I set out to do, but I found that I was getting restless again. There was more that was calling to me.

It was 2012, and it had been almost two years since I had done my last interview. My time had been filled with the logistics of producing the book and installing the exhibits. I was stretched thin learning the details of moving art exhibits around the country and leading public programming. I missed the interviews, the face-to-face time with people of different backgrounds, and having rich and revealing conversations.

At the same time, our political climate continued to deteriorate. Social issues were overheating. Barack Obama's presidential campaign at first offered the possibility that we had moved beyond the issue of race in our country but quickly exposed how much work we had yet to do. And our work was not restricted to race. Same-sex marriage. Gun rights. Religious liberty. Corporate responsibility. Police tactics. Immigration. Gender identity. The divisions were laid bare, and the rules of decorum had been discarded.

Frustration gave way to hate. People unfriended others on social media and retreated into their silos of like-minded people. Conversations quickly amplified to shouting matches, and disagreements led to division. The outrage machine was running at full throttle. Looking back, that trend has only accelerated. The polarization that initially drove me to start this project has only grown more entrenched.

As our social and political lives have become more divisive, an entire industry thrives in our country to further agitate. Opposition research scours the news to find the slightest infraction and inflates it to a crisis. Radio talk shows spend 90 percent of their airtime railing against the other side for ruining the world. Slippery-slope arguments pervade every conversation; opposing sides entrench their positions and refuse to give up an inch of ground for fear that it will unleash a domino effect that will undermine the bedrock of our nation.

Each news cycle leads us down the rabbit hole of the outrage of the day. Single events are spun to death, and each analysis is criticized and reanalyzed until it is hard to know what is good and true.

I'm not certain that human beings are designed to absorb the kind of information that comes at us each day. I'm not sure we have the capacity to process all of the pain that the world has to offer.

In the long term, the effect is corrosive. Trust erodes. Suspicion builds. Fear. Separation. Mistrust. Our social fabric frays, and we follow a destructive cycle of blame, vilification, and marginalization.

I saw the frustration building all around. I felt it welling up inside me. Even now, a sense of hopelessness can overwhelm me as angry voices drown out those who seek real solutions and as partisan sparks are fanned into flames.

In the midst of the chaos, there was a growing appetite to find a better path. People wanted a way to connect, but they didn't have the tools to do so. For every outrage perpetrated in the world, a crowd of people stood up and said, *"We can do better."* For every shooting, there was a vigil. For every wound, there was an outpouring of healing.

Someone once told me that while the world likes to see things in black and white, *A Peace of My Mind* explores the gray areas in between. That work seemed more important than ever. There is truth in nuance and wisdom in subtle difference, and *A Peace of My Mind* was positioned to explore it.

Rhetoric likes to simplify and vilify. It is easy to paint entire groups of people with a broad brush and discredit their concerns as illegitimate. But when we get to know a single person from that group, the story becomes much more complex. When we put a human face to the issues of the day, it becomes more difficult to dismiss, discard, or demonize.

Producing a book and two exhibits hadn't completed *A Peace of My Mind*—it had only laid the foundation for something bigger. If our first collection was

gathered in Minnesota, the next step should be a national platform. That much was clear, given the tone of the day. But I didn't know what that might look like.

I started floating the idea of a national collection of interviews with my friends. I would call it *A Peace of My Mind: American Stories*. I didn't know how it would happen, but I thought if I talked about it enough, people would become interested and start to hold me accountable in some way. I was planting the seeds for external pressure, hoping that if this next step became a part of public expectations, I would have no choice but to see it through.

I did some rough math on the project, and it seemed impossible. Miles on the road, time away from home, unbillable hours, gas, food, and lodging all added up to a big number. I wasn't sure exactly what that number was. Every time I scribbled figures on a piece of scrap paper (which I would promptly lose), the total came up different. But every version had this in common—the number was large, daunting, and discouraging.

But I kept planning anyway. I drew out routes and plotted potential stops. I made lists of issues to address and questions to ask. I thought it through from every angle and then crumpled up the paper and shook my head. Who had this sort of time? Who had this sort of money? Who had the energy to do something so big? And to what end?

I wondered. I planned. Quite possibly I obsessed. I questioned. And then I started. I just took the first step. It sort of felt like I couldn't *not* do it, so I started down the path, figuring the fog would lift as I moved along and the next steps on the path would become visible.

I circled an open week on my calendar and noticed that I had enough frequent flier miles for a free flight. A journalist friend in Durham, North Carolina, offered a place to stay and some interesting connections, so I walked through that open door. It was time to begin the next part of the journey and see where that path would lead.

I had met Barry Yeoman on assignment for *Ladies Home Journal* years before as he wrote a profile on Matthew Shepard's mother, Judy. Matthew was the college student beat to death in a 1998 Wyoming hate crime because he was gay, and Judy was crossing the country speaking out against bullying in high schools. Barry was assigned to write the story, and I was asked to photograph Judy to accompany his text.

As soon as I met Barry, I knew his friendship was going to stick. He was kind and wise with a quick but gentle sense of humor. His curiosity was boundless. We exchanged contact information and stayed in touch. I watched his writing as he followed my photography work and eventually the development of *A Peace of My Mind*. I was impressed with the way Barry navigated difficult subjects and wrote about complex issues with clarity and grace. We spoke on the phone from time to time and looked for other opportunities to collaborate. As I thought about this national collection of stories, Barry was one of my dependable sounding boards. As I voiced concern over how the whole thing would play out and my reluctance to start, Barry offered a launching pad and logistics support for a test run whenever I was ready. I took him up on it.

The only way I know to approach a large project like this is to try it, see what fails, regroup, and do better the next time. I planned an experimental week of gathering new stories in Durham. Barry provided a free couch for lodging, a snuggly fifty-pound pit bull mix named Scooter to share it with, an enviable depth of knowledge of Durham and its people, and a firm grasp of what I was trying to accomplish.

Who should I talk to? Why? Who do you know? Who has a good story to tell? Who would be open to this conversation about peace? The parameters were wide open. I had nothing but a blank slate, so we could start anyplace we wanted and build from there. Barry made a long list of suggestions for potential interviews, and as I narrowed down the choices, he made email introductions. I reached out to people, and as my travel dates drew near, I lined up a half dozen interviews, leaving a little free time for any pleasant surprises that might crop up along the way.

Barry introduced me to Claudia Horwitz, who, early on, encouraged me to aim high as I asked her to share her thoughts on peace. Claudia was founding director of Stone Circles at the Stone House, a seventy-acre retreat center outside of Mebane, North Carolina, dedicated to the support of people and organizations working toward social change.

Claudia lived in a small, simple home surrounded by an open prairie that had faded to shades of brown in the crisp autumn air. We sat at a kitchen table beside a large picture window that looked out at the landscape, small birds darting here and there in the morning sun. We moved through the basics of the interview, with Claudia explaining that her efforts grew out of an awareness

that social justice work could exact a tremendous toll on people and her desire to make the work of building social movements more sustainable.

When I asked about peace, she said, *"There are words we use so often that they lose their meaning. I think* peace *is in danger of being one of them. Sometimes I worry that our most powerful and important ideas become words that are used to paper over a deeper level of exploration and analysis. I have that fear with the word* peace. *We need to be rigorous in our understanding of peace, and we need to be specific. We need to identify the kinds of peace we're talking about, and we need to be unflinching in our ability to articulate that and put it on the table.*

"I feel like folks are talking about [peace] less and less in these ways that I find really fascinating, and that's alarming to me. I wonder if we've given up on the possibility of peace and we're settling for whatever else is possible—occupation, a low level of conflict, making ourselves comfortable with a proportional response— whatever the thing is in terms of the global arena. Have we given in to the darker side of our nature in some unconscious way that we're not totally aware of? Have we been complicit? Do we really want to do that?

"I'm not a pessimist, but I do see patterns, and I've seen this pattern over time: We have been less willing to put the best possible scenario in the center and to aim for that. I think we've started to settle."

After the interview, Claudia walked me through the retreat center property. She stopped to feed the chickens and harvest some late-season greens. I explored ideas of the national project out loud with her. I didn't want to settle. As the world became more polarized, I wanted to elevate an alternative. I wanted to find a way to have difficult conversations in a calm and productive way so I could better understand the complicated dynamics of the world. This was a path that was worth pursuing. I would have to figure out a way to make it happen.

My days in Durham were spent conducting new interviews. In the evenings, I debriefed with Barry and his husband, Richard. By the end of the week, a few things became clear. Seven days in one town was a comfortable human pace, but it was entirely too long if I ever hoped to complete a national journey. Selecting which stories to tell would mean leaving an unbearable number of worthy stories left untold.

From the very start, I was haunted by the stories I would have to pass by. It was, of course, an impossible task to drop into Manhattan and choose just two

or three stories to tell. But there is a richness in that wandering that promised to reveal a bigger picture.

I once watched a PBS documentary of a young woman who backpacked her way around the globe and encountered an elderly man in a remote mountain village in Asia. He had lived his entire life in that village and never left. She marveled at how well he knew the community and at his sense of belonging in that place. But even as she admired the deep roots he had grown there, she had a sad awareness that she would never experience it for herself. Her path was a transient one. The beauty and wonder of her life were a different kind than his. Both paths were exquisite and fascinating, but she could never experience his path and he could never experience hers. They had both chosen, and those choices were exclusive. My path required me to travel in the spirit of that backpacking woman more than the elderly villager if I was going to cover enough ground to make this work.

William Least Heat-Moon wrote a book in the early 1990s called *Prairy-Erth: A Deep Map*. After traveling for years, he wondered if he could find the same abundance and joy he experienced on the road by staying in one place. He chose Chase County, Kansas, for his experiment. He planted himself there and got to know the people, the land, and the history and wrote more than six hundred pages about it. He settled in the most unlikely place and told us about the richness and beauty that he found there.

I knew the same truth existed in any place. I had seen it in my first collection from Minnesota. Any community can offer a window into the entire world, filled with insight and wonder. Individual stories held universal truths. It would be easy to become lost in any one place, but if the goal was a nationwide view, it would require me to keep moving.

Without a doubt, I would need someone like Barry Yeoman in every community I visited to help find the people I wanted to interview. I was going to be deeply dependent on advocates, champions, and allies. Years of travel work had gifted me a robust network of connections in far-flung places, but it was finite. I could rely on friends and colleagues scattered across the country, but I would need to depend on the goodness of strangers as well.

Another thing became clear after that first trip to North Carolina. I would need to pace myself—for economic reasons, if nothing else. I didn't have a budget that allowed me to drop everything and just travel the country. I would have to

do it in sections. Work a little, save a little, and burn up the surplus on another road trip. Flying didn't make sense because of the cost and because it was too location specific. It made more sense to get in the car and drive a big loop, passing through as many states as possible along the way, meeting new people and gathering stories. Driving offered the flexibility to change plans when needed. I would keep moving for sure, but sometimes the route would be uncertain as I pulled out of the driveway. Sometimes the meanders only revealed themselves once I was on the road.

At first, I considered doing one interview in each state—fifty stories total— and call it done. But that felt too contrived. Too gimmicky. The project didn't need to fit a template. Much like the first book, I just wanted it to be broadly diverse. I would have to follow my curiosity and intuition, trusting that if the path was interesting to me, it would be interesting to others as well.

There were other reasons to pace myself. Since I learned a lot from that first trip to Durham, I assumed I would learn a lot more from the next trip. I came home and used that new knowledge to craft another—better—trip. I refined the process and my methods. I reconsidered how I would connect with people, who I would interview, and the questions I would ask. If the entire body of work were to be produced in one long journey, I would lose that rhythm: experience, blunder, consider, refine, plan—experience, blunder, consider, refine, plan— repeat. I needed the space between trips to understand how to adjust my course and keep improving the process along the way.

Something else important happened on that first trip. It became easier to say out loud, *"I'm working on a national project."* Things had moved beyond theory, and I had taken the first step. Now it was time for the second step and the third. One interview at a time, I saw that it was possible. It was going to be a long road, but it was real now—and we were moving forward.

CHAPTER 10

RECOGNIZE THAT PAIN IS UNIVERSAL

There are wounds that never heal.

All in all, I had a comfortable upbringing. A small midwestern town, two parents who attended every track meet and band concert I was a part of. We took family camping trips to the mountains and the oceans and even once to Disney World, even though my dad didn't like crowds.

I received good grades, I was able to work for a little spending money, and I was the president of both the band council and the student council. Yet those teen years were a bugger, and I struggled. Probably no more than any other kid, but I wasn't sure where I fit in. For sure, I was more aligned with the music and theater crowd than the jocks or the cool kids. I am not certain if it was the actions of others or more of a self-imposed isolation, but I was painfully aware of where I did and didn't fit in. Most places, I was certain that I did not.

Not long ago, I attended a Loverboy concert. I was not a huge fan back in the day, but our neighbors invited Karen and me to join them, and it seemed like a fun outing for a summer Thursday night. We set up our folding chairs with the others at the base of a local ski hill and grabbed overpriced beers under the setting sun. The band sounded great even though they had aged like the rest of us who were watching from the audience.

In his introduction to the hit song "Working for the Weekend," lead singer Mike Reno said, *"I want you to think back to the moment when you first heard this song and remember where you were and what you were doing."* I thought to myself, *Well, I can't be certain, but odds were pretty good I was alone in my bed-room, practicing my trumpet.*

It was not as pitiful as all that, but I did spend a great deal of time feeling like an outsider. I managed to grow up to be a reasonably well-adjusted human, depending on who you ask, but I share this to say that even now, decades later, I can feel the echoes of my marginally awkward high school existence in my life. I can recognize how it has shaped the way I engage with others and the way I see myself.

It seems that no matter how we reason and intellectually understand something, we are still steered by currents that formed in our youth. I interviewed an older Black man in Saint Paul, Minnesota. He grew up in the Rondo neighborhood, a vibrant Black community in the early part of the twentieth century, until the interstate system was developed and sliced right through the middle of the neighborhood.

The ambitious infrastructure project needed land, and the path of least resistance was to push the freeways through those neighborhoods with very little political power. The Rondo neighborhood was bisected. It lost its critical mass and never fully recovered.

This gentleman was a young boy when it happened. He lived with his grandparents, and his grandfather was a holdout. He was not going to sell his home to make way for the freeway and eventually found himself on the wrong end of eminent domain.

So as a young boy, he remembered riding his bike home from school one day to find his grandpa handcuffed on the hood of a police car and firefighters using their axes to rip up the plastered walls, break out the windows, and make certain the house was uninhabitable. The freeway would be built in spite of his grandpa's objections. That's how eminent domain works.

But imagine how that felt to the young boy on the bicycle. He told me it formed such a negative impression of law enforcement and authority in his mind that even to this day—a half century later—he feels a visceral anger well up whenever he encounters a police officer.

It happens all the time. Someone abused as a child has trouble learning to trust. A veteran returning from combat is triggered by Fourth of July fireworks. A person ridiculed in front of a crowd retreats from public settings.

These experiences are deep and powerful, and they shape who we become. They are difficult to unlearn, and at times, they move us in ways that we don't even recognize.

An older white woman approached me at the end of a retreat and began by confessing, *"I've never told anyone this before . . ."* If she had blinked, the pools of water that glistened in her eyes would have spilled over and run down her cheeks.

She grew up in Alaska during the civil rights movement. Given the demographics of the state, she had seen very few Black people in her life, but after watching the news, she remembered her parents talking about the N-word with her as a young girl. They explained that all people deserved to be treated kindly and with respect. In hindsight, she understood that the N-word was not to be used, but in her three-year-old mind, she somehow had misunderstood and believed that it was a term of endearment and friendship.

Sometime later, as she was building a snowman in her front yard, a Black man happened to be walking down her street. Hoping to be kind and welcoming, this young white girl ran up to him, waving and shouting, *"Hi, Mr. N***** man! Hi, Mr. N***** man!"*

Needless to say, it was not well received. The man reacted with anger and lashed out at the little girl. She was equal parts horrified and confused and retreated to her house in tears. Now, decades later, the tears returned. The deep shame and humiliation of the moment had stayed with her all these years. She hadn't meant to harm anyone—quite the opposite. And by the time she understood what had happened, the damage was done, and there was no real opportunity to recover or offer healing for either person involved.

Even as she grew to understand the incident, her fear of making another mistake had driven a wedge that she was unable to overcome between her and anyone from the Black community. She had closed off possibilities because of it, walled herself off as a form of self-preservation even as she recognized the drawbacks of that approach. No doubt, the man came away with his own scars from the experience, and everybody lost.

We are all broken in different ways. To see it in ourselves and fail to acknowledge it in others is a mistake. To turn it into a competition to see who has been wounded more deeply misses the point. Pain is pain, and it is real to the person who feels it. Calling it silly or unhelpful does nothing to heal the pain. Indeed, it often makes it worse.

I met Carl Kenney in Durham, North Carolina. Barry had made this introduction as well. Carl described himself as a minister, author, advocate, teacher, and *"prophet of the people."* He believes that we spend too much time and energy

fighting one another because of our differences—with devastating and wide-reaching results.

Carl said, *"We're living in a world of broken people. Many people don't even know they're broken. We spend so much time and energy fighting each other, be it based on race or gender, political differences, or religious differences. I try to be the person who stands in the middle and helps others hear each other. People can't hear because they're so glued to their ideas. I'm telling people to shut up long enough to listen to each other."*

This struck home. Maybe that was the work of *A Peace of My Mind*. Maybe that was my work, to help people hear each other, even as I continued to learn along the way. Carl had used the words *minister* and *prophet*. I wanted to hear more about his faith and how that impacted his understanding of peace. My own faith journey had been an evolution of sorts, and I saw that faith had brought both comfort and anguish to many people. There was so much rich beauty in religion, yet in so many ways, humans have mucked it up throughout history. I've seen that damage drive people away from religion, but in Carl's case, it had driven him closer to his own faith in order to examine, refine, and understand how it called him to engage with the world.

"My theology is rooted in the compassion of the Christ. I'm a person who has experienced the love of God after having made my share of mistakes. I've been in recovery over thirty years. My sister died at age thirteen. I was a teenager, and I started using substances to hide my pain. My God loved me through that, and I bring my own personal experience of recovery to my faith. I see that I am worthy of God's love, and I see the very spirit of God in every face. I cannot look at a person and hold myself higher than them. I can't measure them as less than me because of what they believe, or their orientation, or any other issue that may be present in their life.

"My theology is an experiential theology. It's been supported by the teachings of Christ, who found me and said, 'I love you still,' knowing that I did not deserve that. It comes out of knowing that even in my walk of faith, I've made my share of mistakes. I have not been a perfect vessel. I never will be, but I've been faithful, and I see that in everyone I meet. We share in common our frailty. Who am I to judge? That's what gives me the strength to keep on moving."

My own faith is communal. I've come to see the Bible, in many ways, as a guide to living well together in relationship, in community, and in wholeness

with one another. I grew up in the Wisconsin Synod Lutheran Church, and it never sat well with me, as it leaned toward the conservative end of the faith spectrum, while I did not. Adherence to authority seemed more valued in the congregation of my youth than questioning dogma, and so I learned not to challenge expectations and accepted the status quo, even when it felt uncomfortable to do so.

That changed when I went to college. When I joined the campus youth group for the Wisconsin Synod as a freshman, I was the only male in the group. That meant I was going to be president. There was no need for elections; it was predetermined. *"Why?"* I asked and was told, *"Because you are the only man."*

"But she's a better leader," I protested, pointing to one of the women in the room. *"She has more knowledge of the Bible than me,"* I added as I pointed to another woman. I worked my way around the room. *"She has been in the group longer. She is a senior. She is way smarter than me."* They all watched and waited for me to finish. There were some sympathetic eyes in the group, but in the end, I was told that none of those other things mattered. I was the dude in the room, so I had to be the president.

So I quit. I left the room, left the church, and never looked back. I still don't know if they went through that entire year without a president, recruited some random male so they could have a leader of their preferred gender, or dissolved the group entirely. It might have actually been the first time I had the clear opportunity to stand up for what I believed was right.

I shared all this with Carl, and then we shifted the conversation toward peace. Really, the entire conversation was about peace, but now I was moving toward the questions that directly addressed it.

"When you say peace, I get an image that haunts me in my sleep. I see a world void of hostility. If we are created to love, and I believe that we are, then loving each other should be the easiest thing we have to do. I just want to yell, 'Be OK with each other!' I think of the kingdom of God as a world where people are able to coexist without hostility, without judgment, without ridicule, without measures. I don't have to tear you down for the sake of making me better.

"When I look at myself in the mirror, I say, 'I am who I'm created to be,' and I don't have to add to that. I don't have to add more money or more prestige or anything that others value as significant in this world. I am at peace with myself because this is what I'm created to be."

Seeing the brokenness in our own lives is not the same as being weak. An honest assessment of ourselves, struggles and all, helps us understand why we do the things we do. A little bit of grace and compassion for ourselves can evolve into grace and compassion for others.

It's easy to love those who are loveable, but we struggle with the rest of the crowd.

Asked to share a time when she was able to find good in an adversary, a woman in one of my workshops responded, *"I came to understand that the people hurting the most tend to hurt others. Looking at someone with that perspective, the only answer is love."*

Any movement toward peace requires proactive kindness and love. Is that hard? Of course. Is it effective? I would say it's worth a try. As we examine the way we move through the world, it's worthwhile to examine our goals. Do we hope to lash out and make sure another person hurts a little more than we do? Do we intend to dismiss someone else's struggle because we believe it isn't as worthy as our own? Or do we hope to lift one another up, heal what wounds we can, and find a way to live better together?

Think of a time when someone acknowledged your own struggle. I am guessing that carried with it empowerment, healing, and the desire to offer a little bit of grace in return. Now wash that example across the entire nation and imagine what it could do to restore the social fabric around us.

CHAPTER 11

SEE BEYOND LABELS

Standing on the campus of Temple University in Philadelphia, I was waiting to meet Tyrone Werts. It was Saturday morning, and the school was quiet. I had seen a portrait of Tyrone taken decades earlier, but I wasn't certain what he looked like now, and I had left his phone number in my car, so I waited, trying to make eye contact with any older Black man who passed as I watched for a glimmer of connection. It was a hot summer day, and I had sweated through my shirt hauling gear to the athletic center where we planned to meet. I wasn't certain of Tyrone's connection to Temple. All of his emails had been friendly but brief. I didn't want to press so hard that I scared away the opportunity, so I just rolled with it. I became comfortable with uncertainty in the process and welcomed whatever came from each exchange.

Howard Zehr had introduced me to Tyrone. A professor I knew at Eastern Mennonite University, Howard had done much to help grow the modern restorative justice movement, a concept that I was only recently introduced to. Restorative justice works to repair the damage done by crime. It strives to restore balance. Restorative justice suggests that justice doesn't have to be only about punishment; it can be about healing as well. In an ideal setting, it brings together victims, offenders, and community members to collectively determine how best to resolve an infraction and create healing for all parties as opposed to the institutionalized, state-sanctioned punishments that are a part of our traditional justice system.

In a phone call with Howard, we explored ideas about punishment, prison reform, recidivism, reconciliation, and how to reintegrate former inmates into society. *"I want to talk to someone who's been through it,"* I said. *"Who do you know that I should meet?"*

"What part of the country are you headed to?" Howard asked.

"Philadelphia."

"Then you should try to interview Tyrone Werts," he said.

Howard was a photographer too. And a writer. In fact, he had several books of portraits and stories focused on the prison system and the people who were affected by it. His work closely paralleled what I was trying to do with *A Peace of My Mind*, and when we connected through a mutual friend and traded books, Howard quickly became a mentor and a role model. Now he offered to connect me with Tyrone, whom he had photographed in the 1990s for his own book called *Doing Life*, a collection of stories about life-term prisoners.

"Tyrone's sentence was commuted," Howard said. *"He was released last year."*

Right on time, Tyrone appeared at the far end of the hallway and walked toward me with a slight limp. He wore a dark-gray suit with a bold red tie, and he called out my name and broke into a broad smile when he was still some distance away. He led me to his office in an academic building just a few blocks away, where he explained his work with the Inside-Out Prison Exchange Program, an innovative project that put prisoners and college students in the same classroom to study social issues together and learn from one another.

The office was humble, with plain beige walls and older, institutional furniture. There was a couch tucked into a small alcove under the only window in the place, and I suggested we do the interview there. Anything to reduce the formality of the exchange was helpful. Anything to make the other person more comfortable was good. Tyrone waited patiently as I set up my equipment and then started sharing.

In 1975, at the age of twenty-three, Tyrone was convicted of second-degree murder and sentenced to life in prison. He told me when he first went into Graterford Prison in Pennsylvania, he was a cocky, arrogant, angry young man. It all began in elementary school when his teacher put it in his mind that he was dumb and that he couldn't learn. This idea became Tyrone's own belief, and it eventually led him down a path of self-destruction. It all led to the crime that he was convicted of.

"I was not the triggerman when it happened," Tyrone explained. *"I was a couple blocks away when the crime happened. But I was found guilty of conspiracy and sentenced to a mandatory life without parole sentence."*

As I understood the backstory, Tyrone was with a group who decided to rob an unofficial club in someone's home. Tyrone was waiting nearby to escape with them. The robbery went bad, as these things do, and a person was shot and killed. Tyrone chose not to take a lesser plea, convinced that he would be found innocent of the larger crime, but this wasn't the case, and the verdict set the course for the rest of his life.

When you first go to prison, they do an assessment, Tyrone told me. Mr. Bello, a prison counselor, read through Tyrone's tests. He found that Tyrone read at a second-grade level, his math skills were on par with a third-grader, and his comprehension was really low. But, Mr. Bello added, *"Your IQ is above average. You can do this stuff."* He convinced Tyrone to sign up for classes and challenge himself. This simple act of compassion and belief in Tyrone's potential led him on a journey to a new life.

Tyrone shared, *"Within six months, I transformed into the person my mother and father raised me to be. I went to school and got involved in great programs. It became important to me that I leave a legacy. I wanted my daughter and siblings to know that even though I was in prison, I was a good person."*

Over the years, Tyrone became a model prisoner, getting his high school and college degrees. He led other programs to make a positive impact on inmates, including the Inside-Out Program, which he used to work from the inside and now could work from outside.

His actions led Governor Ed Rendell to commute his sentence on December 30, 2010. Now Tyrone is free, and he works with young people so they don't make the same mistakes he made.

Tyrone talked about his own aha moment while he was in prison: *"In this moment of clarity, I had this epiphany. I mean, it just like hit me like a ton of bricks. What came into my mind was the day I got sentenced and all the noise that was behind me. The wailing, the weeping, the crying, the yelling. From my family, my wife, my daughter, my sisters, my friends.*

"It didn't register to me the day that it happened—the day I got sentenced. But it hit me that day in my cell, and I said, 'Wow. All this time I was focused on me.' All that bitterness and anger and resentfulness that I was carrying, it was weighing me down.

"And in that moment when I realized the pain I had caused my family, the victim's family, it just left me. I started to go through this process of some reflection,

saying, 'Man, I'm out here talking about how I'm innocent. I didn't do anything wrong. I was railroaded' and all that.

"And I just began at that moment to say, 'Man, I got to take responsibility for my life.' I mean, not just my crime, you know? I was willing to take responsibility for my crime, but I had to take responsibility for my life, what direction it was going to take, and how I was going to make this up to my family and the victim's family."

We finished the interview, and I thanked him. I thought about the photo we would make, and I said, "Tyrone, I don't think we can make a good portrait here. There's not much to work with."

We talked for a little while, and my mind raced as I considered possibilities but came up with very little. There were options on campus, but nothing made great visual sense with the story Tyrone had just shared, and nothing carried the weight of his experience. The prison was an hour northwest of the city, and I was certain that getting permission to photograph there would take days or weeks to coordinate, if it could happen at all.

Then I decided to take a risk. I opened with "Let me know what you think of this . . ." and added, "Before I ask—and to be clear—'No' is always an acceptable answer."

"I'm a visual person," I said. "Here you are looking like your reformed self. You're wearing a suit and tie—you look sharp—and it seems to me like it would be an interesting visual contrast to put your reformed self out in front of the house where the murder happened."

Tyrone didn't say anything for a good long while, and I worried if I had crossed a line. I do that sometimes, and I misjudge exactly where the line is. I wondered if that's the sort of question you should not ask a man who had just gotten out of prison. He looked at me long and hard and finally said, "That would mean a lot to me."

I couldn't have led with that question. It was only after I had spent an hour or two with Tyrone that we had established the rapport and the foundation of trust that allowed me to venture onto that fragile ground. Too often, we launch right into the most contentious conversations without doing the hard work of building trust and relationship.

So we drove across town and found the house. Tyrone led in his vehicle, and I followed in mine. The street scenes transitioned from campus to business

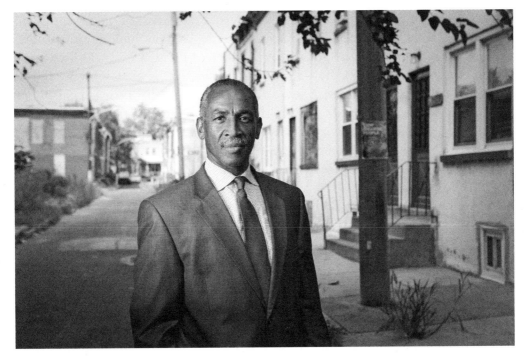
Tyrone Werts

district, through tidy neighborhoods and on to a collection of older, run-down row houses. Finally, Tyrone pulled into an alley, slowed his vehicle, and parked.

"This is it," he said as he got out of his car and nodded toward a two-story stucco block of apartments that ran along one side of the alley with an empty, overgrown lot across from it. A few of the windows were boarded up. Vines grew on one side, and weeds pushed through the cracks in the pavement out front. Power poles tilted down the length of the alley, and on the one closest to us, a faded poster stapled to it read, *"Stop shooting people."*

We stood outside and talked. Then we made the portrait, and it was powerful. It's one of my favorites from the series, specifically because it was challenging in many ways, because I'd had the courage to ask and because we'd put in place the relationship and trust that had made it possible.

When I planned to interview Tyrone, my daughter, Brenna, was fourteen years old. We talked about my upcoming trip, and she asked, *"So you're going to go hang out with a murderer?"* My only response was *"Yeah—I guess I am,"* though I didn't really know what to expect from the experience.

When I returned home, Brenna looked at the photo I had made of Tyrone, and she said, *"Dad, he doesn't look like a murderer."*

And I thought, *That's exactly the point.* What is a person convicted of second-degree murder supposed to look like? Typically, we hear a word, phrase, or label and our minds flood with assumptions. We get a partial picture of a person and our imaginations are quick to fill in all the blanks, whether or not it has anything to do with reality.

I'll admit that I did the same thing. Perhaps it's just human nature to extrapolate, but it can also be human nature to examine our reactions and question whether they are valid. It can be human nature to reevaluate, reconsider, and allow room for the truth to work into the picture.

When I finally met Tyrone, he was nothing like I expected. He didn't match the person in my mind. And the more I got to know Tyrone during our conversation, the more I appreciated his strength of character and his life journey.

CHAPTER 12

ASK GENTLY

I had just finished a book reading in Durham, North Carolina. The crowd was small but appreciative. Afterward, a man named Vincent approached and said, *"You should come to Boston."*

"Sounds good," I replied. *"Let's figure that out."* I needed to eventually find my way up the coast, and any open invitation was worth exploring. You never know where a conversation might lead.

Vincent was a member of the Arlington Street Church, built in the mid-1800s, whose sixteen steeple bells *"ring out for peace and justice."* The church was an early voice for the abolition of slavery; an advocate for the civil rights movement; and in October of 1967, one of the first places Vietnam War protesters marched in to burn their draft cards.

A year after I met Vincent, he was waiting for me on the front steps of the Arlington Street Church. He brought me inside, where dark wooden pews offset soaring white arches and light streamed through Tiffany glass windows. Vincent had arranged a small gathering for adult education, and I squeezed in a conversation with the Sunday School students as well.

It was a small engagement but enough of an excuse to pass through Boston and ask Vincent to help me line up a couple of interviews, including one with Laura Patey, whom I met at her home the next day along with her wife, Leigh. The two women had been together for thirty years and wed in 2004 when Massachusetts legalized same-sex marriages. Together, they adopted two adolescent boys out of the foster care system who were in their twenties by the time I met Laura.

Laura and I sat in her living room as the nation was debating same-sex marriage. Before we started the interview, Laura stepped out to make us both

some tea. I scanned the titles on her bookshelf. On one shelf, I found many of the same books about faith that I have in my own home. The Bible, a catechism, and contemporary titles on faith, service, and spirituality.

Another shelf was filled with the same books on parenting that I was familiar with. *What to Expect When You're Expecting*, guidance on how to parent a teenager, and so on. (In the interest of full disclosure, in our family, Karen read all these books—my style was more along the lines of believing that all the parenting skills I needed lived innately somewhere inside of me. This was not always my most effective parenting strategy.)

But there was a third shelf in Laura's house with titles about same-sex marriages and parenting—titles that on some level I understood must have existed but were entirely off my radar.

"I see we have a lot of the same titles on our bookshelves," I said when Laura returned with the tea. *"We've got all these books in common—help navigating the challenges of parenting, books on faith and spirituality—but then there are all these other titles I've never seen before, dealing with complexities I've never even had to consider in my own parenting. Can I ask you a question about that?"*

"Of course."

"You know there are people who disagree with your lifestyle—there are people who are upset with the idea of same-sex couples raising children; we hear their voices loudly in the debate our country is having right now. I'm sure you have found ways to work through those reactions for yourself. But I sometimes have trouble helping my own kids face cruel realities in life. How do you prepare your kids for any negative reactions that they might encounter in the world based on your family structure?"

Laura smiled. She said, *"We discovered that kids pick on kids for any number of reasons. We armed our kids for the fact that not everyone was going to value our family. That was OK as long as we surrounded ourselves with people who did: our church community, our friends, and others. We practiced making statements. When somebody would make fun of Jesse on the football field and say something about his two moms, he would say, 'Pick a real issue.' That was the line. 'So pick a real issue.'"*

She told me she had always been interested in advocating for those who were marginalized by society. She recalled her own struggles of not quite fitting in as she was growing up and the difficulties in coming out to her family when

she was in her thirties, and she believes that those experiences have led her to be a protector of—and an advocate for—the underdog.

"When we connect with others who we perceive as different from ourselves, we realize that there is far more commonality than there is difference, and that's what I am always looking to do. When I advocate for folks who are somehow marginalized, it's a matter of making sure that they feel and know that they're valued and that they are loved. It's that connectedness that gives them a sense of self that allows them to then make other connections. That's what I think our purpose is on this earth."

Laura went on to share some personal stories about how she had needed to advocate for her own sons. *"When Alex was in school, one of the administrators said, 'Well, you know, these kids.' And I was like, 'Which kids? Are you talking about kids who have been in foster care? Are you talking about kids with two moms? Latino kids? Which 'these kids' are you talking about? What are your expectations? Do you see this kid as a human being? As someone who has unbelievable skills and assets? Or do you just see them as a marginalized kid who is OK to throw away?'*

"That attitude kills their soul and their spirit. We talk a lot about embracing who you are and what it brings to your life. For me, it's not about having people tolerate or accept you; it's about embracing your identity."

I found it interesting that Laura had found a home in a faith community when so often it was the religious voices that tried to push her away in the heated rhetoric of the day. She talked about finding strength in the people who did support you and the ones who did value you. When civil marriage was legalized in 2004, Laura and Leigh chose to get married in their church even though they'd had a commitment ceremony years earlier. Their priest had been told by a bishop not to officiate over same-sex marriages, but after a few meetings, their priest said, *"I can't think of why I wouldn't do this."* She said, *"Anybody walking down the street who sees this beautiful little church and wants to come in and have a marriage in this church can do that. Yet here are two people who have been pillars of the community and I'm not allowed to marry them? That doesn't make any sense."*

So she performed the ceremony, and Laura shared one of her favorite moments of the reception afterward.

"Our older son Jesse got up to give a toast at this reception, and it was a very powerful statement. He was probably about sixteen at the time, and he talked to

the priest and he said, 'Thanks for giving us all a seat on the bus.' That was the extent of it."

And really, that's all anyone is asking for. Everyone doesn't have to agree. We just need to make room for one another. We want to be seen, heard, and valued. There is a world of good that can ripple out from that foundation when those things are present and a world of pain when they are not.

"Those who are opposed to gay marriage don't need to have a gay marriage," Laura said. *"Those who are opposed to gay people adopting don't need to be part of that. That's really OK. I feel like they are wrong, but it's really OK. I can value difference of opinion, but I really feel very strongly about human rights for each of us, especially when we are talking about love and caring for each other. How can somebody say that that's not right to do?"*

It was a conversation that was only possible in an environment of trust and respect. Laura knew she didn't have to defend her position to me. We were free to explore in a back-and-forth conversation that acknowledged the value and worth of each party.

We tend to wield difficult subjects like a weapon. We introduce them with a barb, then wait to set the hook. It may feel good to defend a position that way, but it does little to build common ground or enhance understanding. I am convinced we can talk about anything if we approach it thoughtfully. I tell people when we sit down for an interview that I will probably wade into difficult territory. They are always free to decline or redirect, but I appreciate challenging conversations, and I am convinced we can approach them gently.

Kim Book lost her daughter. Ask gently.

Penina Bowman survived the Holocaust. Ask gently.

Dan Gallagher served in the Vietnam War. Ask gently.

There is a big difference between asking gently, rooted in genuine curiosity, and demanding information from someone who may not be prepared or willing to share it. I try to create space for a graceful exit from the conversation if this is not the right time or place. Nobody wants to be forced into an exchange. Nobody owes me dialogue, and I have to take the time to create an environment where people feel welcome and honored.

I've learned that we can find ways to have productive conversations around even the most contentious subjects, but you have to earn that opportunity. You

have to invest time in building a foundation of trust before wading into difficult issues, and that's the part we tend to skip over in the public realm. We tend to lead with the thorniest problems. We frame them as an attack, a challenge, or a judgment, and the rhetoric heats up quickly. We step right into the fire, and we are surprised when we get burned.

CHAPTER 13

LOOK FOR SOLUTIONS

When I drove into Detroit before dawn, the streets were dark. As I exited the freeway and slowed down on the urban streets that threaded through commercial districts and residential neighborhoods, a ghostly scene unfolded. Blocks of boarded-up homes. Burned-out businesses. Nearly 40 percent of the city's streetlights were out, and as I got close to where I would meet the next interview subject and moved through some of the hardest-hit neighborhoods, it seemed like the number was closer to 100 percent. I knew the city struggled, but I'd never been there before.

My Durham friend Barry had just published a story in the *American Prospect* about the work that people were doing to turn the city around, and he connected me with John George of Motor City Blight Busters. *"If you want to understand Detroit,"* Barry said, *"you need to meet John George."*

I arrived at the Motor City Java House, a part of the collection of projects John had championed as he worked to breathe new life into the neighborhood near the intersection of Lasher Road and Grand River Avenue in the northwest corner of the city. I was early, with plans to catch up on emails and editing over a cup of coffee, but the shop was still closed, so I continued to drive through the neighborhoods until it was time to meet.

John George was in his early fifties. He wore his Detroit Lions cap cocked at a slight angle, a Blight Busters T-shirt tucked into black jeans, and a zip-up jacket to guard against the spring chill. The Java House had the feel of a cozy living room with an eclectic mix of sofas, tables, and chairs. We sat at a four-top table, with a portrait of Malcolm X on the wall over John's left shoulder and a collection of tri-fold foam-core boards displaying photographs of some of the blighted and abandoned homes in the neighborhood that John's group intended to bust.

John started by saying, *"When the nation gets a cold, Detroit gets the flu. And it's never been truer. We are suffering from double pneumonia right about now."*

He explained that in the 1980s, he lived next to a crack house. The epidemic had hit his neighborhood pretty hard, and with one child at home and another on the way, he did all the things you are supposed to do to change the situation. He called the police. He called city hall. But nobody would—or could—do anything about it.

John thought about moving. Nobody wants to raise their family in that sort of environment. But then he thought, *Wait a minute—this is my home. I pay my taxes. I mow my lawn, and I take out the garbage. I am not going anywhere.*

So instead, he went to the hardware store; bought plywood, nails, and paint; and boarded up the crack house. When the drug dealers came back, they couldn't get in, and they just moved on. His solution worked pretty well, and his spark of success could have stopped right there—but John fanned that spark into a flame. He talked with his neighbors and encouraged them to do the same thing, to pitch in. In his own words, he told them, *"You can either help me or get the hell out of the way."* They decided to help.

John organized a group of people, and they started demolishing abandoned houses and replacing them with community gardens and orchards. They took community liabilities and flipped them into community assets. They realized that people took pride and ownership in their neighborhood when they were a part of the solution. John George's grassroots efforts evolved into a 501(c)(3) called Motor City Blight Busters. Their logo echoes the one for *Ghostbusters*, and he cracks a wry grin when he sees a problem in his neighborhood and asks, *"Who you gonna call?"*

Motor City Blight Busters has gathered thousands of volunteers over more than three decades of work. Like the city itself, they are a diverse group of people who believe they can make a difference. John had a vision of how to turn around a difficult situation, and he acted. He shared his vision with others, he inspired them, and he convinced funders to come aboard.

One block at a time, they are improving their city, building relationships, strengthening communities, and creating hope along the way. John said, *"We all know what the problems are, and there are many. But to continue to focus on the problem and not create a solution is a mistake."*

John took me on a tour of the neighborhood in his old Cadillac with police sirens on the top and logos emblazoned across the side. We drove through entire

city blocks where none of the homes were occupied. Some were burned. Some were boarded up. Others had the windows broken out and were simply open to the elements. The foreclosure crisis had hit the city hard. People walked away from upside-down mortgages when they could no longer make the payments. The banks held abandoned properties, but there were no buyers. Deserted properties encouraged unwanted behavior.

Detroit lost its critical mass. As people moved out, there were fewer customers to support businesses, and shops closed their doors. The tax base continued to erode, and there wasn't enough revenue to provide services. The city itself was in crisis and didn't have the resources to turn the situation around, but urban pioneers like John George wouldn't give up.

"We boarded that one up. We'll tear that one down. We're talking to a developer about restoring this old storefront." John talked fast and with a young boy's enthusiasm. He gave a running commentary block by block as we moved through the neighborhood, and he revealed his grand vision for bringing life back into the city. *"Why not?"* he asked. *"We are out to change the world, and we're starting in Detroit."*

It was a bold statement, but it seemed like if anyone could do it, it was probably John George. He had the right combination of hustle and guts. He wasn't afraid to get his hands dirty, and he was a tireless advocate. We returned to the Java House, and John walked me through the collection of spaces loosely affiliated with the coffee shop. He had an artists' stage for public gatherings, storage for building materials, and some new housing that was being renovated above the Java House. All of it was designed to bring new opportunities and new energy into the neighborhood, and the tour was interrupted by a steady stream of people stopping by to say hello, ask John for advice, or update him on other projects in the area.

I had a little trouble keeping up with it all. I asked John if I could walk down the block to photograph in and around a collection of derelict homes that Blight Busters was slated to tear down soon. I was curious, and I was also trying to scout a place where I could photograph him.

"No problem," he said. *"Be careful."*

I wasn't certain exactly what I was supposed to be careful of, but as I entered the first house, it became clear. It was a two-story, turn-of-the-century shell that was probably once a handsome home, but now the siding was faded, missing in some places and covered in graffiti in others. The front-entry steps were absent,

and the door was boarded up, but the rear door was off its hinges, and I walked right in. Even with the windows broken out, the air was fetid. The home was strewn with bottles and trash. Piles of feces—some human and some not—filled the corners and appeared to be smeared across the walls.

I didn't linger. The space was repulsive, and I wasn't certain I was alone. I photographed a couple of other houses on the street, and they were the same. Signs of desperate people and difficult living. I didn't want to surprise anyone who didn't expect me. When I found John again at the Java House, he asked, *"What did you find?"* I just shook my head, and he said what I was thinking: *"Nothing good ever happens in a house like that."*

"Let me show you something," he added, and we crossed the street to the Motor City Blight Busters headquarters and another commercial building that they were renovating. I had the sense that John could lead a never-ending tour, but as we walked through the renovation project, I found the setting for our portrait and asked him to pause. A long, gutted corridor ran the length of an outside wall. Exposed studs framed one side and the ceiling. The opposite side was an expanse of cracked and pocked plaster with an occasional window. Pools of light poured in through the windows, alternating with the shadows that settled between them.

I sdirected John into one of the swaths of light, the corridor stretching out behind him. He stood there looking proud and matter-of-fact, waiting to check off the next thing on his ambitious to-do list.

People had given up on Detroit. Leaders were retreating to triage, deciding which parts could be saved and which would be abandoned. Critics dismissed it as a failed city, beyond repair or redemption. But John George saw potential, and he rallied others to his cause. He started with nothing but a stubborn determination to make things better. He leveraged grassroots talent and resources and refused to give up. Together, he and his allies cut grass, tore down abandoned buildings, planted gardens, and made a difference when others said it wasn't possible.

When it comes to peace, we need leaders who are willing to tackle seemingly impossible problems. We need to cultivate a bold new vision of how we can live better together. And we need citizens willing to step up and do the unglamorous work of making it happen. In Detroit, I'm reminded of the Confucius saying that the man who says he can and the one who says he can't are both right.

I went into Detroit expecting to find despair, and in its place, I found inspiration. As I drove away, I asked myself, *What if I did more of that? What if I looked for those sparks of hope and fanned them into flames? What if I looked at examples of what is working in the world and used them as our model for how to move toward a more peaceful world?* This is a lesson I need to learn over and over again, and people like John remind me that it is true: sometimes you just have to do the messy work yourself because nobody else will.

CHAPTER 14

STAY AT THE TABLE

I met Maham Khan at Harper College in Palatine, Illinois, just north of Chicago. She talked about starting as a first-year student at the school. She was Muslim, but her faith was private. She didn't wear a hijab or talk much about her faith.

Like many first-year students, Maham looked for ways to make new friends and get involved on campus, so she decided to join the Muslim Student Association. It was a small, quiet organization, and much to her surprise, at the first meeting, she was elected president.

Being president was a little outside of her comfort zone. But, Maham thought, *How hard can this be? We'll study Quranic verses on Tuesdays, and we'll have some pizza on Thursdays—I can do this. What could possibly go wrong?*

Well, as it turns out, this was in 2001. A few weeks later, September 11 happened, and all of a sudden, Maham was *way* outside of her comfort zone. Overnight, she found she was the head of an organization on campus that was at the center of a storm of misunderstanding, fear, and anxiety.

"September 11 happened, and suddenly it was the most important group on campus. Just like everybody else, I remember exactly where I was that day, what happened, the emotions.

"I remember I was running late for class, and that was my big concern that morning. I was on my way to class, and my teacher told me, 'If you're late one more time, I'm dropping you a letter grade.' I'm running up the stairs; I'm praying for a miracle. I remember getting into class, and just—everyone huddled into a corner— and then realizing that something devastatingly wrong had happened.

"While everybody is freaking out and confused, and as I was too, there was this real concern of [how] the guys who did it have something in common with me. It

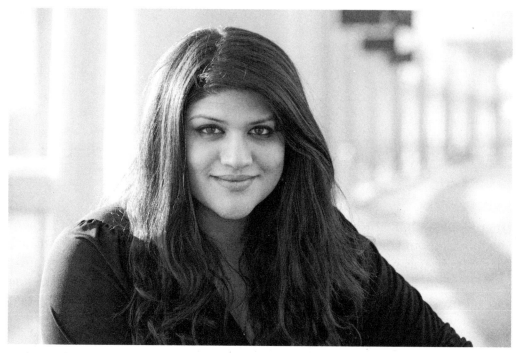

Maham Khan

was really uncomfortable. There's a whole other fear in that that is indescribable, that no one else—unless you are Muslim—could relate to: not only are you afraid of what's happening, but you just immediately know that this common identity is going to be problematic. That's the honest truth. I mean, that day I was not just scared for my family and my dad being downtown and all these things. I knew that this was going to be much bigger than this day."

When we are this uncomfortable, we usually do one of two things. We run away or we decide to face things head-on, and that's what Maham chose to do. Even though tensions on campus were high and Maham was way outside of her comfort zone, she started organizing interfaith dialogue sessions on campus. She realized that when communication broke down and students muttered things under their breath as they passed each other in the halls, tensions rose. But when people met face-to-face and talked, when they got to know one another's names and hear their stories, it held the potential to build relationships—and tensions eased.

In Maham's own words, *"There are people who have never really sat down and had a conversation with a Muslim about what they believe. I think that's part of the problem. We fear that which we do not know and understand. The only way to know and understand is to expose, but we aren't allowed to expose because political correctness tells us not to. We have this sort of institutional problem, and I try to break that barrier.*

"I say, 'To hell with political correctness.' If you're uncomfortable being on an airplane with me, that's fine. Let's talk about it. Let's talk about why. I bet we have a lot more in common than you think. I think people are terrified of having honest, raw conversations about race and religion and gender issues and things like that because real honesty reveals sometimes unpleasant things about ourselves. We may not want to confront what we discover.

"It may not be so pretty, but we can talk to one another."

Maham said her efforts on campus worked well because people were willing to stay at the table. No matter what our struggle or conflict, when we stay engaged with one another, continue dialogue, and keep working on our relationships, there is a hope that we can find our way toward some sort of resolution, but when we walk away from the table, the hope walks away with us. So the question I have to ask myself is, *"When things get difficult, will you stay at the table?"*

CHAPTER 15

EMBRACE THE JOURNEY

Something magical started happening: my exhibits started booking not just in Minnesota but across the country.

I say *magical*, but I had been laying the groundwork for years, making connections and chasing every lead I could imagine. And rather than using my assignment work to subsidize the growth of the project, now *A Peace of My Mind* could begin to subsidize itself. The exhibit fees could offset the travel costs and help define the path for new interviews as well. This shift in what drove the project offered a glimpse of how this national collection could play out. It was a house of cards. It was like weaving threads of gossamer to hold it all in place. I robbed Peter to pay Paul, but one story at a time, the collection grew.

In 2013, my friend Wade Barry nominated me for a Peacebuilder Award from a Denver-based nonprofit called Jovial Concepts for the work I had done to date for *A Peace of My Mind*. He didn't tell me about the nomination; he just quietly submitted it after seeing a call for entries online. Months later, I received a random email announcing that I had won. They wanted to present the award at their September 21 event in Denver to commemorate the International Day of Peace. They wondered if I could bring a part of my exhibit, and I said, *"Sounds good to me."*

I already had an exhibit scheduled for Kansas that fall, so the outlines of a road trip started coming together. I built a loop that included the Kansas and Denver events plus extra time to do new interviews in Kansas, Nebraska, and Colorado. Then I did what I always do: I looked at the map and thought, *You know, if I just go a little farther, I can add one more state.* That's how Utah got tagged on to an otherwise sensible itinerary.

As the details of the Denver loop began revealing themselves, a few logistical snags came into focus as well. We had recently traded our big, shiny truck for that budget-friendly Honda Civic, but the Civic didn't have enough cargo space to haul the exhibit I had promised to bring out west.

Our second vehicle was a reliable Grand Caravan until our teenage son, Jordan (a recently minted new driver), tried drag racing another teen-piloted vehicle in an icy parking lot and sent our van to the junkyard. Nobody was hurt. Money was tight, so we bought a Honda Odyssey with one hundred thousand miles and a rebuilt transmission off of Craigslist and hoped for the best.

The guy we bought it from fixed old vehicles from a shop on his farm and offered what seemed like a fair warranty. We used that warranty to address some transmission concerns a few times before this trip west, and every time, we told ourselves that now things were fixed, and all would be fine. It had to be fine.

Turns out, it wasn't fine.

I loaded the exhibit and all my photo gear into the van—it was packed right up to the ceiling—and I started driving west. It was a Friday, and I had an early start under the autumn's cobalt-blue sky. The miles ticked off through Minnesota, Iowa, and then Nebraska with the radio turned up loud. I might have been singing along when I felt the engine shudder. I paused but then finished the song.

It happened a second time. Then again. I kept singing. The fourth time I felt the hesitation, the RPMs raced, the van lost power, and the cabin filled with a thick, foul smoke. There was an exit ramp within view, and I willed the van toward it. I managed to coast to the top of the grade and off to the side before rolling to a stop. It was 4:00 p.m. on a Friday. I was ten miles west of Ogallala, Nebraska, and Denver was still two hundred miles away.

I lifted the hood as a car pulled up behind me. *"It's your transmission,"* the young man said as he got out of his vehicle. *"I was right behind you, and I could smell it."* He had just finished a tech program in engine repair, which made him infinitely more qualified than I was, though with my recent history of transmission repairs, I had come to that same diagnosis on my own.

He poked around the engine to see if he could find a way to help me limp into town, but in the end, he shook his head and offered to call a friend who could tow

me. There was one shop that could look at it, but it was Friday afternoon, and he wasn't sure they were open. He called them too, someone answered, and they agreed to wait.

Ogallala doesn't stock many transmissions for Honda Odysseys. Actually, the precise number is zero. So the earliest I might have an answer on the van was sometime Monday when they could contact their suppliers. But my award was being presented Saturday—the next day—so I asked about a rental. It turns out that Ogallala doesn't stock many of those either. The shop had exactly two vehicles I could choose from: a big, old dinosaur of a Cadillac or a brand-new PT Cruiser. The Caddy smelled like cigarette smoke, so I chose the PT Cruiser and proceeded to consolidate my overburdened van's contents into a clown car. It didn't work. I wedged as much as I could into the tiny car, left the remainder in the back of the van, and told the owners of the shop I would call Monday to figure out the rest.

And this is the way the adventure unfolded. Opportunities led to trips. Mishaps turned into stories, and the path moved ever forward.

A week later, I was outside of Moab with the rental, standing on an outcrop of red rock in Arches National Park, hoping for one more bar of cell service to sort out the next steps with the van.

Truth be told, Moab had only made it onto the route because I wanted to see the landscape. I had been to Arches National Park as a young boy camping with my parents, but it was a brief visit and I had always wanted to return. I love our national parks, so pick out any grand, natural splendor, and odds were good it would become a dot on my map as I plotted the course of this journey.

Once the route was roughed in, the process of deciding who to interview was sometimes a self-imposed wild goose chase. In this case, I had no natural leads and no advocates on the ground whom I could ask for help. In my planning for the trip, I turned to our good friend Google and typed in the words *Moab* and *peace*, which led to a listing for the Peace Tree Juice Café. On their website, the café talked about a Native American legend of warring tribes who made an accord and buried their weapons at the base of a tree, coming together as one prosperous nation and living in harmony. That was the peace tree. The web listing ended with these parting words: *"We thank you for visiting us and hope your experience is satisfying and enjoyable. Naturally, we wish you—PEACE."*

It was enough of a lead to justify a phone call.

A woman answered, and I asked to talk with a manager. She was the manager. I explained the project as quickly as I could and asked, *"Would you be willing to connect me with a couple people?"* She said she would do her best and asked what sort of people I was looking for.

This was always a difficult question. I had ideas, but sometimes serendipity had better ones. I harbored my own notions about how to steer the project, but I had come to recognize that remaining open to unexpected possibilities delivered results that I couldn't have even imagined. So typically, I planted seeds and waited to see what would sprout. I told her to think of two people.

The area around Moab was filled with so many dramatic rock formations and towers, I wondered if she knew any big wall climbers who might share a perspective related to that. I had been a rock climber in my younger and more limber days, I explained. I hadn't climbed anything particularly impressive, but I had played on the rocks of Minnesota's North Shore, in the Needles of the Black Hills, and in Rocky Mountain National Park. I loved to be on the rocks because it required so much concentration that all the world's distractions faded into the background. For me, it was a Zen-like form of physical meditation. I wondered aloud if that would be an interesting story to explore.

As for the second person? I told her to use her imagination—to think about the people in her life who would be interested in this conversation about peace and who might have a unique perspective to share. Trust that intuition, I said, and I would call back in a week to see what she came up with.

I tried again a week later, but as the trip got closer, I still didn't have a firm answer. *"Why don't you just stop by about 9:00 a.m. on Tuesday,"* she said. *"We'll figure it out."* So as I drove from Denver to Moab, I wasn't certain who I would interview, but I trusted that things would work out. I had been offered manna every day to this point, and I grew to expect nothing less.

As I pulled into Moab, I arrived early at the Peace Tree so I could grab breakfast. I asked the server if I could talk with the manager, and he told me that she wasn't in on Tuesdays. I panicked a little. I explained what I was doing in town and that I was supposed to meet someone to interview a little later that morning, although I wasn't sure who that was supposed to be.

"Yeah, that's me," he said. And that's how I met Evan Haworth. As it turned out, Evan had a story I never would have expected and that I never could have asked for.

<p style="text-align: center">*　*　*</p>

We agreed to meet in the afternoon, when he finished working his shift at the café. *"Follow me,"* he said, and we drove out of town to a small gravel lot and trailhead.

As we started walking down the trail, Evan explained that he worked at the Peace Tree, but he also played the Native American traditional flute. Moab is a tourist magnet, bursting with scenic wonder, but Evan was frequently disappointed to see visitors having a hard time unplugging from the work-a-day world. He would observe them on hiking trails, checking their phones and completely missing out on the beauty all around them, so he made up a little game. We were playing it now.

Evan would hike into a red-rock box canyon with his flute, finding a location where he could watch the trail but was hidden from view. When he noticed a distracted hiker, he would play a few notes. The hiker would stop and look around to locate the source of the music, but because the sound bounced off the canyon walls, his location was undetectable. When they returned their attention to their phone, Evan played a few more notes and the hiker would pause again. It wasn't always a phone. Sometimes people were confounded by an unhappy child or a pebble in their shoe or any one of the multitude of things that distract and derail us every day. Regardless, that little interruption of music allowed them to set aside their distraction and return to the present. Then he would play a full song and watch them melt into the moment.

Of course, at that very moment, I was distracted by worrying that I wasn't getting this conversation recorded. Fortunately, Evan told me this story again once the mic was live as we sat on a flat rock at the head of a box canyon. At one point, a noisy group of hikers approached. He pulled out his flute, and when he began to play, a hush fell as they stopped to listen. When he finished, they walked on in silence, and Evan smiled. *"Happens every time."*

Evan offered his thoughts on finding peace: *"I would say to the world: live right now. You can't fix what happened a minute ago, and you can't change what's going to happen next. So live now."*

Evan went on to explain another way he used his flute to connect people and bring a little peace into his corner of the world: *"I had this customer, an elderly lady, and she'd come in once a week. We actually became really good friends, and*

she'd come in and ask me to play the flute for her every once in a while. Then one day, this strange lady came in. I had never seen her before, and she introduced herself to me as this woman's daughter, and this woman was on her deathbed, and she thought she would come down and ask me to go play the flute. And so I did. I just did it as a friend, a way for me to say goodbye."

He went on: *"I went over there and started playing, and the music just started happening. This song just started coming through me. When I got home, I went to bed. I had a dream about her, and she told me, 'Hospice is where you need to be.'"*

Now Evan has made it a practice to bring his flute into hospice settings and use the music to help families navigate the act of dying. The music helps remove fear. It brings comfort. It allows families to be centered and focused during a difficult time.

"There's been many times where I would walk into the hospice room and the family members are there. It's a really strange time emotionally. Sometimes there is hostility and sometimes there's so much grief, and from a patient's point of view, it's hard to let go when your loved ones are feeling that. I would start handing instruments to the family members, and they'd look at the rain stick and they'd start moving and making the noise.

"All of the sudden, they start clanging on the percussion. You just hand them the instruments to deal with the grief and they become my muse. The family emotion is what I take within myself, and I translate that emotion into the music with what they're creating. I'm just adding the melody. They're the ones creating the magic, and it helps the patient pass on. And it creates an awesome memory for them. That's my way of carrying on their memory of who they are."

We hiked out of the box canyon and arrived back at his car at the trailhead. *"What about the rock climber?"* I asked. *"Your manager was going to track down another person for me to talk with."*

She hadn't had much luck in that department, but Evan knew a guy who worked in a climbing shop across the street from the Peace Tree. Maybe I should ask him, Evan suggested.

It's not how I liked to work. I preferred to give people a little warning rather than walk in off the street and ask for a half day of their time. But I had run out of options, and the climber perspective was the idea that had drawn me to Moab in the first place. So when we got back to town, I walked across the street to Pagan Mountaineering and asked the person at the counter for Taylor Bond. *"That's me."*

Taylor's SUV had a modified air intake situated like a snorkel near his roofline so he could ford big creeks. There were vinyl stickers of skulls across his hood that were crafted by a friend with a new print shop. We both piled in, and he drove me down a rough gravel road that descended into Kane Springs Canyon toward the Colorado River. He had in mind a large, flat boulder on the side of the road. The rock was the size of my first house, and we pulled over to survey the situation.

"How's this?" Taylor asked. I thought it was as good as any studio I'd ever seen. The only sound was the wind moving through the sculpted sandstone above us. Taylor wore ripped jeans, sandals, and a T-shirt. His hands were scabbed, taped, and scarred like any serious rock climber's would be. He hadn't shaved in many days, but then, neither had I.

Taylor was skeptical of peace in the bigger world: *"There's always that one asshole out there that's always going to be like, 'I want what you have' or 'I'm tougher than you,'"* he said.

"It's a beautiful thought to say, 'OK, yeah, we're all just gonna get along.' If you really sit back and think about it, there's just always going to be that one fucker out there that just doesn't want to go along with everybody else.

"You see it in everything. There's always the one kid at school that's going to be a bully and pick on this guy. The one president that thinks he's better than us. The one country that thinks it's better than you. I just don't think it's a plausible thought. Maybe I'll just come off as ignorant saying that, but it's really what I believe, and it's sad."

I wanted to believe something better was possible, but I also had to admit that things looked bleak at times. There were times that it felt like this endeavor to reveal the dignity and light of each person was a losing battle. Perhaps it was arrogant to imagine that photography and storytelling could make any impact at all in this rising tide of national rancor, but then again, maybe it was foolish not to try. Maybe there was redemption in Taylor's story, and I wanted to hear more.

"I think what it really comes down to is everybody wants what they can't have instead of just being happy with what they've got. The grass isn't always greener.

"If you spend your whole life worrying about that, that's going to make my life more stressful and way worse. Maybe that's one of the problems with the whole world is that they're not focusing on making themselves better. You've got to start

on the inside and work your way out. It's really easy to control my little zone or my little bubble. It's almost impossible to control the bigger bubble of life."

Taylor had moved to Moab a few years ago after life had taken a difficult turn.

"I worked my ass off for ten years as an electrician, living how everybody expected me to live. Then two years ago, I kind of lost my shit because I had lived in the same town for thirty years. I sold my house, bought an RV, and went on the road."

He wound up in Moab, got a job at Pagan for minimum wage, and spent his free time climbing rock towers in the desert. Like me, Taylor found peace in the singular focus of the activity. But while my climbing had brought me dozens of feet above the ground, his took him hundreds. I tried to imagine the vulnerability, concentration, and sense of wonder that working your way up a rock wall that imposing would instill.

"You know what I love about climbing? The idea that you can get your mind off of everything. It's one foot, one hand, and all you've got to worry about is the next move. You forget about life in general because you have to focus hard on what you're doing.

"When I'm stressed out, or work's going wrong, or I'm having trouble with my girlfriend and everything is overwhelming, I get on the rock. When you're focused on putting your foot in the right position, or putting your protective gear in the right spot, it all just melts away. It's euphoric. You forget about everything and just focus on the goal at hand. You have to, because if you don't, you fall."

He was climbing the next day with friends and invited me along. I didn't climb. The walls along Potash Road outside of Moab were a little beyond my middle-aged abilities, and I didn't want to slow them down, but I spent the afternoon at the base of the rock as they worked their way up and down inviting cracks on the smooth wall, calling familiar encouragement to one another: *"Look left . . . can you follow that edge?" "You got this!" "Don't give up, man . . . you almost got it!" "Trust yourself!"*

"Which way do I go?" one of them asked.

"Up!" the smartass from down below replied. Oh, sorry—that was me.

The small group of climbers laughed and worked their way up the rock, letting the worries of the day fall away. And they were good enough to make room for me.

Taylor's parting wisdom was as follows: *"Just keep moving forward. I've been an asshole, and I've done lots of bad things, but not lately. It's easy to be an asshole sometimes, but just try not to do that."*

It was good advice as I made a few last calls to resolve the van issue. I sort of wanted to be an asshole as the frustration mounted, but it was nobody's fault, and taking it out on someone else wasn't going to change my predicament. The vehicle was worthless with a bad transmission in Nebraska, so we decided to hire a flatbed truck to haul it home so we could get it fixed and then sell it. As it happened, I had musician friends driving from Denver to Minneapolis on just the right day, and they agreed to squeeze me into their van for a ride home. More manna.

The loop out to Moab had some bumps for sure. But I was making it home in one piece, even if my van wasn't. Life could be worse.

CHAPTER 16

YOU HAVE A CHOICE

A wild goose chase of sorts led me to a long phone call with a man named Clive in Nebraska. He helped run a storytelling festival, and I figured if anyone would understand the power of stories and be willing to help me, it would be a fella like Clive. We talked a while, and he asked, *"Have you ever been to Nicodemus, Kansas?"*

"Nope."

"Well," he said, *"you oughta go there and find a woman named Angela Bates. She's your person."*

And since that's what I do, that's what I did.

Nicodemus was settled by freed slaves after the Civil War. There were plenty of these sorts of towns back in the day, but Nicodemus is the only one that still exists west of the Mississippi. All of the current residents of Nicodemus are direct descendants of the freed slaves who settled the town.

There are competing accounts of how Nicodemus received its name. One version claims a biblical reference, and the other suggests it was named after a legendary man brought to America on a slave ship who eventually purchased his own freedom.

Regardless of which version is true, the town founders marketed the place as a Western Eden. A Promised Land. They promoted heavily to freed slaves who found little relief in the Reconstruction-era South as they looked to become a part of the New Exodus to far-off places that offered more opportunity.

I arrived in Nicodemus early, as I am inclined to do. I get flustered when I am pressed for time, and that makes it difficult for me to do my best work. It may be residual jitters from doing executive portraits for *Forbes*, *Business Week*, and a

host of smaller publications. Photograph the CEO of a Fortune 500 company, and at best, you'll get about five minutes of their attention. If you are late, you are not likely to find much compassion or flexibility. I learned to be early—no exceptions.

When it was finally time to sit down with Angela, she described Nicodemus like this: *"The town is small in terms of population, but it's huge in history. It represents an entire chapter in American history where African Americans were moving west after the Civil War."*

Although it was a harsh landscape to settle, the town grew and prospered. In its heyday of the 1880s, Nicodemus had nearly five hundred residents. There were two newspapers, three general stores, three churches, an ice cream parlor, a baseball team, and a community band.

Angela was proud of her heritage: *"I'm a descendant of people that had a vision, that had determination, and that had faith in God, and they made their dream a reality. I carry with me the gene of determination, the gene of faith, and a desire to make a difference."*

The entire community was proud, and they lobbied the National Park Service for recognition. It took years, but finally in 1996, Nicodemus was recognized as a National Historic Site, and five buildings were preserved as a part of it. It was a worthy effort, but there were tensions in the process centered on the notion of outsiders coming in to tell the story of Nicodemus. The community wanted to tell its own story, and so just down the road, Angela now leads the Nicodemus Historical Society in a small house on the edge of town so the local residents can tell their own story.

Life can be complex. As we sat in the Nicodemus Historical Society, surrounded by photographs of the early town and settlers, Angela explained the following: *"African Americans have been raised in a country that does not have the best past. We tend to forget that we have been terrorists in our own land against our own people. And being African American in this country has not been the best experience, so to speak. It's been a great experience in terms of teaching us how to be tolerant. How to wear the mask and adjust to an environment that has been very hostile to us—and still is—in many respects.*

"For example, we have a park service here, and the park service is like a foreign installation, but we've invited them here because they represent the federal government and they're a part of preserving this place and interpreting the history.

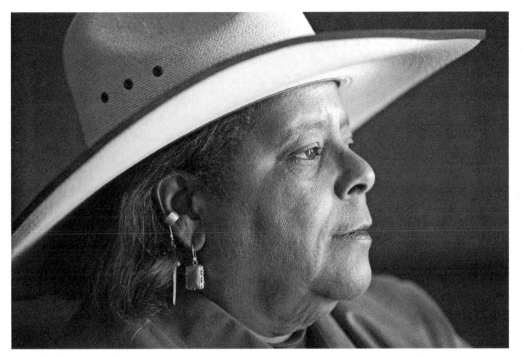

Angela Bates

But most of the staff are white. They have their job and they represent the federal government and they have their own agenda. But their agenda may not necessarily be ours. It may be complementary [. . .] but it's a little bit different than ours."

I asked Angela to back up a little and talk more about the idea of masks. I assumed she was talking about a sociological concept called code-switching, but I was interested in her words and her definition of the idea.

"You know, African Americans wear two masks. You know, the mask that we wear when we encounter the white world, and when we're among ourselves we're just ourselves. And even though it's not about the differences, it's about understanding the differences, because if I am of the dominant group in the society and I impose that on everybody else, everybody else has to step up to the plate. And me stepping up to the plate is what I have to do to survive in this environment and this society.

"But when I go home, I don't have to. Or when I'm around others that are like me, I don't have to wear the mask; I don't have to talk a certain way."

I didn't have the sense that Angela was wearing a mask for our conversation. We sat on metal folding chairs in the middle of the museum's weathered wooden floor. This place had once been the home of early settlers. She was at home in every sense. I hoped that she was bringing her full self to the conversation, and I hoped that she felt that I was too.

"All of that dynamic is present every day. So as an African American, I have a choice. How am I going to react to the world around me?"

Those words caught me, and I thought, We all have that choice. We can't always control what happens to us, but we absolutely can control how we respond to it.

"Believe me," Angela continued. "There are many, many situations that happen throughout the day where I know and I am reminded that I am African American. But when I meet people, I want them to know who I am. You may see me as an African American woman and you may react to me initially as an African American woman, but by the time we finish talking, then you will just know Angela. And then you will just know my spirit. It has nothing to do with my color. But we as African Americans cannot escape that. It's a part of who we are. We have to deal with the world that we live in.

"So those differences are there, but it's not about the differences. It's about those moments when we are encountering one another—what are we going to do with those moments? But then as we embark upon understanding one another, all of those differences fall aside, and what's left is just the human experience.

"You start to see that you're just another human being that has likes and dis-likes and the same kind of desires that all of us have. We all have the same basic needs. We really all want to be accepted and loved and appreciated. And that's—that's a human kind of thing. It has nothing to do with color. It has nothing to do with culture. It has nothing to do with race. It has something to do with being a human. And all the other stuff? Foolishness. It's all foolishness.

"We have to get past all those other things that make up the world physically and make up us physically. All of those things become distractions. 'I don't like you because you're not living on the right side of the tracks. You're not driving the right car. I don't like the way that you're dressed. You've got sandals on. You should have a suit and tie.' You know, 'I don't like you because you've got a goatee and you look like you're just too relaxed to be doing what you're doing.'"

I should point out that I have a goatee. As we did the interview, I was wearing shorts and a T-shirt. I had on Tevas. I suppose she was talking about me, but it wasn't accusatory. It was just an observation, and it was clear from Angela's presence and tone that she took people for who they were.

"You don't like me because I'm dressed like this. I don't like people that wear cowboy boots and cowboy hats. They're a bunch of hicks." And now she was talking about herself.

"We bring all of those biases to one another when we encounter one another, as we approach one another. You know? We bring all of that to our encounters with one another and they're just prejudices. Ignorant foolishness. That's what they are.

"It distracts us from the core of who we really are. And that's because we don't have faith. We don't think that we're going to have enough money to pay the bills and buy the food and have the transportation and wear the clothes. We don't think we're going to have all that, so we don't have faith. And because we lack faith, we walk around like we have to do all these things and have all these things because this is what's going to ensure us to sustain ourselves. And that's where the peace gets lost.

"Peace is a state of being. You will arrive there. You can't find it. You can't pursue it. You arrive there. But I think we get so hung up in the foolishness of life that we cannot pay attention to the real things.

"But what is life? What, really, is life? Is it the pursuit of all that stuff? Is it the pursuit of materialism? I think that's gotten us where we are. We need to stop and just take a deep breath and say, 'You know what? I just thank God for this day and for this encounter.' Because tomorrow ain't promised. What's really

important is the encounter that we have with one another, the little bit of energy that we exchange with one another. That's what's important."

We finished the interview and a thought occurred to me. I said it out loud before I realized how it might sound: *"What do you think the odds are that we could get the whole town together for a portrait?"*

And Angela replied, *"You'll probably get everyone but my dad—he's kind of crabby."* She followed quickly with *"I'll start making phone calls."*

A few hours later, I set up on the edge of town, near a stone marker carved with the name Nicodemus and 1877, the year the town was founded. Slowly, cars and trucks approached and pulled off to the edge of the highway. The citizens of Nicodemus got out and deliberately climbed the hill to the marker. Sixteen people, all direct descendants of the freed slaves who settled the place—even Angela's dad. And we made a town portrait.

As I drove out of Nicodemus, Angela's words echoed in my mind: *"I have a choice. How am I going to react to the world around me?"*

What was I going to choose?

CHAPTER 17

LET YOUR HEART BE BROKEN

I was invited to install one of my exhibits at the Sojourners Summit for Change in Washington, DC. Three hundred leaders from across the country gathered to explore the intersections of faith, race, and social justice. A large percentage of those attending were leaders from the Black Church, and we met for the opening session the afternoon of June 17, 2015.

Later that evening and five hundred miles away, Dylann Roof walked into a Bible study at Mother Emanuel African Methodist Episcopal Church in Charleston, South Carolina, one of the oldest Black churches in the country. He sat with a small group of congregants for an hour discussing the word of God, and then, as the others closed their eyes in prayer, Roof pulled out a .45-caliber Glock pistol and opened fire, killing nine people, including the head pastor. He walked into a holy space, received a warm welcome, and violated that sacred trust in the most horrific way.

The next morning, the mood at our Washington, DC, conference was somber and heartbroken. Jim Wallace, the founder and editor of *Sojourners* magazine, spoke of lament and the need to allow ourselves to mourn the brokenness of the world. Too often, we are stunned by horrific news and then swept along to the next headline or our next obligation. We don't have time to process, and we don't take time to grieve. So right then and there, the leadership of *Sojourners* created the space to do just that.

Our lament can not only soothe our souls, but it can lead us to action as well. A pastor friend called it Holy Discontent, that righteous anger that burns inside against the injustice of the world. Use that fire poorly, and it will burn you. But tend to the fire and use it well, and it will give you light, warmth, and the ability to change the world.

Wendell Phillips was an abolitionist who spoke with conviction during a time in our country when he faced great peril for doing so. After one speech, a friend asked him why he was so on fire, and Wendell replied, *"Because I have mountains of ice before me to melt."*

I was reminded of Mel Duncan's words on one of my exhibit panels just outside of the room: *"I have seen things that I would rather not see and would rather not know. I have seen horrific things done to people. Yet if we are going to engage and transform, that exposure [and] that deep knowledge is required. I continue to believe that when most of us are presented with those kinds of conditions, we will act to change those conditions. I think that it's a situation of keeping one's heart open so it can be broken and broken again. If it's not open—if there are not those cracks—there is not the space for active compassion. And that active compassion, based upon a true understanding of the realities of this world—not some romanticized notion but the true understandings of the struggles—open one to the possibilities of how we work to change."*

The conference plans for the morning were altered by the events of the previous night. The organizers asked us to gather in small groups for conversation. Eight to ten people around each table in the ballroom were asked to share their own thoughts about race and injustice and the ways we had encountered it in our lives.

Most of the people at the table—the people of color—related experiences that were outside of my own, and they spoke of deep wounds and profound frustration. One young man told a story from elementary school where the students were asked to draw a picture of what they wanted to be when they grew up. This young man drew an image of himself as a firefighter, and when the teacher came along and looked over his shoulder, she said, *"Oh, Robert—that's not what a garbageman looks like."*

People talked about being pulled over for driving while Black. Hearing car doors lock as they approached to cross an intersection. One young man remembered his parents frequently telling him to never run. *"Nothing makes white folks more uncomfortable than seeing a Black man run,"* they said.

I was in the minority at the table, and when I opened my mouth, I wasn't happy with the way I articulated my thoughts. The white folks at the table—God bless them—were trying to help, but they were fumbling. I was fumbling. Many of our stories came across as defensive, with a deflection that explained that *"We*

weren't that kind of white people." "We are not all like that." But it didn't help. The point is, entirely too many people are like that, and tending to our own egos in the conversation simply distracted from a full and necessary acknowledgment of the pain that was at the table.

The fact that I am not Dylann Roof does nothing to change the heinous events of that night. The fact that I have never called anyone the N-word does nothing to alter the fact that every person of color seated at that table had heard it spit at them. We squander the opportunity for healing when we hear honest pain and respond by saying, *"Yeah, but I didn't do it."* In fact, that response only serves to create additional pain.

I'm paraphrasing, but one woman shared, *"My mother used to spend hours braiding my hair after long days at work. She couldn't afford to take me to the salon. So it's aggravating to see white models wearing cornrows on the runway as high fashion, but Black women can't wear them in certain settings because it's 'unprofessional.'"*

I tried to say that the authentic human moment she shared with her mother held so much more value than the commercialized world of fashion. But instead, when I opened my mouth, what came out was more along the lines of *"Well, maybe you are measuring it wrong."*

Ugh. I knew immediately I had missed the mark. Not only had I communicated my own idea poorly, but I had failed to acknowledge her frustration, and in the process, I had caused more pain. I was met with blank stares. I watched the woman who had just made herself vulnerable to the group take a deep breath and move on without comment.

I was devastated. But this moment wasn't about me. There was bigger pain in that room. It was not the time to worry about defending my own self-image or ego.

I had spent years of my life exploring conversations around difference and bridging divides. I felt like I had nurtured a healthy sense of empathy and compassion—a willingness to listen—but still, there was so much that was outside of my experience and beyond my grasp. It's almost as if you can have your eyes opened and think you understand a situation, and then at a later date, your eyes are opened wider. Being woke is not a destination; it is a never-ending process. It was a sobering morning on so many levels, and I came away understanding that there was much to be gained by simply listening and bearing witness.

* * *

Despite my desire to be a witness and ally, I often fell short. I returned to the Sojourners Summit for Change the next year with a fresh awareness of the issues—and promptly displayed my ignorance once again. My second year at the summit, we didn't install an exhibit, but we decided to gather stories from the participants in a studio session. I wasn't certain how it would play out, but I thought it would be interesting to photograph the people at the conference and, working off the round-table discussion from the previous year, ask them to share their own experiences around race. The specific prompt was *"When was the first time you saw issues of race manifest in your own life?"* The goal was to answer the question in twenty-five words or less, make a black-and-white portrait, and combine the image and words. By the end of the conference, we hoped to have a body of work that offered personal insight into the issue and could be used to encourage additional conversations.

Jeanelle, one of the participants, had written two very personal stories on a scrap of paper. She wasn't sure which one to use as her statement to accompany the photo, and she asked for input.

The first was *"In first grade, I told my friend, 'Black people can wear their hair in more styles than white people can.' She went home crying."*

And the second was *"As a little girl, my grandmother from Mississippi told me, 'Don't trust white people. You can trust Jews, but not white people.'"*

I read through both passages quickly. My exact words escape me, but in my haste, I said something along the lines of *"I like the second one because it sounds like the sort of dumb generalization a white person might make, and clearly white people don't have a lock on saying dumb things."*

I said that. About her grandma. And even as I heard the words coming out of my mouth, I cringed. I thought, *Oh, dear God, that is* not *what I was trying to say.* But it was too late. The words came out. The damage was done. I could instantly see the hurt in her eyes—the disbelief at what she just heard.

I was in a hurry. I was tired and a little unfocused. But that doesn't matter. It was inconsiderate, and the damage was done. I apologized, but it was clear that it didn't stick. This woman had allowed herself to be vulnerable. She had taken a risk by sharing deeply personal stories with a total stranger, and I had not honored it. In fact, I had trampled on it.

"*She grew up in Mississippi,*" Jeanelle said flatly. "*She had a lot of reasons to not trust white people.*"

"*I know,*" I said as I felt particularly and conspicuously clueless.

Here I was at a conference about bridging divides, with a project built around bridging divides, and I had just driven a goddamned wedge between myself and another lovely human being in the span of one thoughtless comment.

We fumbled our way through the photograph, but I wanted to crawl into a hole. My first thought was *Good Lord, get me out of this situation,* followed quickly by *I hope I don't see this woman again during the conference . . . how embarrassing.* My third thought—and the one that should have entered my mind first—was *I'll have to do something to try to fix this. Or at least to own it.*

It was too late. Jeanelle had moved on, and I had lost her in the crowd. The entire conference was headed into a general session, and she had already disappeared into the auditorium.

A part of me wanted to let it go, but I knew I couldn't live with that. If the goal of *A Peace of My Mind* was to connect people and the actual process had just pushed someone away, I needed to address it.

I set up my laptop at a table just outside of the main conference hall to do some editing. An hour later when the session was over, I waited for the room to empty and saw Jeanelle walking toward me.

"*Do you have a minute?*" I asked, and she sat down. I was nervous. She was measured. Most likely, she had justifiably sized me up as a jerk.

I told her that I recognized I had chosen my words poorly. I explained that the thing that came out of my mouth didn't really even reflect the way I understood the world. "*It's the antithesis of everything I am trying to do with my work,*" I said. "*I know you don't owe me any forgiveness or acceptance, but I hope you will hear me when I say that, like you, I was horrified at what I said to you earlier, and I knew the minute I opened my mouth that it was thoughtless and hurtful. I'm so sorry.*"

Jeanelle's posture softened, and she offered me some tentative grace. We kept talking. That moment opened a ten-minute conversation that ended with a hug, and we both felt a little more whole and connected as we crossed paths for the remainder of the conference.

* * *

Too often, these small conflicts are brushed aside. Justified. We simply move on and ignore them, but when we do, the harm is left to linger, smolder, and chafe, getting in the way of future engagements.

Soon enough, we learn to retreat from situations that *might* be difficult in order to avoid something that *might* go bad. We insulate ourselves from the bad we fear might happen, but in the process, we deny ourselves the opportunity to experience the potential good.

Jeanelle and I met for coffee a few months later as she passed through Minneapolis to visit family. We revisited the conversation. We laughed, and we moved on to talk about other things. I'm not saying we changed the world, but we also didn't leave a wound to fester and perhaps ripple out in other ways for days and years to come. I'm also not saying I didn't still feel shitty. I still cringe when I think about that stumble. Addressing the issue didn't make it go away. It's not a magic eraser. But it feels right to face it and learn from it. It lets the other person know that you recognize you made a mistake. And that matters.

Since that day at the Sojourners Summit, I continue to read, learn, and understand more about white fragility, allyship, and microaggressions. As a white person, it's easy to gloss over these uncomfortable moments. They don't impact my daily life, and I'm not forced to navigate them on a regular basis. It's the very definition of privilege. But what is the larger cost in society? It's painful when someone knowingly hurts you. But it is just as bad—or possibly worse—when someone is blissfully unaware of the damage they inflict. To be an ally—to be actively antiracist—requires us to acknowledge, address, and resolve the wounds that we inflict or the ones that we allow to fester around us.

CHAPTER 18

OFFER GRACE

Listening, acknowledging pain, recognizing blunders, accepting responsibility for mistakes. The lessons I was learning around race rippled out into other aspects of my life. I had the chance to explore these ideas in a different way with Deanna Thompson in Saint Paul, Minnesota. She had been in the audience when I spoke about *A Peace of My Mind* at a local church, and she introduced herself afterward.

Deanna was diagnosed with stage-four breast cancer at forty-two years old, and it had metastasized into her bones. Her doctors said she had fewer than five years to live, but I interviewed her six years after the diagnosis. She attended our book release party eight years past her diagnosis, and when I saw her again recently for coffee, she was doing well a full decade after she learned about the cancer in her body.

Deanna talked about the awkward conversations around her diagnosis, but her story resonated across the broader spectrum of difficult subjects. Where she says *cancer*, you could insert the words *race*, *faith*, or *politics* or any other difficult subject, and the same notions would be true.

"There's a hunger for people to have real and deep conversations about cancer but also just about the suffering that we go through in life. I don't feel like we have enough spaces in our culture to really dig deeply into those experiences. We have pat responses, and often we don't know what to do when we ask somebody how they're doing and they don't say, 'Fine, thanks. How are you?'

"We shy away from those conversations because we don't know what to say. We worry that maybe we shouldn't bring it up because the person doesn't want to talk about it or doesn't want to think about it. We're afraid we're going to say the

wrong thing. For those of us living with cancer or going through other awful things, a lot of times, we don't have words to describe what's going on, and so those conversations are difficult."

We met at her home in Saint Paul and sat at a patio table in her backyard on a glorious summer day. A pedestrian walkway passed behind the hedge on her property line, and our conversation was accompanied by the sounds of children riding their bikes and neighbors walking their dogs. The life I heard in the neighborhood reflected the life I saw on Deanna's face. Although she talked about the anxiety of upcoming doctor appointments and the ever-present possibility that the cancer could return, she was healthy. She was vibrant.

At the time, my own father was struggling. Years of smoking had caught up with him. He had remained in my childhood home for a full decade after my mom died, even though she had been the homemaker and he lacked many of those skills. Karen cooked meals and stocked his freezer. Neighbors checked on him and brought in his mail. He started utilizing some of the services he had implemented during his long career as the county human services administrator. We hired a cleaning lady. But dementia started to creep into his world, first manifesting as forgetfulness and eventually progressing to the point where it was clear he wouldn't be able to stay in the house.

There were difficult conversations about to happen in my own family around him giving up his car and moving out of his home, and as I interviewed Deanna, it was as much for personal understanding as it was about the project. I asked her how she creates space for the most challenging conversations and why it can be so difficult to navigate them.

"One of the things I stress is that there isn't one right thing to say. There is not a list of things you should absolutely always say and a list of things you should never say.

"Sometimes you have to say, 'I'm sorry. I just don't know what to say' rather than saying nothing. If you know that someone has just lost their father or whatever it is, then likely, there is some level of it being public. If it's public, risk asking about it. It's harder when people don't acknowledge it and pretend that everything's fine."

All of these conversations come at an emotional cost. When you open yourself up to someone's honest pain, it's going to impact you in some way. We tend to shield ourselves from that. We insulate ourselves from the most difficult

conversations, and as a result, we skate along the surface. We think that we are doing ourselves a favor, but in the process, we deny ourselves the opportunity for deep and authentic relationships.

These interviews are no different. I carry with me all the weight of the sorrows and joys of each interview. It is hard to do more than one in a day because I've learned that I need the time to process the emotions and the new perspectives. But it's a price I gladly pay to experience the connection and humanity of each conversation. It's how I feel alive.

Our conversation shifted away from her immediate health situation to how her journey with cancer has allowed her to understand dialogue around sensitive issues more broadly.

"Issues of race, interfaith dialogue, tension or conflict, and conversation—these things are also really hard. It's hard to be vulnerable. It's hard to try something out when you're not sure if it's the right thing. My experience with being on the receiving end of a lot of conversations where people are trying to figure out what to say is that I really appreciate the honest attempts at making a connection.

"We're really hard on each other for not getting it right. It's not that people don't say stupid things. They do. But I know that I've been that person who has said something that's missing the mark—whether it's about someone else's grief, whether it's about someone else's religious beliefs that I don't know much about, or whether it's about someone who is from a different background than I am. I've made mistakes, and so I get uncomfortable with some of the conversations about how those of us with cancer are above ever saying anything wrong.

"It doesn't mean that people don't say bad and hurtful things, but I'm hoping we can have a little bit more grace in dealing with each other, that those of us living with serious illnesses can be graceful in our responses to people who mean well but say something that hurts, and that people can be gracious with us when we try to step out and say something that offends people in return."

Grace. It's a word that seems absent, or at least rare, in our public life. We are quick to judge, posturing for the chance to reply and decry. Our collective resentment and wrath are boiling over, and we are looking for a place to aim them. People do say stupid things. That's true. But we have fostered a media landscape and an entire society that uses that opportunity to tear one another down.

I've come to believe that people bring their better angels to these interviews. They offer their best selves, and it's a powerful exercise. When we articulate the

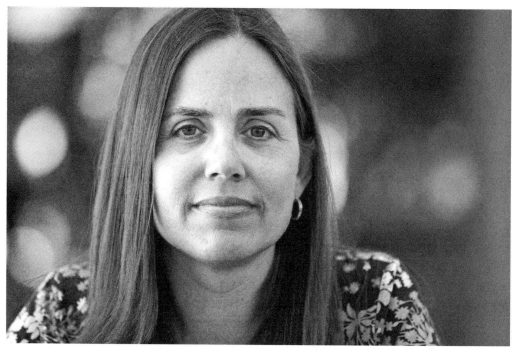

Deanna Thompson

moments in our lives where we have done well, we can elevate those examples and use them as our compass. It is important to aim high, but it is also helpful to recognize when we fall short of the mark and admit our human failings without beating ourselves up too badly. Grace goes both ways.

"When somebody says something to me that I don't agree with or is misinformed, on good days, I might try to offer a different perspective, like 'Here is why I don't think God gave me cancer,' for example. 'Here is why I don't share that particular perspective.' I'm an educator, so often, on good days, I'll try to adopt the educative response, maybe try to teach a little bit: 'Here is where I see some problems with that viewpoint.'

"You can't always and don't always have the energy or time to reeducate, so sometimes I just take it and think that the person had good intentions and let it go.

"I really do believe that most people most of the time aren't intentionally trying to be hurtful. When I keep that in mind, that's helpful rather than just thinking about how it felt or sounded to me, but rather to say, 'If I didn't have stage-four cancer, I'm not sure I would know what to say to me either.'"

Life is hard. Facing the end of our lives—or the lives of those we love—can be particularly hard. Through Deanna's story, I understood that grace can make it a little easier. As I began a difficult journey with my dad, Deanna helped me understand that there was no road map. There was no set of instructions, but we could forge ahead anyway, asking for grace when we stumbled and offering it when it was needed. It's a lesson that goes far beyond her diagnosis.

CHAPTER 19

FORGIVE

I've always understood forgiveness to be every bit as liberating for the forgiver as it is for the forgiven—maybe more. I'd played with the idea for years but always had trouble articulating it clearly.

In January of 2013, I was hauling an exhibit to install at New York University, and I drove past the exit for Newtown, Connecticut. It was just weeks after the shooting at Sandy Hook Elementary School. There were small flags for each of the victims arranged in the snow beside the exit. I hadn't paid attention to my exact route, and I hadn't seen it coming, so it all caught me off guard. Suddenly, it became very quiet in the van.

I knew instantly that I wanted to interview someone who had been touched by public violence, but I also recognized instinctively that I didn't want it to be Sandy Hook. The trauma was too new. The shock too immediate. I felt like the families were being pulled in front of the media for sound bites and were getting a little beat up in the process. I wanted something with a little more time and perspective, but I didn't yet know what that should be.

A few short weeks later, as I planned a trip through the Southwest, I traced my route on the map and saw that on my way to Dallas, I would pass by Oklahoma City, whose darkest day unfolded when Karen was six months pregnant with our son, Jordan. At 9:02 a.m. on April 19, 1995, Timothy McVeigh and Terry Nichols blew up the Alfred P. Murrah Federal Building in what is still the largest single act of domestic terrorism our nation has ever seen. Like the rest of the United States, I remember the news footage of the scene. I was moved and devastated by the photograph of firefighter Chris Fields carrying a bloodied child toward medical care in the aftermath.

It was going to be a process to find someone connected to that day. A friend's mom knew Carol Hamilton, the poet laureate for the state at the time of the bombing. I called Carol and we connected, but she was going to be out of town when I passed through. She offered some names of families she knew who had been touched by the tragedy, but many of them had tired of telling their stories. They wanted to move on, and reciting the traumatic history made forward progress too difficult. Finally, someone suggested I reach out to the Oklahoma City National Memorial and Museum, and they were willing and able to connect me with Bud Welch.

Bud's only child, Julie Marie, graduated from Marquette University in 1994. She was fluent in five languages and was offered a job that August as a translator for the Social Security Administration in the Federal Building in Oklahoma City. Eight months later, Timothy McVeigh and Terry Nichols blew up the building. Julie Marie and 167 other people died that day.

Bud Welch fell apart. Of course he did. He became an alcoholic. His business struggled. Although he had been opposed to the death penalty all his life, that conviction faltered. He really wanted nothing more than for Timothy McVeigh to be executed so he could try to pick up the pieces of his life and move on.

I met Bud at the Oklahoma City National Memorial and Museum. A media representative for the museum had helped make the connection and offered a large, empty event space for the interview. I was set up at a folding table in the center of the room and had just finished replacing the batteries in my recorder when Bud walked through the door. I was nervous to meet him. I wasn't sure how to begin a conversation with a stranger about the tragic death of his child, even though we both knew that's where the conversation would lead.

Bud was kind. He had been sharing this story of his life for years, and he took the lead in the conversation. We sat across from one another at the table, and he began. Before meeting Bud, I had taken time to explore the museum, and I had seen portraits of each victim, so as Bud started talking about his daughter, I could picture Julie Marie's face.

"I gotta say, after her death, I was so full of anger and so full of revenge that once Tim McVeigh and Terry Nichols had been arrested and charged, I didn't even want a trial for the bastards probably for a month. I just wanted them fried."

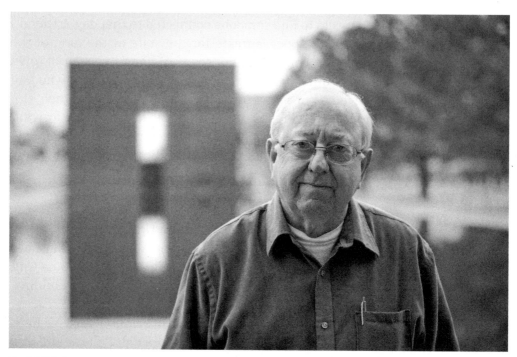

Bud Welch

Bud had run a gas station in town. When you are a small-business owner, you have to find a way to keep going even in the most difficult times. I understood that from the loss of my own mom, even though our circumstances and specific experiences were profoundly different. Bud talked about his routine and how he struggled through the grief process.

"I came to the bomb site every single day after Julie's death. I remember it was about the last day of January of '96. It was a cold day, about three in the afternoon, and I was standing across the street from where the Murrah Federal Building had once stood. The building had all been cleaned up, and there was a chain-link fence put around the footprint of the building. I was standing under what we now call the Survivor Tree across the street from the building.

"My head was splitting from abusing alcohol the night before, every muscle in my body ached from alcohol poisoning, and I went to asking myself a series of questions that afternoon. What did I need to do to be able to move forward? What I was doing simply was not working. It was like I had this basket in front of me. And I had Tim McVeigh's life in it, I had Terry Nichols's life in it, I had all this alcohol in the basket—and tobacco—I became a heavy smoker at the time.

"And there's three questions that afternoon that stuck in my mind: Do you need trials to begin now? (The first trial didn't start for twenty-five months.) Do you need convictions? Do you need executions?

"I struggled with those three questions for probably twenty or twenty-five days. They were on my mind almost all the time. And I finally came to the conclusion that the day we would take Tim McVeigh or Terry Nichols from their cage to kill them simply wasn't going to be part of my healing process. I was able to clearly understand that. Then I stopped the abuse of the alcohol. I stopped smoking. And I started doing some positive things to put my life together."

Bud saw a news clip of Timothy McVeigh's father on the television, and he thought, *That guy is as wrecked as I am.*

Bud told me, *"He turned and looked directly into the lens of the television camera for about two seconds, and when he did, I could see a deep pain in his eyes— the same pain that I was living through at that same moment. And I knew, in spite of what I was going through, that someday I needed to go tell that man that I truly cared how he felt and did not blame him or his family for what his son had done."*

It took more than three years, but eventually Bud found the courage and the opportunity to do just that. Bud had gone on the lecture circuit, sharing his

experience of loss and forgiveness, and one talk brought him to Buffalo, New York, near where Bill McVeigh lived. Sister Rosalyn, a nun who worked in prison ministry, arranged the meeting. Bud prepared for it by learning what he could about Bill.

"I learned that Bill was a shy person, that he didn't talk much. But I learned also that Bill had a hobby that he loved to do every summer, and that was raise a big garden in his backyard. He lived on about an acre and a half of land, and he raised a garden that was about three-quarters of an acre. He let neighbors come and pick the veggies as they chose. He's real proud of that garden.

"The next morning, when Sister Rosalyn took me out to his house, I remember he had a doorbell, but I didn't use it. I knocked. And I knocked kind of softly. He came to the door, and after I introduced myself, I said, 'Bill, I understand that you have a nice garden in your backyard.' Well, this guy's face lit up. He got this big smile on his face, and he didn't seem the least bit shy to me in that moment.

"He said, 'Yeah, would you like to see it?' I said, 'I'd love to see it.' I knew when I was following him through his garage to his garden that we'd find common ground. We went out there and spent about thirty minutes. He's kind of kicking dirt clods around, and we're getting to know one another. He invited me into the house, and as we were walking to the house, he told me that his youngest daughter, Jennifer, was there. He said, 'She learned you were coming, and she wants to meet you.'

"I'd seen Jennifer in the courthouse on three or four occasions, but I had never met her. I actually rode on the elevator with her one time. And so we walked in the back door into the kitchen. He introduced me to Jennifer, and the three of us sat at the kitchen table. It was a round table, and Jennifer sat across from me and Bill sat to my left. The table's pushed up against the wall on the right. I noticed some family snapshots hanging up above the kitchen table. It was of his granddaughter that lived in Florida and his other kids and relatives. And after we were talking there for about five or six minutes, I noticed that the biggest photo was right above my right shoulder and behind me just a little bit, and it was an eight-by-ten of Tim.

"Well, during this next hour and a half or so, I'm quite frequently glancing at that photo of Tim up on the wall. I'm not looking at it with anger or anything like that. I'm looking at it more inquisitive, trying to figure out how this young man could have killed my daughter, who was only three years younger than him. My thought was that they were both Roman Catholic. If they had been raised

around one another, they could have even possibly dated. And so I was just . . . I was puzzled.

"Well, after a while, I started feeling self-conscious, and I caught myself look-ing at it and felt the need to say something. I didn't have a clue what to say. I just looked at it, and I said, 'God, what a good-looking kid.'

"Well, you've heard it said that the silence was deafening. The only thing you could hear in that kitchen was the refrigerator running. And everything else was quiet. And after this long silence—Bill—well, Bill had asked me when we were in his garden, he said, 'Bud, can you cry?' And I thought, Why is he asking me this question? *And I said, 'Yeah, Bill, I can. And I usually don't have much trouble doing so.'*

"He said, 'All of my adult life, I've been unable to cry. My father was much the same way.' And he said, 'I've had a lot to cry about the last three and a half years, but I just can't do it.'

"Well, after this long silence ended at the kitchen table, Bill looked up at the wall and he very simply said, 'That's Timmy's high school graduation picture.' But when he said it, there's this great big tear that rolled out of his right eye and down his cheek.

"I could see right then this father could cry for his son. That helped me so tremendously to meet him and go through that stage, if you will, of what I call restorative justice. Because at that moment, his son was in Florence, Colorado, on death row, and I simply didn't want to see him die."

There was a tear in Bud's eye as he spoke, though it never fell. Mine did. The event space had transformed into sacred ground as Bud shared his journey. As we sat across from each other, two small humans swallowed up by the enor-mity of the space and the enormity of the story, Bud explained how he started working against the execution of Timothy McVeigh even though he ultimately wasn't successful in that effort.

"On June 11, 2001, a Monday morning at 7:00 a.m., we took Tim McVeigh from his cage in Terre Haute, Indiana, and we killed him. And there was nothing about that process that brought me any peace or any feel-good. In fact, I actually felt revictimized.

"Another thing happened that day, and now Bill McVeigh and I had one thing in common. We had both buried our children. They died in very different ways, but we had both buried our children. You know, when your parents die, you go to the

hilltop and you bury them. When your children die, you bury them in your heart, and it's forever. It never goes away.

"But if you can get through some of the healing process without retribution, it's the best way to be able to heal."

Bud talked about the transformation he noticed in himself.

"Before Tim's execution, starting about June of 2000, I started having these feelings that I was forgiving, and it went on probably for five months. I really had the feeling that I had forgiven both Tim McVeigh and Terry Nichols. And when you finally reach that feeling, it's not an event. It's a process, and it takes time. I don't know how to teach that, if you will. But I know that I went through it. I can tell you one thing: If you're able to forgive, it doesn't do a damn thing for the killers. You totally release yourself. That's where the good comes from."

Since that time, Bud has traveled the world working against capital punishment, having realized that he got no relief—he got no sense of peace—from the loss of one more life.

I've never been in Bud's shoes, and it's hard to imagine how I would respond if I were, but when I hear Bud's story, I have to ask myself who I can forgive in my life and how it might free us both up if I did.

CHAPTER 20

TRY AGAIN

It's a three-hour drive from Oklahoma City to Dallas / Fort Worth Airport. The previous day's interview with Bud had been emotional, and I woke still holding the weight of it all. It was Jordan's high school spring break, and he had agreed to meet me on the road for the second week of this trip. I was scheduled to pick him up later that morning, and he was standing at the curb as I pulled up.

We aimed to drive northwest with plans to stop at the Cadillac Ranch outside of Amarillo, Texas. We squeezed in little moments of fun as we could.

In 1974, a small collection of artists known as Ant Farm buried ten Cadillacs in a row, nose-down in the dry earth of a Texas field, with tailfins pointed toward the wide-open skies. You can drive there, walk through an unlocked gate, and wander around. Climb on them, paint them if you'd like, or leave your own mark in your own creative way. The artists encouraged that sort of inter-action with their creation. It is the stuff of a teenage boy's dreams, and I had stopped the day before at a hardware store for a few cans of spray paint. Jordan and I explored the Cadillac Ranch under the hot Texas sun and tagged one of the cars with a bright-red peace sign before getting back on the road.

Our destination for the night was Las Vegas. Not the one with bright, shiny lights in Nevada, but the small, dusty town with the same name, just east of Santa Fe, New Mexico. There, a friend offered lodging and some logistics help.

But before Cadillac Ranch had even faded in our rearview mirror, there was another sight approaching us from the south: a billowing, brown cloud hung low on the horizon—a dust storm. Within minutes, it grew into a wall that loomed over us. There was no place to hide.

As the cloud overtook us, visibility abruptly reduced to a hundred feet—then even less. The afternoon sun gave way to an eerie, deep-brown gloom, and

the wind blew grit over and into our car. Instantly, traffic ground to a halt, and as frustrating as it was to be stopped, I was glad to be nestled in between the semitrucks that idled all around us for some sort of protective buffer.

The wind took hold of our car and shook it. We watched ribbons of sand twist across the hood. There was a fine grit in our teeth. It was a long hour before the storm let up, but even then, traffic didn't move. A second hour passed, and another began. Finally, cars started turning off the freeway and driving across a scrubby field toward a frontage road. We did the same and a hundred yards up ahead saw that more than a dozen semis had jackknifed and collided to block the entire interstate. Had we left the Cadillac Ranch a few moments earlier, we would have been in their midst.

Just another hundred yards ahead on our left, we saw an enormous feedlot that stretched on for acres, and it slowly dawned on me: That dust cloud that shook our car, that grit we held in our teeth—it wasn't just dust and sand. It was also poo. Welcome to Texas.

As the dust settled, Jordan and I kept driving west toward New Mexico. I'd met Pat Leahan in 2011 at a Memphis conference for the Peace and Justice Studies Association. Pat ran the Peace and Justice Center in the small town of Las Vegas, New Mexico, and in 2012, she interviewed me for their community radio station and podcast. During the interview, she mentioned an upcoming silent auction that served as their annual fundraiser, and I offered one of my books as a fundraising gift. Pat said if I was ever coming through the area, she would love to help out with the project, and now I was taking her up on that offer.

This journey truly was a series of cobbled favors from friends and kind hospitality from strangers. During this visit, she helped coordinate a talk for me at the local campus for United World College. She connected us for a couple of interviews in the area, and she offered free room and board at her home. I was given the guest room, and Jordan got a pair of energetic lab-mix dogs on the foldout sofa bed. The next morning, Jordan and I set out to meet Hassan Ikhzaan Saleem, who told me in emails to just call him Ikhzaan.

The ranch where he lived and worked was hard to find, he explained in his messages, so we chose the intersection of two nearby highways where we could meet, and he would lead us the rest of the way. As Jordan and I waited, a dusty

pickup truck pulled up beside us, window rolled down, and the young, dark-skinned man inside leaned out: *"Are you John?"*

"I am."

He extended his hand and we shook. *"Follow me."* And we were off. We followed a series of increasingly smaller paved roads up the dry mountainside and eventually onto a gravel drive that wound through the ranch property and stopped at a modest house that sat beside a functional barn, nestled into a landscape of ponderosa pines and broad, scenic views.

I knew a little bit of Ikhzaan's background based on what Pat had mentioned, and it occurred to me that he might be the only Maldivian cowboy in the world. He was certainly the only one I had ever met. The Maldives is an island nation off the coast of India. It is one of the lowest-lying nations on earth, with an average elevation of four feet above sea level. So as climate change does what climate change is going to do, the Maldives will be one of the first nations affected.

As he was growing up, Ikhzaan had never seen a horse, but he developed an inexplicable love for Louis L'Amour novels and John Wayne movies. Every year, Ikhzaan's father would give him a toy horse for his birthday, and every year, the toy horse would be a little bit bigger.

Eventually Ikhzaan signed up for an exchange program through United World College, and he participated in a home stay with a family outside of Las Vegas, New Mexico. The family owned a ranch, and Ikhzaan not only saw horses, but he learned to ride them. He not only rode horses, but he learned to train them in the Vaquero style, a traditional Spanish style of training horses with a distinct absence of strict deadlines and goals.

I'll admit, at times I wonder where these conversations will lead. I question why I am talking to a horse trainer about peace. Or a shrimper. Or a sculptor. But wait long enough—talk long enough, ask the right questions—and without exception, people reveal beautiful stories and rich insights that make the answer perfectly clear. Peace is personal. We bring unique experiences to our understanding of peace, and for Ikhzaan, it can be accessed through his work with horses.

"When I was getting into horsemanship, a great cowboy and horseman said to me, 'If humans were like horses, there'd be more peace on earth. A wild horse— a feral horse—is being chased by a mountain lion. It's running one hundred miles an hour, and the mountain lion gives up and lets it go. The horse doesn't just

stop and go back to grazing. The horse stops, gets down on the ground, and rolls in the dirt. It makes a transition.'

"'If humans would take the time to make the transition between their lives when they're doing things, there'll be more peace on earth,' he said. I've always remembered this, and I try to apply that to my life.

"So whenever you get frustrated, it's OK to lose it, but just remember to transition out of it. Forget everything at the end of the day. It's done."

Ikhzaan supported this theory with a story of backpacking with his friends in the mountains that surround the ranch.

"We were doing what's called Skyline Trail in the Pecos, where we go from mountaintop to mountaintop without coming in. And it's just out there, over the exposed tree line, and it's windy and snowy and you get tired and you're carrying a hundred-pound pack and you're aching for four to five days out there and you lose it. You get mad, you argue with your teammates, and you argue with your partner.

"But the moment where the trail ends and you come downhill, you're like, 'Wow, we did that.' You know, you look back and say, 'Thirty miles of high country, we just did that,' and then you give everything else up. 'Yeah, you were lazy setting up that tent,' 'You didn't do dinner' . . . it all goes away.

"Yeah, bad things happened. Some people were lazy, and it wasn't all fair, but you only talk about the good stuff. That's peace to me."

But it doesn't always work that way, I pressed. Sometimes the obstacles are just too big.

And Ikhzaan replied, "In a sense, everybody's your brethren. It doesn't matter if you're from the United States or the Maldives. These imaginary lines on maps and these pieces of paper that say you are this and I am that—it doesn't matter because we're all the same. We have a relationship with humans, the four-legged, the trees, the earth.

"I'm not Mahatma Gandhi. I'm not Martin Luther King Jr. or Nelson Mandela. My parents said to me, 'You might never change the world, and you might never see the change you want to see, but at least you tried. At least you can be accountable.' So that's why I try.

"And that's the goal. One day, there will be peace. Maybe I'll not live to see it, and maybe my kids won't live to see it, but we tried. That's why we do it again and again."

<center>*　*　*</center>

We finished the interview and went outside to explore our options for the photo-graph. Some settings have very little to work with, but this location was like a visual candy store. Ikhzaan put on his hat, a well-worn, light-colored felt hat with a braided leather band. He added a tan insulated vest and a red bandana against the chill of the morning. He saddled up a horse. He rode the horse, stood beside it. The photos were fine, but it wasn't yet what I wanted. The sun was bright, and I struggled with the lighting, especially the heavy shadow that the brim of his hat threw across the dark complexion of his face.

Ikhzaan got off his horse. The animal was tired and completely uninterested in my photo shoot, choosing instead to snack on the grass growing at the base of the fence. The horse's head stayed down and below the edge of the frame. Ikhzaan called the horse's name, and it raised its head briefly, but I missed it. We tried again. And again. And again. When the horse looked in the right direction, Ikhzaan didn't, and vice versa. It was clear the horse was losing interest in the game, and he simply stopped playing.

Maybe Ikhzaan was losing interest as well. The entire process was taking too long, and everyone was ready to be done, but the magic shot hadn't happened yet. I asked for Ikhzaan's patience. I asked for Jordan's help. He picked a hand-ful of sweet, green grass and stood in front of the horse, just outside of the left edge of the photo, and he held the grass up high. It got the horse's attention—it raised its head and perked up its ears, and the shot was perfect. I could see it through the lens, and I pressed the button.

"There it is," I said. *"That's what we were waiting for."*

I showed Ikhzaan the image on the back of the camera, and he approved. The small details make all the difference, he agreed. And that's why we do it again and again.

We returned to Pat's house, where she had prepared a simple meal of soup and bread for us. She opened a bottle of Jameson. She had invited a few friends over, and as the evening passed, stories swirled of the various protests, vigils, and actions that Pat had led and been a part of over the years. Eventually, the hour was late, and the Jameson was gone. Jordan and I had to leave early in

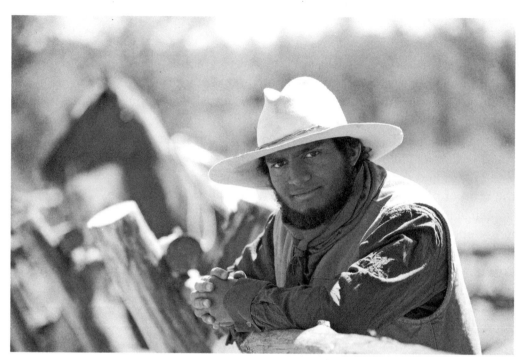

Hassan Ikhzaan Saleem

the morning to get to our next stop, so I headed to the guest room, and Jordan settled onto the couch with the dogs.

I'm not overly social in the morning, so it was a quiet routine of coffee and packing the bags until we stood beside the car. My grandfather had taught me never to say goodbye. *"Until we meet again,"* we said to Pat and watched as her house faded in our rearview mirror.

We left Las Vegas sooner than we wanted. Some places were so comfortable I could have stayed, and this town was one of them. The pace was relaxed; the people were warm and welcoming. But I'm sure, given enough time in the place, I would get restless there too. I'm wired that way, and sometimes it's better to leave when you are still in love with a place. We moved on to Santa Fe. We visited the Pecos National Historical Park. We made a side trip to Four Corners National Monument and sprawled out on the marker with a limb in each state for photos to text home to Mom once we found a strong enough signal. But this was a road trip with a mission. There was more work to do, and we kept moving.

CHAPTER 21

FIND YOUR GIFT

The road into Shiprock, New Mexico, was flat, dry, and barren. The geologic formation that gives the area its name is a weathered volcanic plug that now rises 1,500 feet above the surrounding land and is visible for miles in any direction. The monolith has traditional and cultural significance to the Diné (more commonly known as Navajo) people, and according to oral traditions, it is at the center of their existence in that area.

The land is sacred geography, and the formation is called Tsé Bit' a'í, or "rock with wings," alluding to the traditional story of a great bird that delivered the Diné people from a warring tribe in the north to the current Four Corners landscape.

The Diné language has an oral tradition, and there was no standardized written alphabet until the 1940s. Even now, traditional stories are being documented and written down to preserve their cultural heritage.

I recognized that my first book didn't include any Native American voices. In fact, it was someone with Native American ancestry who had pointed out the omission to me. Hudlin Wagner, on page thirty-four of our original book, claimed a tricultural background of Black, Native American, and West Indian heritage. As I planned my southwestern route, I wanted to be intentional about inviting more voices in and continually broaden the scope of *American Stories*.

The law of averages suggested my odds were better by pursuing multiple possibilities to find the right person to talk with, and that's what I did whenever possible. The more diverse the perspectives, the more enlightening the stories would be, and I defined diversity in broad terms. I wanted academics and activists, artists and accountants, accordion players and almond farmers.

So in one state, I would ask for help from a human rights organization, and in another, I might reach out to a storytelling association.

In this case, I called a roadside gas station and gift shop, asking if there were any local artists they could introduce me to. I also found a four-year college in Arizona—aptly named Diné College—to connect with someone who taught there. Online, the college spoke of fostering academic development rooted in the language and culture of the Diné people. I hoped that one of these paths would lead to an interesting conversation, and it turned out that both did.

The gas station told me they carried and sold the work of a Diné sand artist named Eugene Baatsoslaani Joe, and at Diné College, I connected with a woman named Sheila Goldtooth, who taught Diné culture and philosophy and also served as a traditional healer for her community. I invited both to be a part of the series, and they both said yes.

Through my years as a photographer and with this project in particular, I regularly put myself in settings where I didn't fit in. I found myself in places where I was unfamiliar with the expectations and heavily dependent on the grace and hospitality of the people I encountered.

I had photographed Winona LaDuke in her vice-presidential bid with Ralph Nader and later, with her efforts to preserve, cultivate, and market traditional foods for the Mississippi band of the Anishinaabe. She has since been active in environmental issues, including resistance to the Dakota Access Pipeline.

I had documented the efforts of Peter Hill, a white Carleton College graduate who lived in deep relationship with the Oglala Sioux of the Pine Ridge Reservation. The tribal elders invited him to teach their traditional language to the local high school students because there was nobody else available to do it. In both cases, I had the benefit of the trust of the people I was photographing.

In other circumstances, I had encountered difficulty and misunderstanding. I tried once to produce a series of portraits and stories with a small tribe in Wisconsin. The very few tribal members who still spoke the language were aging, and I hoped to document them. The council asked me to write a proposal, and I did. They asked me to drive over and appear at one of their regular meetings, and I did. I could sense the hesitation in the room, and I offered to give them the copyright and full use of the images, but in the end, the answer was no.

I simply wasn't the one to do the project, and I had to be OK with that. I believed in being persistent, of course, but at a certain point, the correct response is to say, *"Thank you for your time,"* and move on. In the history of our country, there was no reason for their community to trust people who looked like me. People who looked like me had lied to them, stolen from them, broken agreements, and worse. I examined my intentions and tried to assure myself that they were sound. I tried to assure them as well. I hoped they could use the work as they sought grant funding to study and preserve their language. I hoped to offer it as a gift, and I couldn't imagine how it could be seen any other way. But the "gifts" this community had received over the years had always come with strings attached. There are historical currents that shift and shape our modern exchanges, and we need to be aware of them if we are going to be able to navigate with grace, compassion, and effectiveness.

Eugene Joe had quickly agreed to the interview, and Jordan and I followed the directions to his home on the edge of town. The road faded from asphalt to gravel and then to a soft and powdery sand. Soon it wasn't really a road at all but two thin tire tracks through the arid land. I could see the house that Eugene had described, and I followed the fence line until we arrived. Eugene was waiting on a lawn chair in his front yard to greet us.

The house was a modest ranch style, and he invited us inside to set up. I was nestled into a comfortable brown sofa, and Eugene was in an armchair across from me. The curtains were drawn against the harsh desert sun outside. We made small talk as I set up my gear, and as we began the interview, I intended to ask Eugene about his art, but he beat me to it.

"A lot of people ask me, 'How did you find your gift? How did you know you had talent?' And I say, 'You don't find your gift overnight.' Your elders are great teachers. They guide you into your manhood or your womanhood."

That sand art that Eugene produces is rooted in healing ceremonies and communication with the gods. Often created on a flat piece of earth outdoors, Eugene's work is composed on small slabs of stone or thin board. Later in the day, I watched him funnel small streams of colored sand onto a layer of glue to adhere the sand as he worked in his small studio.

"That was part of my grandfather's task with me. In the time of wagons and horses and dirt roads, my grandfather used to tell me, 'Go on that hill.'

"That's where my discipline began. At the time, I was barefoot all the time, wearing an old, dirty T-shirt and running around my grandfather's estate. He told me to sit out there and meditate and focus on my life. He told me, 'You have a gift that's inside of you. Go there and find it.' And I said to myself, 'Out here in the desert?'"

Eugene laughed and then continued.

"He told me, 'Always focus on going forward. Never look back until there's white hair on your head.' I didn't know what he meant at the time, but later, I began to understand.

"And so I would sit up there, maybe for three or four hours. My first task was to ask myself, 'What am I doing here? I'm a child. I'm supposed to be out there playing with children.' Black Elk said our children were mature when they were the age of seven, and they were men at an early age. And so we teach them to be disciplined, to become men, to face the reality of life."

The ritual of Eugene's work resonated with me. The calling was familiar. And the discipline to remain focused on the eventual goal expanded my understanding of peace.

"Sitting there, the first thing I thought about was that I was afraid of ants, spiders, snakes, scorpions, and centipedes. Before I left the wagon, my grandfather said, 'Don't think of things that surround you that will interfere with you. Focus. Focus on yourself. Don't look at the ants. Don't look at the centipedes. Don't feel the heat that burns your skin. Become one so you learn how to face what surrounds you. And learn to overcome those fears.'

"Sitting there on the hill, I began drawing on the earth—and there was the gift. That's why I'm a sand artist. It was set before me. All I had to do was reach out and walk into it."

Although we sat in his living room for the interview, the more Eugene shared about his story, the more I knew I wanted to make his portrait outside. I asked if he would be willing to drive a bit to Tsé Bit' a'í, the dramatic formation that lent its name to the area, and he agreed.

I asked Eugene how he would like to end the interview, and he said this: "Everything is up to you. If you want peace in your life, you have to make that peace. If you want to be successful, you have to make that happen. If you want an education, you have to make it happen. It's up to us, up to the whole world itself to become one again. That's how I see it, and I believe in that."

*　*　*

Eugene Joe

A little farther west, I had lined up a meeting with Sheila Goldtooth at Canyon de Chelly the next day. As a photographer, what I knew of the area was rooted in the photographic work of Edward Curtis, an artist who documented what he perceived as a fading culture due to westward expansion of the European settlers. There is controversy around Curtis's work and the romanticized portraits he, a non-Native, created in the early days of the twentieth century. There is evidence that he was disturbed by the treatment of the tribes and the theft of their land, but that narrative doesn't necessarily come through in his work.

Our interview with Sheila was scheduled for the late afternoon, so Jordan and I filled the morning with a four-wheel-drive tour of the canyon, led by a young Diné guide, to see the landscape in a new way and hear a personal perspective on the history, perhaps adding bits of color to Curtis's black-and-white images that lived so large in my mind.

As we heard from our guide about growing up in the canyon, and as he pointed out the homes of the people he knew and the ones he was related to, the idyllic vision of Edward Curtis faded and was replaced by a human landscape of real stories and personal experience. We heard both the struggles of living in a remote landscape and the richness of a tight-knit community. It was a good transition into the afternoon's conversation with Sheila.

When I imagined traditional healers in the Diné culture, I most often thought of men, but Sheila challenged that notion. Sheila Goldtooth's interest in healing began at a very young age, when she watched her uncle serve the community as a traditional healer. *"The philosophy and the teachings were all a part of growing up,"* she said. *"Learning the ceremonies made a lot of sense to me, and I understood it at a very young age."* She apprenticed with him and now performs ceremonies and blessings for people to help bring them back into balance and harmony, particularly for young people who struggle with the tension, pressures, and competing demands of Western and Diné societies.

"We learn in our culture that everything is alive and sacred to us, whether it be the rock, soil, air, wind, animals, insects, reptiles, and so forth. Everything has a purpose for living on this earth, and we have mutual respect for everything that exists.

"Being in peace basically means being in harmony with everything that is out there, with everything that exists in Mother Earth and Father Sky. I always say that being wealthy is having a hogan with a dirt floor. No running water, no

electricity. That's being wealthy because you're as close to Mother Earth as you can be."

Jordan and I interviewed Sheila on the south rim of Canyon de Chelly, within sight of a formation called Spider Rock, a thin sandstone spire rising seven hundred feet above the canyon floor. Tradition says the tower is home to Spider Woman, who wove the universe into being and serves as protector of humanity. The location was close to the campground where we stayed and surrounded by the natural environment that Sheila spoke about. We sat on a rock ledge as the warm sun drew out the scent of the juniper trees that surrounded us.

"When you become a traditional practitioner, you don't have enemies," she continued. "Your enemies become your friends. It's an understanding of having harmony with everything and everybody. Those that do harm to you or that don't like you, you're still going to be at peace with them. In our way, we don't practice anything harmful; we just pray for everybody and everything.

"Western education teaches you to do things for yourself. You're going to be aggressive, and you're going to try to be successful. In our culture, yes, you're responsible for yourself, but you have to remember the people. You have to remember Mother Earth. You have to remember where you come from. It's not going to be just an individual thing.

"We had a system of peacemaking—well, let's translate it as peacemaking. People would talk about conflicts, kind of like a conflict resolution session. If people were in conflict, local practitioners or prominent people in the community would come and talk about whatever the situation was and how it was affecting the community. That is still an option that people have within our Navajo Nation court system."

I tend to move quickly. There is an urgency and determination to my days that I don't even notice until I am confronted by a slower pace. There was a patience that was palpable with both Eugene and Sheila—a deliberate and expansive view of the land and the way we move through it that echoed the broad and dramatic environment that surrounded us.

When we slow down, it becomes easier to see connections—to one another and to the earth. Both Eugene and Sheila spoke of a close connection to the earth, and that resonated with my own love of nature. But these stories went

beyond that love and embraced a deep relationship with the natural world. The interdependence. The healing power of that deep relationship with the earth and all the creatures of it.

That ever-present sense of connection was key to my understanding of peace. Each action rippled out and impacted others. Each person was a part of an intricate web that holds us together.

CHAPTER 22

WORK TOGETHER

I sat at our dining room table with a map spread across it. I'd just booked an exhibit in Atlanta at the Breman Museum for Jewish Heritage and Holocaust Remembrance. During the display, they wanted me to be on-site for a day of programming, so it was the perfect time to build out a road trip to gather new stories. August was not my preferred time to visit our southern states. I'm no fan of heat or humidity, and down south, they have both in excess. But there was a window of opportunity, so I opened my well-worn Rand McNally *Road Atlas* and started imagining possibilities and plotting points along the route.

The museum was the first fixed point on the map, and they offered to connect me with potential subjects in Atlanta. A year earlier, my exhibit had been at the Laman Public Library in Little Rock, Arkansas. I reached out to the curator and asked if she could suggest someone there. I started researching civil rights organizations in Mississippi and Alabama to find voices who could speak to the history of our civil rights movement. I had once photographed a story about dining in a little river town on the west bank of the Mississippi called Donaldsonville, Louisiana, for a travel magazine. Located among sugarcane fields and oil refineries, the town featured a delicious mix of antebellum architecture and Cajun food. I had met a person at the Chamber of Commerce there, so I made another mark on the map. Slowly but surely, a winding route revealed itself.

With a little detective work and a healthy dose of determination, I am convinced you can connect with any sort of person in just a few phone calls—sometimes less. I learned this through years of doing travel photography assignments for magazines. You want to find a farmer with a beautiful old windmill on a ridge? Go order a cheeseburger at the local café. Sit at the counter and

strike up a conversation with whoever brings you the menu. Tell them what you are looking for, and if they don't know where to find it, ask them if they know anyone who does. Remember to leave a nice tip for their help. Follow that wild goose chase far enough, and eventually you will reach the right person, and you might even get invited to dinner along the way.

I tried this process to find a shrimper in Louisiana. I recalled a scene from the movie *Forest Gump*, with shrimp boats bobbing in the harbor and their nets hanging off of side booms like wispy fairy wings. I had never seen a shrimp boat and decided that if I interviewed a shrimp boat captain, I might also get a chance to see and photograph the boats. I called the Chamber of Commerce in Donaldsonville. The person I had known there had left, but I explained my connection to the town and what I was looking for.

"I'm trying to find a shrimp boat captain to interview," I said. *"Do you know any?"*

The first answer was no.

"Well, how about the restaurants in town?" I continued. *"They all sell seafood . . . maybe they know of someone?"*

The woman at the chamber gave me some phone numbers for the restaurants and the names of the owners to call on.

The first restaurant owner didn't know any shrimpers, but he did have a lawyer friend in town who was representing a lot of shrimpers in a class-action lawsuit against BP after the big oil spill in 2010. *"Why don't you try him?"* he offered.

So I did, and sure enough, the lawyer had several shrimpers as clients. He sent a few names and numbers my way of people he thought might be willing to talk with a guy like me. I dialed the first number and connected with Kenny Theriot, a third-generation Cajun shrimper out of Chauvin, Louisiana.

The drive to Kenny's was like nothing I had ever seen. The land southwest of New Orleans was a latticework of road, levy, and water. Houses were propped up on stilts, and boats lined canals in every direction. I was way ahead of schedule, so I wandered, trying to capture the beauty of this unique and soggy landscape. I stopped at a single-lane wooden swing bridge that crossed a bayou just to take a closer look. It was a cloudless day, and the calm water perfectly reflected the sky and the boats that lined the canal.

The bridge was operated by a man in a modest wooden control shack in the middle of the structure. I saw him eye me up as I walked toward the span. *"Good morning,"* I offered with a wave, and he quietly nodded in response.

"Where can I stand to photograph it?" I asked, pretty sure that if my question didn't announce I wasn't local, my Minnesota accent did.

"You gonna fall off?" he wanted to know.

"Not on purpose," I smiled.

"Then stand anywhere you want."

So I walked onto the bridge and stood in the middle as the operator spun the roadway parallel to the bayou shoreline, allowing boats to pass, and then swung it back into place so that vehicles could cross again. I watched the boats. I wandered. I photographed pelicans balanced on pilings in the water. I found an old cemetery with crypts standing above the sodden ground as they do in watery places like this. Then it was time to go meet Kenny.

I had been with Cajuns before on an assignment to photograph barge traffic on the Mississippi. For that project, I rode the biggest tow on the river, five barges across and nine long, from St. Louis to New Orleans. The captain was Cajun, with an accent so thick I could barely understand him. I did a little better with Kenny, but I still asked him to slow down for the sake of my northern ears.

The Cajun inhabitants of the Louisiana bayou were descendants of French Canadians, known as Acadians, who had settled modern-day Nova Scotia under French rule. When the area became British territory in the 1700s, the Acadians were expected to renounce their Roman Catholic faith and adopt the protestant expectations of the British crown. When they refused, they were seen as a political threat and pushed out, eventually given refuge under the Spanish flag in southern Louisiana.

Kenny looked a little like my dad. Short hair, unshaven, as I was. Jeans and a well-worn shirt. We sat at his kitchen table to talk, the shades pulled down against the hot Louisiana sun. I asked Kenny what it was like to be a shrimper, and he said this: *"Well, you go out there and you find shrimp, and you catch them."*

He waited for me to respond. I smiled and said, *"Thanks, Kenny—that's real helpful."*

He cracked a grin and went on: *"You clean them, ice them, and you just do that all day and all night long. You come in and you unload them, and you get ready and you do it again."*

So I had found a wise guy—someone who liked witty banter—and I was game to play along. Again, I wondered to myself why I would seek out a shrimper when I was trying to have conversations about peace. But as Kenny began to talk about his Cajun heritage, the connection was clear. The Cajun community was tight-knit, brought together by a common experience and by a history of prejudice against them.

"When we were shrimping, we all worked together. One would build a boat, we'd help him. The next one would build a boat, we'd help him, and then pretty much everybody wound up with a boat at the end, so it worked out pretty good."

There was a strong sense of community in the bayou. That notion of community—of making sure everyone had the tools and the resources they needed in order to thrive—was directly related to my own notion of peace.

"When I think of peace," he said, *"it's everybody getting along and working together and just helping each other out. When people are in trouble, you help them. When people need something, you help them, and vice versa. You do it for people, and people do it for you."*

He talked about his upbringing and how the world had changed over his lifetime.

"We started off with nothing and just worked our way up. In today's world, the kids want things right away. They don't want to live in a run-down trailer; they want to live in a brick house or have a new car. We never started like that. People buy something they can't afford now. In them days, we didn't do that.

"We Cajun, I don't care who come down here, you're welcome in my house. At one time, everybody knew everybody, and everybody just take care of everybody. It doesn't matter if I agree or disagree with the guy—if he needs help, I'm going to help him. It's just the way it is."

But times had changed, and Kenny worried about the shift.

"When I was a kid growing up, we didn't have air-conditioning. Our doors were open, our windows were open, we had attic fans and cool air blowing in the house. You could walk in somebody's house and that didn't mean nothing. Nothing happened.

"In today's world, my doors are locked. Every little noise you hear, you wonder if somebody is coming in your house. Society is changing. Nobody knows nobody. You don't know who is next door. I'm not saying it's good or bad, but I've got a .357 in my room, and I tell my kids not to come in my house unless they call.

"I don't think people got time to socialize. They leave to go to work in the morning; they come back at night. They're tired, and I'm telling you, I get tired too; I don't want to go running around. Back in the days, everybody used to sit on the porch, they gossip, and everybody knew what was going on. I want you to ride around and tell me how many people you see sitting on the porch talking to each other. You don't see it."

I heard Kenny longing for community. I heard a lament of schedules that had become too busy and a life that had gotten too complex. I had never fished shrimp a day in my life. I wasn't Cajun and could barely understand the accent. But the message resonated with my own experience. We had lost our connections, and the ramifications of that were going to ripple out for years and generations to come.

As we talked, I got the feeling that Kenny and I could find some things that we disagreed about, and it wouldn't take long. I imagine we had voted differently in the last election cycle. But here we were, enjoying one another's company, having conversations about some far-ranging issues and finding common ground.

As I packed up my equipment, Kenny asked, *"Could ya eat?"* And before I fully considered how this might play out, I replied, *"Yeah . . . I could eat."*

I don't eat seafood. I don't like it. I don't need to like it, and I don't want to like it. I'm not allergic, but I've started telling people that I am. It's just easier, because if you tell someone you don't like seafood, they say things like *"Oh, have you tried ahi tuna? It's not fishy at all"* or *"I bet you would* love *salmon on a cedar plank, though!"* or *"Not even crab? You should definitely try crab!"* Fish, lobster, crab, oysters, it doesn't matter. Never liked it. Never will. And I'm OK with that, but it seems the rest of the world wants to change my mind.

So it was with mild horror that I watched Kenny walk over to the refrigerator; pull a huge, deep, stainless-steel pan out; and drop it heavily on the table. He proudly peeled back the foil cover and revealed a heaping mound of steamed crabs—critters he had caught himself, I was sure. I swallowed hard and tried to smile because even though I was completely grossed out, I wanted desperately to not be rude. Kenny and I were building rapport, and I wanted to ride that wave, no matter the culinary cost.

I eyed up the cobbed corn and potatoes that were mixed in the pan and decided to make the best of it as Kenny dropped what appeared to be a miniature surgical kit next to me. There was a nutcracker, a little pokey thing, and a pair of tweezers. I am more skilled with a knife, fork, and spoon in my simple

midwestern, landlocked life. *"You're going to have to show me how to do this,"* I said. *"Most of the animals I eat keep their meat on the outside."*

Kenny gave me a quick lesson in shucking crabs, showing me the parts to eat and the parts to discard. It seemed a subtle distinction in my view. I did the best I could, fed myself tiny little bits of crab, and washed it down with two cans of cola as we kept talking. One part crab, two parts potato, three parts corn, an enormous gulp of cola, repeat. I was pretty slow, but that was by design. I figured I could supplement the meal with a quick cheeseburger once I hit the road again.

Kenny's wife joined us at the table to eat and visit, and I was beginning to feel like I would make it through the meal. I could feel her watching my slow progress. She ribbed me a little about my amateur crab-cracking technique, and finally she couldn't take my incompetence any longer. She announced with a flourish, *"Move over, honey—you're gonna starve to death if you crack your crabs like that."* And she proceeded to quickly and expertly produce a large pile of crab meat on the plate in front of me. I was horrified.

"Thank you," I said and kept my dirty little crab-hating secret to myself.

"Where are you staying tonight?" Kenny asked.

"I have no idea," I said. *"What do you suggest?"*

"I've got a burnt-out RV in the backyard if you want to stay there," he offered.

"Burnt-out?"

"It got hit by lightning and the electric got fried—I haven't gotten around to fixing it yet, but it will keep you dry."

"Sounds good to me," I said. Money was still tight, and anything that helped keep costs low helped move the project down the road. Do the math on the lodging costs for a forty-thousand-mile road trip. It isn't pretty. Even the cheapest hotels will add up to a big number, so I came to welcome the unexpected kindness of new friends along the way—even if it meant downing a meal of boiled crabs and sleeping in a burnt-out RV.

"In the morning, we can go looking for alligators," Kenny said, as if he needed to sweeten the deal.

"Sounds good to me."

And then he offered what I had barely dared to hope for: *"If you can stick around one more night, shrimping season opens—if you want to come out on the Gulf, I'll take you."*

And I said, *"That sounds good too."*

Most of my road schedule was tight. It was important to keep moving if I was going to make it through the project, but I did leave little windows of free time here and there to make room for surprises, or just to take a day off, and one of those free days was just around the corner.

"Let me make a couple calls and see what I can shuffle around," I said.

Twenty-four hours later, after a good night's sleep in his burnt-out RV and spotting alligators in the bayou, I climbed aboard Kenny's boat and headed out on the Gulf of Mexico. We left the harbor at four in the afternoon and came back in at eight in the morning. In the process, we caught 1,200 pounds of shrimp. And I haven't eaten a shrimp since.

I photographed through the dusk, captivated by the deep-indigo sky and the warm glow of the boat's work lights. But once it was pitch-black, I was done taking pictures and tried to make myself useful on the little vessel. When the nets were pulled up and emptied, all sorts of sea life spilled onto the deck. I sorted out the other things that had been caught and tossed them back into the Gulf. Crabs, rays, baby sharks. It was a little game I called "shrimp, shrimp, not a shrimp." Kenny chuckled at me and shook his head. *"You don't have to bother with that,"* he said. But I shrugged and kept tossing.

I worked the sorting table and made sure that only shrimp went into the cooler hold. Between loads, I walked carefully on the deck of the ship. Only a modest, three-inch curb served as a barrier to the pitch-black waters beyond. The waves were gentle that night, but a piece of ice or a stray slippery minnow underfoot and I might wind up going overboard and getting swept up in the same net as the shrimp. Nobody on the boat wore life jackets.

There are a lot of reasons Kenny and I might have disagreed. I had the sense that we got our news from different sources. He liked to hunt and fish, while I expect he recognized pretty quickly that I was more of a tree hugger. But these differences were exactly why Kenny's voice belonged in the project. It turns out, photographers and shrimpers share some common struggles. We are both dependent on the weather. We're never sure how much money we will make in a day, week, or month. Sometimes it feels like you are a little guy adrift on a big sea, at the mercy of bigger forces.

Of course, when you are out to sea on a little boat with people you barely know, it's a good idea to be friendly. But there's also a good life lesson in it. Kenny and I had plenty of reasons to be at odds, but we also had reason to find common ground and enjoy one another's company. What if life was just that simple?

CHAPTER 23

CULTIVATE GRATITUDE

This southern trip was longer than some of the previous loops I had planned, and it had come together more quickly than most, so not all of the puzzle pieces had fallen into place before I left home. My networks were thinner in the South, and as I was on the road, I still had some holes in my schedule. From cafés and cheap hotels along the route, I sent emails to see if I could fill in the gaps.

Denise Strub was the managing editor of the *Bolivar Commercial*, the daily paper of record in Cleveland, Mississippi. She replied promptly to my email, which led to a phone call, which led to a meeting in her office. I explained the project and hoped she could point me toward someone unexpected. She was both encouraging and enthusiastic. I was an old newspaper guy myself and felt confident that nobody knew a community better than the local newsroom.

For each trip, I tried to craft a rough balance of demographics. Old and young. Male and female. Diverse ethnicities, faiths, economic classes, and political perspectives. But, as I told Denise, a good story tops it all. Who do you know that I should talk with? Since I am from up north, who might help me understand the South a little better? Who is interesting in your circles? Who have you met that you think I should too? Who's unique to this area?

Denise introduced me to Elaine Baker.

Elaine grew up in Mound Bayou, Mississippi, known as "the Jewel of the Delta." Founded in 1887 by former slaves, Mound Bayou is the oldest self-governing all-Black municipality in the United States. Elaine grew up in an era of segregation, with "White only" and "Black only" signs in neighboring communities, though she didn't experience day-to-day racism in Mound Bayou because there were no white people present in the town. She learned that her value and worth were not determined by others. As a young girl, Elaine picked cotton

for 2.5 cents a pound and went on to get a PhD in sociology from the University of Georgia.

I had never heard of Mound Bayou before. The history of it intrigued me. The town was just ten miles north of Cleveland, and Elaine agreed to an interview. She offered to meet at her Baptist church, and I gratefully accepted the offer.

To say I have an informal presence about me as I interview people would be an understatement. On this day, I was dressed in shorts and sandals, a T-shirt, and an unbuttoned flannel shirt. I struggled with my equipment, if only because I was trying to do the work of a three-person crew all by myself. We decided to talk in the sanctuary, and as I managed cords and changed batteries, Elaine sat patiently in one of the pews, back straight and hands folded in her lap, waiting for me to begin. Her calm and accepting smile was a counterbalance to my own frenetic preparation as I made sure all of the technical elements were in place before turning my attention to our conversation.

When I finally sat across from Elaine in a folding chair, I was quickly enveloped by her deliberate pace. The hurried process of setting up melted away as she settled into a story of what it was like to grow up there.

"Mound Bayou has historically produced individuals who have gone far beyond the confines of Mississippi and even the United States to make their mark. The legacy of achievement remains very much a part of who I am and the circle of people that I grew up with.

"It's a legacy of education, spirituality, religion, economic development, and self-pride. It's not a perfect city because we're human beings here. There seemed to be, during the first fifteen years of my life, a sense of gratitude for the legacy of our founders and the early settlers. There remains a nucleus of people who want to maintain that peace of mind, if you will, of community, entrepreneurship, and self-help."

I wondered out loud how a person develops a sense of self-worth when they grow up in a time and place in history that didn't recognize that worth through policy and behavior.

"You do that because of the environment that does not deny that reality but helps you not to be defined by that reality. You learn to live in Mound Bayou as free people and to craft your own future. We had role models. You were expected to be all that you could be."

But I've seen adversity work in peculiar ways. I've seen hardship bring out the best in people, and I've seen it crush others. Oppression can press down as

a mighty weight, but it can inspire action as well. What is it that determines a person's response? I suspect it has a lot to do with connection and relationships. As I listened to Elaine talk, I heard her describe a rich and robust support network that may not have been loud enough to drown out oppressive voices, but the sound of that love and encouragement was certainly loud enough to always be heard. I wondered what small voices of encouragement could be planted to help a person endure and even thrive in a difficult situation while at the same time work to eliminate systemic challenges.

Of course, I asked Elaine about peace.

"When I think about peace, I think of tranquility and calmness, of having come to an understanding of who you are and what the world is, knowing there's a place inside of you that no one can take from you. Above and beyond, it is knowing that there is someone greater than you who looks down, who knows all, who is the great I Am, in spite of all of the other garbage that goes on.

"I believe that there is a God who's a sovereign peace. If you can stay tapped into that force—it doesn't mean that negative things don't come—but if you hold on, you will eventually get through it, even as the ultimate end is death.

"I have come to appreciate demonic forces—jealousy, envy, greed. Those forces foster enmity. For me, there are positive forces and there are negative forces. One has to develop a discerning spirit to be able to know when they are rising up in you and where they're coming from.

"God has enough for everybody, but everybody doesn't get the same thing.

"I think it's important that you revisit: What are your core values? What are your core principles that don't change? Love for one another, helping your neighbor out, pride in accomplishments and achievements.

"When I bring my strengths to your strengths and combine those with others, we have a much greater mosaic than if I just stand out there alone."

We are better together. I heard it from so many people, and I wondered why we forget it so easily.

Elaine loved her church. You could hear its importance and influence in her every word. I interviewed her there on a Saturday afternoon, and she asked if I could stay to attend worship with her the next morning. There was nothing I wanted more, but I had burned up my free day on the shrimp boat, and this

time, the road was unforgiving. I needed to move on to another interview across the state the next morning. It was a lost opportunity that gnawed at me for the rest of that trip and more.

But one of the gifts of this project has been the relationships that have stayed with me. I keep in touch with many of the people I've interviewed for these books, and when Rhodes College hosted my exhibit in Memphis in 2017, I saw that it was only a couple of hours north of Mound Bayou. I called Ms. Baker and told her I was going to be in the neighborhood (yes—two hours away has become "in the neighborhood" in my view) and that I could probably drop by on a Sunday. Karen was planning to come along on the trip, and Elaine again extended an invitation to worship with her at her church.

"How's that going to be when a couple of white, northern Lutherans walk in the door?" I asked, and Elaine laughed. *"You will be the only ones, but we'd love to have you."*

The service was two hours long, and we were, indeed, the only white, northern Lutherans in the house. The music was loud and prayerful. The message was filled with joy, and the woman beside us could not be confined to her seat. She stood. She raised her hands. She jogged to the back of the church and back up to our pew, then did it all over again as the spirit moved her. When it came time to leave, we could hardly get out the door. People came from across the small sanctuary to shake our hands, give us hugs, and make us feel welcome. *"This is your church now,"* one woman said. *"Come back soon." "Come back often."*

It crossed my mind that just a year earlier, that prayer group in Charleston, South Carolina, had welcomed Dylann Roof in a similar way, and he violated that trust in the most horrific way by shooting and killing nine congregants. I couldn't shake the thought, but if anyone else in the church was thinking the same thing, they didn't show it. They simply welcomed us.

The pastor approached with a broad smile and a firm hug. I told him, *"You know, at our Lutheran church in Minnesota, we tend to sit on our hands during the service, but you all don't seem to suffer from that same affliction."* He smiled. He laughed. Then he said, *"There is no right way to praise the Lord. This is just how we do it."*

How beautiful, right? There is no right way to show love. There is no right way to be in community. There is no right way to dance. There is no right way to be. This is just how we do it. And there is rich beauty in the broad spectrum of it.

I tried to believe that if someone from Mound Bayou walked through the doors of my suburban Lutheran church in Minnesota, they would receive the same sort of warm embrace we did that morning. I tried to believe it, but I have to admit that I struggled to convince myself it would be true.

I've been back to Elaine's church since, and I'll go back again. There is something powerful about being welcomed into a new community, and there is something good about feeling loved, whether you deserve it or not. I hoped we could all do that for one another.

CHAPTER 24

BE WILLING TO BE UNCOMFORTABLE

I generally try to have most of my interviews lined up before I leave home. I want to make sure I am productive on the road. But I also tend to leave some open time in my schedule to accommodate the unexpected opportunities that come along. Sometimes one thing falls apart only to make room for something better that was waiting to fill the void.

Heading toward Alabama, I had an interview scheduled with someone who had been active in the civil rights history of the state, but the day before I arrived, he called to say he was no longer available. He wasn't feeling well and would have to cancel our appointment. I was disappointed, of course, and I had no plan B. My worst-case scenario was to be on the road spending money we didn't have and come home empty-handed.

In an act of desperation, I decided to crowdsource a solution, and I tossed my dilemma out to social media. My Facebook post read something like this: *"Does anybody know ANYONE I can talk to in Alabama?"* I understood that I was setting a pretty low bar with my request, but I crossed my fingers and kept driving toward the state. Something was better than nothing, and I just needed something.

Later that day I found two responses on my Facebook post from two different people who suggested I find and interview a woman named JoAnne Bland. So I googled her name, found a phone number, and called her up. I explained the project and then swallowed hard before asking the difficult question: *"What are the chances you have four hours free tomorrow?"* There was a hesitation.

I suggested she look at the project's website and think about it for an hour or so, and I would call her back. When I did, she said, *"Come on over."* It was a powerful story that I could never have planned, and it was sheer serendipity that led to it.

JoAnne Bland lived in Selma, Alabama, a town with a long history of prejudice, racial division, and struggle for social change. When she was eleven years old, JoAnne marched with Dr. Martin Luther King Jr. in one of the defining moments of the civil rights movement, the march from Selma to Montgomery, Alabama, for voting rights.

She offered to meet me at the Selma Interpretive Center on Broad Street, just a block away from the historic Edmund Pettus Bridge, where the marchers were met with brutality by the police the first time they tried to cross on March 7, 1965. On that day, known as Bloody Sunday, police met the six hundred protesters with billy clubs and tear gas, driving them back to Brown Chapel, where they had started.

JoAnne wasn't at the Interpretive Center when I arrived, so the woman behind the desk suggested I take some time to browse through the museum while I waited. I worked my way through the displays and filled in some of the many blanks in my education about the civil rights movement. I learned that Sheriff Jim Clark of Dallas County used an electric cattle prod in addition to his pistol and billy club. I learned that the march organizers had a deep network of volunteers organized to feed and shelter the marchers on their way to Montgomery and that it took three tries before they finally made it.

This was the site of historic photos I had seen. This was the bridge where the young John Lewis marched and suffered a fractured skull on Bloody Sunday. Standing in the same town where so many people risked their own safety to fight for basic rights, I began to sense the dedication and courage that were involved in making change.

After an hour in the museum, JoAnne still hadn't arrived, and she wasn't answering her phone when I called, so I decided to grab a bite to eat. I left my card with the woman at the museum desk in case JoAnne came in looking for me, and I headed to the Downtowner at her suggestion.

It was just three blocks down the street and around the corner, but the August air was still and thick, so when I walked through the door and felt the air-conditioning, I was glad to sit for a while. I chose a table facing the entrance,

ordered a water, and started looking through the menu when a woman walked through the door and right up to my table.

"Are you John?" she asked.

"Do I stand out that much?"

"I know everyone else in here," she replied with a quick wave of her hand. JoAnne was practical and direct.

She pulled up a chair, and we both ordered and talked through our plan for the afternoon. When the food arrived, she offered me one of her deep-fried chicken gizzards. I wasn't inclined to say no to JoAnne Bland—besides, I figured it couldn't be any worse than crab meat. I was wrong.

I picked up the golden nugget and, before I had time to chicken out, put it in my mouth. The crisp breading gave way to a heavy, musky flavor that left a greasy smudge on the roof of my mouth. JoAnne looked at me and smiled like I had just passed some sort of southern culinary initiation. She offered another but wasn't surprised when I left the rest to her. We finished the meal and paid, and she told me to follow her over to her house for the interview.

Finding common ground isn't always easy. It often requires us to move outside of our safe and comfortable spaces. Most of us tend to shy away from things that make us feel uncomfortable. It happens all the time, whether we're in the grocery store, at a family reunion, or in a staff meeting. We avoid situations that can be difficult and places where we might feel unwelcome.

But that's a mistake. Because it is exactly those moments when we open ourselves up to the possibility for growth.

I sat with JoAnne in her living room just twelve days after Michael Brown was shot in Ferguson, Missouri. Everything about the situation—from the shooting of an unarmed Black man to the frustration and unrest that followed—challenged my understanding of the world. Being raised in a small Wisconsin town, what I saw on the television didn't fit into my personal experience.

As JoAnne and I talked, I promise you there were uncomfortable moments in the conversation. Not because of JoAnne—she was nothing but kind and gracious—but because of the dynamics of what was going on in our country around race. My life lens made it difficult for me to truly understand her life experience, and I worried how my ignorance would come across. And here I

was, a middle-aged white guy from up north, sitting with a civil rights icon in her home as she was frustrated and angry that we have not yet gotten to where we need to go as a nation.

But if JoAnne sensed that unease, she didn't let on. With the skill of an experienced storyteller, JoAnne told me about being in that famous march and the history of Selma. She told stories of slavery, poll taxes, Jim Crow, and segregation and then moved on to the frustrations of today.

JoAnne said, *"My earliest memory is going to a meeting of the Dallas County Voters League with my grandmother and not understanding why they talked about getting freedom. My teacher already told me that Abraham Lincoln had freed the slaves. I just thought they were dumb old people—that they didn't understand— they didn't know that we [already] had our freedom.*

"There's a drug store on Broad Street. It's still there today, called Carter's Drug, and they had a lunch counter, and I wanted to sit at the lunch counter as any child would. But my grandmother said I couldn't because colored children could not sit at the counter.

"It didn't stop me from wanting to sit at that counter. Every time I passed by, I'd be peeping in that window. And one day, my grandmother was talking to one of her friends in front of the store and she noticed me looking in the window and she leaned over my shoulder and she pointed in the window and said, 'When we get our freedom, you can do that too.'

"I became a freedom fighter that day."

JoAnne went on. *"People don't talk honestly about race. Just don't talk about it, and we'll all get along. And the moment I question something that I think is racist, you put up a wall, and we can't talk because you feel like I'm accusing you."*

I wasn't sure if she was talking about me or maybe feeling me out. I did a quick self-assessment to see if I looked defensive. I uncrossed my arms, took slower breaths, and tried to relax the wrinkles around my eyes. She was clearly frustrated with the news of the day, and rightfully so. I didn't want to give her any reason to hold back. She was talking about things she had experienced from a time in our history and a place in our country that I never had, and I didn't need to get in her way. I just needed to listen and try to understand.

Racial turmoil continued to roil our country after I met with JoAnne, with protests erupting after the deaths of Freddie Gray, Philando Castile, and others. Emotions swirled around Confederate monuments, and white supremacists marched

on Charlottesville. In the summer of 2020, as I was editing this manuscript, George Floyd was killed by police in Minneapolis, sparking a global wave of protests. The names in the headlines changed, but the tension remained the same, rising with each incident and then being brushed aside as we returned to the status quo.

JoAnne continued: *"Here in Selma in 2000, we elected our first African American mayor in a town that's always been at least 65 percent Black. That same year, a statue of the founder of the Ku Klux Klan was erected on the grounds of one of our museums. It really upset me. It said, 'You may have a Negro mayor, but we're still here.'*

"Protests shut Selma down. And this little old [white] lady told me, 'Y'all better let us have something.'

"Do you really feel like we're taking something away from you? Because to me, her fear was that if we were empowered, we would treat them the same way they had treated us.

"When you continually get hurt by people who don't look like you, you are suspicious of them. Here you come smiling, but you are a wolf in sheep's clothing. You're white, and eventually you're going to show your true colors—that you don't like me. Period.

"I tried to teach my child and my grandchildren that it's not like that. We try to take people at face value. But it's hard for me to explain how you expect racism when you're Black. You expect discrimination when you're Black. And we don't question it as often as we should.

"One day we'll be all right. I'm just tired of waiting for one day. I want it to be now. I want it to be in my lifetime. When we were growing up in the 1960s, I thought by now we'd have that Beloved Community and everything would be peaceful. It has not happened."

We've got work to do as individuals and as a society, and if we are going to be able to do that work, we have to be willing to sit with uncomfortable realities in the process.

JoAnne took me around Selma. She showed me a Confederate statue in the town cemetery. She brought me to the Edmund Pettus Bridge, which she marched across as a young girl on her way to Montgomery with Dr. King, John Lewis, Hosea Williams, Stokely Carmichael, and countless other brave souls whose names are less

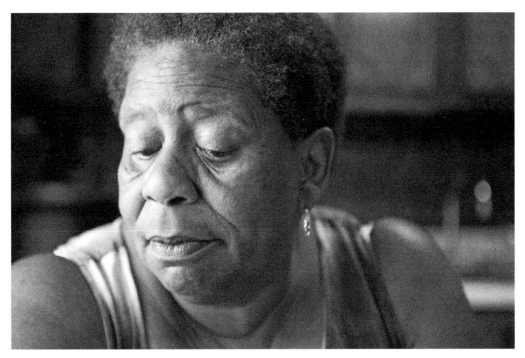

JoAnne Bland

familiar. She brought me to the neighborhoods around Brown Chapel and talked about economic models that kept poor people poor and siphoned wealth out of communities.

These were places I had read about, but seeing them in person and hearing the background from JoAnne offered a richness and depth of understanding for events past and present that I couldn't access through the news. There is power in proximity, and walking those historic streets transfixed me. I would never fully know what it was like to walk in JoAnne's shoes, but when I took the time to listen—when I was open to the discomfort of hearing honest pain, disappointment, and frustration—it opened a door to deeper understanding. It complicated the simple narratives I had encountered and led me down the path toward greater compassion and empathy.

CHAPTER 25

SLOW DOWN

Middle school and high school were awkward for me. When everything else went bad, our family's summer trips to the wilderness sustained me. We'd go in all directions, but the trips west were the ones that populated my dreams. Glacier, Yellowstone, Rocky Mountain, Rainier, and Olympic. We would hit the road early in the day with our pop-up Starcraft trailing behind. My frugal mom provisioned me with one wide-mouthed mason jar full of Lucky Charms and a second one full of Tang. Seatbelts weren't used. If I was asleep, my mom would wake me at the first sighting of our destination. *"There's your ocean,"* she would say, or *"There's your mountains."* They were mine. They were ours, collectively, I remember my young mind thinking as we drove through the public lands that were preserved for now and forever.

In hindsight, these were really the only vacations my parents could afford, but those wild places seeped into my bones and fired my imagination. The trips themselves were just a few weeks each year, but the rest of the calendar was filled by either reliving them or planning the next one.

In fact, these early trips infected me with a sort of wanderlust that I've never quite shaken.

"I would like to have a job that pays me to explore the world," I used to announce to my practical father.

"Well, that's not the way the real world works," he would reply.

"Why not?" I would ask, and I never received a satisfactory response.

I believed that it could happen. It seemed entirely possible to me.

When I plan a trip, it frequently evolves into a bigger trip. Like my dog, I strain at my collar and leash, thinking if I can go a little bit farther, a little bit

longer, there will be more to explore. A postcollege European backpacking trip steadily transformed from two weeks into three months as we scrimped and saved and chose to be frugal on the road.

As I planned my trip out west for *A Peace of My Mind*, there were benchmarks I needed to hit on this leg of the journey. I had met a man named Cowboy Lyle in Medora, North Dakota, whom I wanted to interview, so I placed a dot on the map. A friend had filmed a documentary about a peace activist who built a remarkable working relationship with a Vietnam War veteran in Montana. She offered to connect me. Another dot. One of the subjects from my first book was now codirector of Holden Village, a retreat center I had always wanted to visit, and he invited me to spend a few days there on the trip. One more dot. Friends in Seattle offered lodging and logistics. Friends south of Portland did the same. Karen's sister lived near Anaheim, California. Dot, dot, dot. Connect the dots and you've got the solid framework for an epic road trip. The route toward home zigged and zagged to pull in a few stray states.

The western loop grew into a five-week, five-thousand-mile road trip, and I took my traveling companions in shifts. One of my interns, Nick, joined me for the first leg of the trip. My wife and daughter were my partners from Spokane to Las Vegas. And I drove the final seventeen hundred miles on my own.

Our first stop was in Medora, North Dakota, to find Cowboy Lyle. I had met Lyle a few years earlier as I worked on a project in Theodore Roosevelt National Park for *Midwest Living* magazine. He was on the losing end of a mock gunfight staged for tourists twice a day on Main Street. After the actors finished the skit and the dead ones stood up again to dust themselves off, I wandered up to ask the locals for tips on where to photograph wildlife, one of the items on my assignment shot list. I was directed to Cowboy Lyle. He liked to photograph the wild mustangs in the park and gave us advice about where and when to find them. As we drove the park loop early the next morning, Cowboy Lyle rolled up behind us. He had just come out to make sure we found his prime spots.

Cowboy Lyle helped care for a herd of elk on a ranch, and he let us come along as he fed them the next day. He lived a simple life in a trailer at the edge of town. And now, a few years later, I knew I wanted to connect again as I was working on interviews for *A Peace of My Mind*. But a person like Cowboy Lyle doesn't use email. The one piece of correspondence I had from him was

a handwritten thank-you note he mailed to me after our first encounter. And inside the note, he had included a phone number.

I tried the phone number five or six times. Nobody ever answered and there was no option to leave a voice message. Once again, persistence proved a virtue, and one day, after nine or ten rings, Lyle answered his phone. He remembered me, and I asked if I could interview him. He agreed and suggested that I should call again the week before I arrived in town to arrange the specifics. But Cowboy Lyle never answered the phone again.

Nick and I viewed finding Cowboy Lyle as a quest. Medora was a small town, and we set aside time to rustle him up for the interview just in case we got lucky.

Our first stop was to drive west of town, where I imagined Lyle kept his trailer, based on precisely zero information. I'll call it a hunch. No luck.

We drove to the national park entrance gate and asked if they knew him. *"Oh, yeah,"* the man said. *"Everyone knows Cowboy Lyle."*

"Do you know where I might find him?" I asked.

"Oh, he's around."

I was hoping for something slightly more specific, but it was all we could extract.

The next stop was the North Dakota Cowboy Hall of Fame a few blocks away. It was across the street from the staged gunfight where I had first met Lyle. I asked about how I might find him and was told he sometimes worked at the Medora Musical and Pitchfork Steak Fondue at the top of the hill overlooking the town. So we drove up there.

For dinner before the show, they served up steaks that have been skewered on a pitchfork and submerged in boiling oil.

Again, I had photographed this entire thing for *Midwest Living* in the past, and I knew the lay of the land. I moved toward the staff who were working the pitchforks and asked about Cowboy Lyle. They were decked out as classic drugstore cowboys: checkered shirts, leather vests, jeans, chaps, boots, neckerchiefs, and big old hats. So I was surprised when the young man I approached answered me in a thick eastern European accent.

The musical attracts a big crowd, and it employs a lot of people. There weren't enough folks in the local community to fill all the spots, so they retained an employment service that brought workers from overseas, leading to some

cultural surprises in the process. The Slovakian cowboy told me Lyle had just passed through, but he had gone back down the hill to lower the American flag in the town square, one of the eclectic duties that made Lyle a vital thread in the fabric of Medora. *"Sometimes he sits on the deck of the pizza place until it's time,"* he added as we walked back toward the truck.

So Nick and I drove back down the hill and parked at the town square, certain we were drawing closer to the elusive Lyle. The flag was still flying, and I took that as a good sign. I climbed out of the truck, looked across the street, and there he was, on the porch of the pizza parlor.

At the start of every travel job, I hope to set a good tone. Good weather? Good tone. Crabby people? Bad tone. Lovely landscape with an unexpected rainbow? Good tone. Faulty directions or a missed appointment? Bad tone. You could recover from a bad tone, but starting a trip on a good tone helped dispel the jitters. Like a baseball pitcher with a quirky warm-up routine, I took my good omens where I could find them, and locating Lyle in just five quick stops on the first day of this vast trip set a good tone indeed.

Lyle looked up like he was expecting me, like the very loose plans we had made on the phone weeks ago were all that was really needed, and we agreed to meet the next afternoon for the interview at a quiet picnic area in the national park.

His real name was Lyle Glass, but everyone knew him as Cowboy Lyle. He was born in Crookston, Minnesota, and moved to Medora in 1973.

As he tells it, *"Growing up on a farm in Minnesota, I was more of a farmer, but I didn't like machinery or things like that. My job back there was to take care of cattle, make sure they had water, and clean out the barn. Then I found out about Medora, came out here, and started working with the horses and became a cowboy and helped with spring branding and fall roundups on different ranches. People know me as Cowboy Lyle now, so that's the name I go by."*

We sat at a picnic table in the park, shaded from the North Dakota sun. I wore a T-shirt and shorts. Lyle looked every bit the cowboy he was. Black denim pants, a red button-down shirt, a black leather vest, and a big black hat. I asked what drew him to the area.

"I like the landscape, the scenery. I like the wildlife here in the park. The people around town are real friendly and courteous, and in the summer months when the tourist season gets real busy, I like meeting new people. A lot of people know me from over the years, so I visit with them."

Cowboy Lyle was quiet, and the interview was too. I tried to draw him out, but his answers were short, simple, and sweet. I asked him about what his days were like; they consisted of getting up early, watching the wildlife, hosting flag ceremonies, and doing the Medora Musical. It was an exercise in patience to allow an interview to unfold naturally rather than forcing it into a preconceived shape of some sort. I always entered the conversations with certain expectations, but I tried to set them aside the best I could and let the people lead the process.

"Now, when I think of peace," he said, *"it's being somewhere quiet. You're alone; you can be with your own thoughts. That's why I come out into the Theodore Roosevelt National Park early in the morning or in the evenings because it's nice and quiet out there and I'm alone. I can think about things and do what I want to do out here. When I'm with wildlife, I just feel at peace with them. Usually I come out when something's kind of bothering me, but once I get out in the park, it kind of leaves me, and then I can think about other things and not worry about what's bothering me."*

In 2010, Lyle suffered an aortic aneurysm. The blockage was in his left leg, but the rupture happened near his heart. It left a numbness in his leg, and his ankle lost mobility, so he can't ride often, the way he used to. It was a difficult time, and the park offered healing.

"I would come out in the park and just think about it and think, What is my life going to be like next and from day to day? Thinking about that just kind of relieved me of those thoughts and helped with being at peace with myself. Sometimes my leg gets real stiff, so I get up and walk around to kind of loosen it up. It's something I've got to live with the rest of my life, so I just take it as it comes and live with it.

"Nothing is for sure. Anything can happen to you at any time; you never know when it's going to happen and put a big cramp in your lifestyle and you just have to sit back and deal with it and live with it. Just take one day at a time."

I sort of wanted more. But that was it. As I asked more questions, they led to the same answers, and the well was dry. Maybe it was just that simple. Life had taken a turn for Lyle. He thought about it in some quiet spaces. And then he just dealt with it. Moved on. It made me wish I was better at doing the same. I was aware of the pace at which I traveled, and my tendency to move quickly stood in stark contrast to the simple, quiet life Lyle described. I learned that

peace comes not only from the ways you change the world but also from the ways you change yourself.

That afternoon, Nick and I drove through the park. We hiked up to high places. We heard the wind move through the grasses and saw the light play across the formations. We talked with the occasional passing tourist. We watched a lone buffalo walk through the landscape at dusk. There was a long trip ahead of us. But for the moment, we had done what we set out to do. We had found Lyle and experienced a small piece of the calm and quiet he talked about.

CHAPTER 26

SEE THROUGH
ANOTHER'S LENS

The journey that brought me to Missoula, Montana, actually began decades earlier. I studied journalism at the University of Wisconsin–Eau Claire in the late 1980s. As a journalism student, I believed I should try to understand as many different kinds of people as possible.

At the time, I knew very little about the military. There were people in my life who were veterans. My father served in the navy. My uncle stormed the beaches at Normandy, though he never talked about it. One of my best rock-climbing buddies back in the day was infantry for Desert Storm and slept in a body bag in the open desert just to stay warm.

But knowing people who served in the military is not the same as understanding the military. During my sophomore year in college, I retrieved the mail from my tiny dormitory mailbox and found a postcard that read *"You could be a Marine."* I was intrigued. I read the fine print, and it seemed like you could give it a try and quit at any time if it wasn't a good fit. I read it a second time. Then a third. I called the recruiter to confirm the expectations, and we set up a time to meet.

Just before I met the recruiter, I attended my Biology 101 lab. The lesson of the day was about blood typing. Poke your finger, draw a drop of blood, and smear it on a microscope slide. Easy peasy, right? I couldn't do it. Blood from an accident never bothered me, but something about intentionally breaking the skin was a problem. My professor suggested I have my lab partner draw my blood, and the next thing I remembered, I was laying on the floor with the

instructor gently slapping my face, and I opened my eyes to a huddle of class-mates looking down at the lame dude who just fainted from getting his finger poked for one drop of blood.

I didn't tell the marine recruiter about the fainting episode. It didn't seem like the sort of thing you would offer up to your alpha-male sergeant, but I should have taken it as a sign. The previous summer, I had toured as part of the backup band for a semiprofessional show choir called the Kids From Wisconsin. Sequins. Dancing. Jazz hands. It's hard to imagine a more dramatic cultural whiplash than going from a show-choir stage to boot camp in Quantico, Virginia, but it was the path I had chosen.

It turned out that boot camp was hard. There were angry drill sergeants, physical challenges, bad food, and nonstop mental games. Break you down as an individual and build you up as a team. It was the mantra, it was the method, and it was effective. The other cadets endured it because they really wanted to be marines.

I graduated near the top of my class—thirteenth in my company, if I remember right. I certainly wasn't the biggest guy in the company. I wasn't the strongest, smartest, or fastest. I had no outstanding qualities other than having good soldier posture on the drill field. Chalk that up to high school marching band, I guess. But I learned tenacity. I learned determination. And I learned that I could do things that seemed impossible at the outset if I simply refused to quit.

When I signed up for the marines, I thought it would help establish a great exercise routine, but when I got home, I sat in the recliner and said, *"Thank God I don't have to do that anymore!"* I called the recruiter to tell him I was done.

"How come?" he asked.

"It just wasn't my thing," I said.

And much to my surprise, he simply replied, *"OK. Thanks for giving it a try."*

Now, I promise you that going through a six-week boot camp for the marines does not qualify you as an expert in the military, but it does give you some insights. It does give you a taste of the culture and a sense of the ethic. It offers lessons in teamwork, perseverance, honor. It does help you understand a little bit of how the military community perceives the civilian world and how they think the civilian world perceives them.

There is no question that a military/civilian divide exists in our society. Less than 1 percent of US citizens currently serve in the military; less than 10 percent of our total population has any military experience at all. If you are not from a military family, there's a good chance you don't even know anyone who serves.

I have lived on both sides of that divide, so I have been intentional about trying to bridge that gap. I have willfully chosen to invite military voices into the conversation about peace in the hopes of uncovering threads that reveal our connections. The effort is for myself as well as others.

When I tell someone in the military community that I have created a project about peace, I can be greeted with a healthy dose of skepticism. When I tell my peace-activist friends about my work with veterans, the response is the same. Standing in that gap is often an uncomfortable experience that yields new insights.

The Vietnam War era left our country deeply divided. Peace activists treated returning veterans poorly, and an antagonistic dynamic of "us versus them" was deeply entrenched. Both sides fan those flames of disapproval and judgment. Personal damage was done, and there was very little room for effective dialogue between the two groups. Are there exceptions? Of course. But it is common to find a wedge of perception, trust, and worldview driven between the two communities. As in so many other parts of life, there is a difficult history that has left scars, and those can be difficult to overcome.

Jan Selby, a friend and filmmaker, had just completed a feature-length documentary called *Beyond the Divide* about veteran Dan Gallagher and peace activist Betsy Mulligan-Dague in Missoula, Montana, who had found interesting ways to work together. Jan agreed to connect us.

I first met Dan, who served in the US Army in Vietnam from 1966 to 1967—the year I was born—and he told me about the harsh reality of returning to American soil after his tour. I had always seen the Vietnam War in pretty clear terms, with the military as antagonists in an unjust action and the protesters as the heroic resistors. Through my personal lens, my view was the right view until I met Dan, who reminded me that there is more than one side to every story.

Dan had been told that there was a reward waiting after his service and sacrifice, and the biggest was that people would welcome him back with respect. *"When we got back, we thought, 'OK, now we can pick up our lives where we left them. Now we get to go to college, have families, and have a house.' But the reality*

Dan Gallagher

was a shock. I remember a young blonde girl who carried a sign that said, 'Baby killer.' There was so much anger and hatred in her eyes. I wasn't ready for it."

Dan continued: *"We never really had the chance to talk peace with the peace people because everybody was shouting at one another."* Instead of returning as heroes, the Vietnam veterans returned feeling like villains. This led Dan on a journey of depression and self-doubt. He struggled with his memories of the war and his reception back home. It derailed him, and years of his life were lost.

Over time, Dan built relationships with peace activists and started seeing them in new ways. He hoped they would see him—and other veterans—in new ways as well.

He went on to say, *"Time doesn't heal all things, but it does put distance between them. No one who's gone to war wants a war. Little by little, people in the peace community and people in the veteran community began to talk. The peace advocates were genuine. There was a chance, if nothing else, to turn down the heat on the stove."*

Here's what I learned from Dan—that person you see as an adversary might not be. Don't be afraid to be around people who disagree with you, and remember that we are more alike than different.

I had to recognize that the activists I admired so much had also done a lot of human damage to the veterans who served our country. It didn't mean I had to change my view of war, but it did mean I had to change the way I treated people like Dan.

While I was in town, I also interviewed Betsy Mulligan-Dague, the peace activist who was featured with Dan in Jan's film *Beyond the Divide*. Betsy, the executive director of the Jeannette Rankin Peace Center, saw her role as trying to bring people together in the community. As she and Dan established a relationship, they found value and common ground in one another.

The Jeannette Rankin Peace Center presented Dan with their annual Peacemaker Award, and Dan invited Betsy to speak at a Memorial Day ceremony. They both took heat for their work from their own constituents, but they both believed in reconciliation and kept moving forward anyway.

Betsy said, *"Nobody has a corner on the truth. The truth is probably somewhere in the middle of all of us. I think we all have to be willing to be open to those*

times when we are exposed to different perspectives and opinions and do it with compassion and respect."

During our interview, Dan told me how much he disliked the peace symbol: *"It brings back too many memories."* It carries too much baggage, he said. It took me by surprise, and suddenly I was self-conscious. I had proudly presented him with a business card for my project when we first met, and that card had an enormous peace sign on it.

"I guess I've never thought of it that way," I said. *"I've only ever understood the peace sign as a good thing, but now I'm hearing you say it doesn't feel that way to you. It's certainly not my goal to alienate you or make you feel uncomfortable. It makes me wonder if I should reconsider whether I should use it at all."*

"I don't think you should stop using it," Dan said. *"Because it means something to you, and I like it when I hear you talk about it. So people just need to talk. Like this."*

As Dan shared more of his story, I had to understand and recognize that my beloved peace sign actually caused pain to some people. My lens seemed clear at the start of our conversation, but it had blinded me to Dan's view of the world. Dan's experience was different from my own, and it had led him to a different—and understandable—conclusion. But in spite of Dan's strong feelings, when I spoke with Betsy, she told me this:

"We don't agree on everything. I think Dan's favorite thing to say is 'We can learn from each other and understand each other without having to agree. It doesn't necessarily mean that we can't learn something from each other.' He still doesn't like the peace sign, but he's given me several peace signs—jewelry, a little coin that I carry in my pocket that has a peace sign on it. He's come to understand its importance to me, so he is willing to let go of his own feelings about it."

And with that story, I was reminded of Dan's words in our interview together: *"Courage comes in a lot of ways, and it's not always on the battlefield. Courage comes in being willing to reach out to other countries, to other people, other individuals."*

We all see the world through the lens of our own unique experiences and beliefs. It's a part of being human. That lens can help make sense of the world, but that lens can limit us too. It can block us from seeing the world through another person's experience. It can create a type of tunnel vision that is difficult to escape.

CHAPTER 27

SEE FOR YOURSELF

The peace symbol was first designed by a British artist named Gerald Holtom in 1958. It was a part of the Campaign for Nuclear Disarmament. He designed it based on the graphic representation of semaphore, the communications system that uses flags in predetermined positions to communicate from ship to ship or across other long distances.

The semaphore for the letter *N* (as in *nuclear*) is a person standing with their two flags down and out to the sides, like an inverted *V*. The semaphore for the letter *D* (for *disarmament*) is a person with one flag straight up and one flag straight down, in a vertical line. So when he put those two semaphores together and drew a circle around it, Gerald Holtom created what we now recognize as the peace sign.

I've always been fond of the peace sign, but over the past decade, I've developed a practice to make peace signs wherever I go. I build them out of rocks, I draw them in the sand, I arrange pinecones and I tromp down the snow to leave that mark. At first it felt silly, but the more I do it, the more sense it makes.

When I work with young kids around ideas of peace, the exercise of making peace signs offers powerful symbolism for building real peace in the world.

You don't need any special tools to build a peace sign, I tell them. You already have everything you need. Look around and be creative. You can use sticks or stones, pinecones, or thumbtacks on a bulletin board. You don't need special tools to build a peace sign, and you don't need any special tools to build peace in the world. You already have everything you need.

It doesn't take much time to build a peace sign. A few minutes or less, and you can leave a mark that tells others who pass that way that you believe peace

is possible. And it doesn't take long to build real peace in the world. A smile, a kind word, a helping hand for a friend, neighbor, or stranger. It doesn't cost anything but time—and barely any of that.

Some peace signs I've built simply as markers in the landscape, in the hopes that someone passing by would notice it and smile. I built one out of stones in the shallows of a remote alpine lake and the next day encountered a hiker who described her discovery on the trail. We built one beside the Appalachian Trail near Harpers Ferry on the day our friends started hiking the trail one thousand miles to the south. By the time they arrived in Harpers Ferry a few months later, the peace sign we made was no longer there, but the quest served as encouragement anyway, and they decided to build their own for others to find along the path.

Some peace signs I build as an intentional sign of healing. I built a peace sign at Kent State, at the site where Jeffrey Miller fell when he and three other students were shot and killed by the Ohio National Guard during an antiwar protest in 1970. There were short, flat-topped posts to mark the exact site where Jeffrey had fallen, and people left small relics, tokens, and memorials on top of the posts. I gathered small pebbles and built a peace sign on the top of one of them as well.

At the Ground Zero memorial, on a rainy eve of 9/11, I wiped a momentary peace sign into the water droplets between the names of those who had been lost.

In Mississippi, I found the site where Emmett Till's lynched and beaten body had washed up on the shores of the Tallahatchie River three days after he was killed in 1955. My friend George was with me on this trip. We first visited the Tallahatchie County Courthouse in Sumner, Mississippi, where the men who killed Emmett were acquitted by an all-white jury. Across the street was an interpretive center, but it was Sunday afternoon, and it was closed. A faded note in the window provided contact names and information, and I started dialing numbers and working my way down the list until someone picked up.

I asked if it was possible to visit the river site, and the voice on the other side of the phone explained that it was hard to find. The sign had been removed because it kept getting shot full of holes by rifles, handguns, and shotguns. *"How recently?"* I asked, hoping it was decades ago. He said 2016. I wondered

Kent State University

9/11 Memorial

out loud how anyone could believe our country had moved past its race issues when things like this were still happening.

He wanted to make sure I had four-wheel drive because it had been raining and the route was on a dirt road. He wasn't sure it would be passable, but he offered detailed directions so I could try. The clouds hung low and delivered an occasional mist. We drove the tar roads that brought us close, crossed over the railroad tracks he had mentioned, and found the one sign that was still in place, pointing toward the river site. I counted seven bullet holes in that sign.

It was a remote and rural setting, and as I passed the occasional car, I wondered if the person inside was the kind of person who would have felt grief at the story of Emmett Till or if they were the kind of person who would have shot the sign pointing the way to where his body had been found. It was uncomfortable. I wanted to take a picture of the sign with the bullet holes, but I was hesitant. I wondered how it would play out if someone drove by when I was taking pictures, depending on who that driver was. I decided to photograph the sign on the way out because I didn't want anything to derail my visit to the site.

So we turned right on a dirt road that paralleled the river. We drove slowly, our view of the water obscured by trees and undergrowth, even though it was early spring and the leaves had not yet budded. The man on the phone had given me precise mileage to the site, and I watched the odometer tick off the distance in tenths of miles. He said we would know the site because the two concrete pedestal bases for the removed sign still protruded from the ground. We found it.

We pulled onto the small gravel pad and shut off the truck. The ground was soft from the rain. We followed a rough path a few dozen yards to the bank of the Tallahatchie River, its chocolate waters running high. The shoreline was wooded and lined with tall grasses and dried reeds. In the one small spot in front of us, the bank was clear, and it was possible to imagine the scene from 1955 when Emmett Till was found there.

We stood quietly for a while, the clouds still low and heavy, like the mood. Then, with no other way to respond, I started breaking off dried reeds. I broke them into lengths of eighteen to twenty-four inches and gathered a handful. George gathered some as well. And at the banks of the river, we laid the reeds, one at a time, to build a three-foot peace sign on the damp earth.

It wasn't going to change the facts or alter the historic record. It wasn't going to fix any of the pain that echoed through the years and into today. It was

a personal act of bearing witness. It was a moment to acknowledge the pain of what had happened at that spot. To recognize the human tragedy on the individual and grand societal levels that brought us to that very place on that very day. It was simply a small gesture of healing and a whispered commitment that we could find a way to do better.

Together.

When the world only knows one thing about you, and it is an awful thing, how do you get them to see anything else that you have to offer? Without a doubt, there are other things, and if a person took the time, they could see them. But how do you get them through the door? How do you get them past the initial reaction of *"No thanks—I know all I need to know"*?

Hatred still exists in the world, and a full reckoning with the state of our society requires us to look at it with a steady gaze. As Nick and I made our way west, we planned to pick up Brenna and Karen in Spokane, Washington, and we had a day to explore before their flight arrived. We decided to spend it in Coeur d'Alene, just forty miles east of the airport.

There were just two things I knew about Coeur d'Alene, Idaho, before I'd ever set foot there. First, the city was located in a stunning setting of mountains and lakes. And second, Coeur d'Alene had a troubling history as a hotbed of white supremacist activity.

I am sure the local tourism office would have been pleased about my first observation. Not so much the second. I think about that sometimes, as headlines play out. What do you do if you are the tourism officer for Flint, Michigan? How do you recruit new students to attend Sandy Hook Elementary? What are the positive attributes of Three Mile Island? Waco? Ferguson?

It's true for communities. It's true for entire countries. It's true for individual humans as well. I wanted to be in the town for myself and understand if I could see beyond my first impressions.

I was right about the landscape. Coeur d'Alene is nestled into a valley at the end of a long and winding lake. As Nick drove the route, we marveled at the steep and heavily wooded mountains. The main road led us through the downtown shopping district to a vibrant waterfront with a busy beach, a public park, and active floatplane docks. We grabbed lunch at Hudson's, a 110-year-old burger joint where you can get a hamburger, cheeseburger, or ham and egg

sandwich. And after lunch, we hiked around Tubbs Hill, a 165-acre rocky knob of parkland beside the lake just steps away from downtown. Coeur d'Alene was gorgeous.

But I was right about that other part too. I did a little reading and learned more about the history of the town.

In 1974, Richard Butler bought twenty acres outside of town that became the headquarters of the Aryan Nations. Butler became a magnet for other hate groups. He led marches and rallies. Pretty soon, Coeur d'Alene was in the news and on the map—for all the wrong reasons.

The tourism office didn't like it. The local realtors didn't like it. The shop owners didn't like it. Regular, decent human beings didn't like it. Who would want to come to a town when the only thing they ever heard about it was that it rolled out the welcome mat for the likes of the KKK? Not only was the white supremacist presence bad; it was bad for business.

The town organized against the Aryan Nations. When Butler held a rally, there were counterprotests. In one of my favorite acts of creative resistance, the town organized a pledge drive. When Butler and his crew would march, area businesses would donate a set amount for every minute that they marched, and the money would be given to a human rights organization.

So the white supremacists had some choices. They could cancel the march and make sure they didn't raise any money for human rights. They could march quickly and raise just a little money. Or they could march slowly and raise a nice big pile of money for groups that would counter their hateful message.

I was told the newspaper ran headlines like "Richard Butler raises $34,000 for human rights."

Eventually, there was a violent conflict at the compound when a backfiring vehicle was mistaken for gunfire and Aryan Nations guards fired on the car and harassed its occupants. The Southern Poverty Law Center helped try the case in 2000 and won a large judgment that included the forfeiture of the compound. The buildings were burned to the ground in a firefighting training exercise, and the property has remained unused ever since. It was left to heal.

I felt compelled to see it.

Of course, similar to the Emmett Till site, the former Aryan Nations compound wasn't listed in the "things to do" section of the tourism website. There was no sign marking the spot. Local officials wanted to make sure it didn't

become a pilgrimage destination for other white supremacists. Some people didn't want to talk about it, but after a short search, I found a realtor who was able to give me directions, and Nick and I drove out of town to find it.

Even with the directions, the location of the former compound was hard to pinpoint. In a rural setting, there were plenty of fields and woodlands that could have fit the description. A woman in the vicinity was in the yard of her small farm, feeding animals. I decided to stop and ask without fully thinking through what our presence and our request might look like to her. I stepped out of the truck and felt her cautiously sizing me up. I wondered what she might think about me, and I started to wonder what I ought to think of her.

I was asking if she could tell me where her old neighbors—the white supremacists—had lived. And suddenly that felt like an odd question to ask.

I couldn't be sure if she had known them. Or if she had liked them. I didn't know if she thought the legal judgment against them was fair. Or if she sympathized with their cause. Had she perhaps marched with them? Or against them? I didn't know if she thought I supported them or was one of them. If I was a journalist or a troublemaker.

As we talked, it felt like she was trying to figure me out, and I suppose I was doing the same. How would I react if two white guys in a pickup truck pulled up looking for the Aryan Nations compound? What would I make of them?

In the end, it seemed like our presence was uncomfortable, so the exchange was brief. She pointed us toward the property. I thanked her, and we drove to the site, following her more detailed directions. There was really nothing there but a gravel drive and a locked gate. There were trees, like the rest of the area, but nothing to identify it other than the visceral sense that something ugly had been there before. I made a peace sign out of pinecones on the ground. I tucked a little peace card into a split in the fence post. It was a small gesture of healing on a piece of land scarred by human hatred.

Driving away, I still wasn't 100 percent certain we had found the right place, but if it wasn't the exact location, we had been close. We later learned that the twenty-acre compound had been bulldozed to create a future peace park.

Sometimes when you build a peace sign, it doesn't last. Build one on the beach too close to the water and the waves will soon erase it. Make one out of small

sticks and the wind might blow it away. Someone could walk past carelessly and accidentally scatter your peace sign made out of stones or maybe even intentionally disturb it. Unfortunately, the same is true with building real peace in the world. Not everything is permanent. We may spend time and energy to do something positive to create a little peace, but the wind might blow it away. Or other people might destroy it—by accident or on purpose.

But here's the great thing to remember—if your peace sign gets disturbed or destroyed, you can repair it. You can rebuild it. You can move the sticks back into place. You can rearrange the stones. And it's like that in real life as well. If the peace you build gets disturbed, you can rebuild it again and again and again. Each time you practice, it becomes easier, and pretty soon you'll be an expert at making peace signs—and at making peace in the world.

Perhaps your peace sign will encourage someone who needs it. Maybe your peace sign will remind another that they can choose healing instead of harm. Perhaps it will simply say, *"I was here"* and *"You are not alone."* If you're really lucky, and really persistent, maybe your peace sign will encourage someone else to make one of their own, and then your efforts will have rippled out and multiplied beyond what you could have done on your own.

Back in town, it was supper time. Nick and I found a brew pub along Coeur d'Alene's main drag with outdoor seating. It was a perfect night. The beer tasted good. The building was set back from the road, and patio seating was in the front. It was dusk on a summer night in a resort town, and people were cruising the strip.

Before the food came out, it got louder on the road out front. Pipes rumbled. Horns blared, and people shouted. I looked up and saw a half dozen pickup trucks parading down the strip. Windows down. Music turned up. Confederate flags waving, and passengers whooping and hollering.

They made another pass. Then another.

I stood up from the table and walked out to the street. Just to see it. I took out my phone and took a photo. Just to remember it. And then I thought, just because a thing is in the headlines doesn't mean it is the only truth about a place. And just because a thing is out of the headlines doesn't mean it no longer exists.

The voices that want to divide are loud. The ones who want to unite must not be silent in the face of it. That doesn't necessarily mean we need to out-yell the others. But it does mean that we need to consistently show up for one another and uphold the values of connection, community, and the common good. It is our responsibility, and it's up to each one of us to recognize our own ability to respond.

CHAPTER 28

MOVE TO THE EDGE

There is a rule about road trips that I have learned through the years: if you are in a tiny little PT Cruiser, you will be able to fit everything you need inside, but if you have a giant truck, you will pack more things and somehow fill the entire space. Nick and I had spread out during our week on the road, and we had some serious repacking to do if we were going to fit Brenna and Karen into the truck.

We had spent the night outside of Coeur d'Alene at a roadside RV park and awoke to beautiful weather. We pulled all of our gear out of the truck and piled it high on the picnic table until it gave the impression that we had opened our own pop-up flea market stand. Then we began the slow process of reloading things in a more organized fashion. In the end, we had two empty seats in the truck, and we headed for the airport.

Karen and Brenna climbed in, and we continued driving west toward Holden Village, an intentional community nestled in a remote valley of the Washington Cascades. People visit for a few days, a few months, or a few years. It's a retreat center with a fifty-year connection to the Lutheran Church, but it welcomes anyone interested in contemplating faith, community, and connection to the earth.

I had dreamed of Holden for years, and even though I had never visited, it had become a sort of spiritual touchstone. In 2010, I had interviewed Chuck Hoffman for my first book when he was the artist in residence at Luther Seminary in Saint Paul, Minnesota. Chuck and I had stayed in touch, and now he and his wife, Peg Carlson-Hoffman, had just begun a five-year term as codirectors at Holden. Chuck spoke of his vision for Holden as an incubator of sorts, to inspire, equip, and connect people seeking change and send them back down the mountain to create a more sustainable and just world. He invited us to stop on this big western loop.

Ordinarily, summers at Holden Village were bustling with guests. But the village was an old copper mining camp, and there were some environmental concerns around the tailings that remained, and so instead of guests and programming, the village had closed to the public for a few years to host mine workers who were heading up a remediation project.

Our plans were all tentative: Earlier that summer—in fact, the day after Chuck and Peg had been installed as directors—the forest service knocked on their door to inform them that lightning had started a forest fire near the village. *"It's not a threat right now,"* Chuck had mentioned by email as we planned our visit. *"But if something changes, we may need to evacuate on short notice."* The small core of Holden staff who remained were hungry for a little programming, and the plan was for us to stay for a few days to talk about *A Peace of My Mind* while doing some new interviews in the village.

The trip to Holden itself is an adventure. You can't drive there. You can't fly there. Instead, you commit to a journey. We unloaded our gear on the shore of Lake Chelan, using wheelbarrow-style luggage carts to carry our bags to the end of a heavy wooden dock where we waited for the *Lady of the Lake* passenger ferry to pick us up. As the boat made its way twenty miles up the wilderness lake, the air became hazy and then thick with smoke. The Wolverine Creek Fire was the one that most directly threatened Holden Village, but it was not the only fire in the area. Wildfires from farther west in Washington and to the north in Canada also raged that summer.

By the time we arrived at the dock in Lucerne and climbed off the ferry, it was difficult to see the mountain ridges surrounding us, and we could taste the smoke in the air. From Lucerne, we climbed on an old yellow school bus (ours was named Linnaea) for an eleven-mile drive up a gravel road and into the village, a small cluster of modest, historic lodges and cabins surrounded by rocky peaks. For the few days we were in the village, the sky was either cobalt blue or filled with smoke, depending on the direction of the wind. The slow and easy pace of the community was balanced against the awareness of the nearby fire and preparations to evacuate if conditions worsened.

I decided that it would be an interesting thread connecting my two books if I could interview Peg for my *American Stories* series, and she agreed. Peg had been a corporate art director for Hallmark in Kansas City. Now she lived in the wilderness. Peg was an artist, like Chuck, and we met in the village pottery studio, a long, narrow space that was flooded with light.

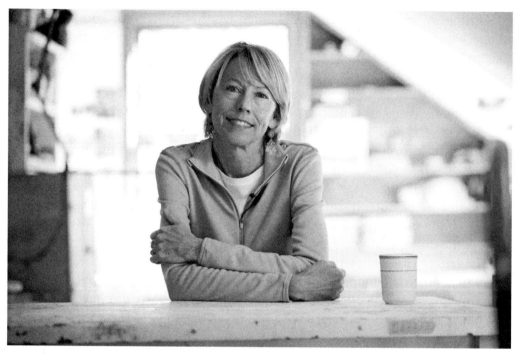

Peg Carlson-Hoffman

Peg told me that in Holden, there's no grocery store, there's limited cell and internet service, and you can't drive a car.

"So Holden is pretty remote," I commented. "What's the appeal?"

"It's living on the edge. It's on the edge of the wilderness, and it's on the edge of what we typically think of as civilization. Living on those boundaries gives you an opportunity to discover the things that you can only discover on the edge, I think."

Being uncomfortable and living on the edges of life allow you to see the world in new ways, and this resonated with me. It was through visiting new places that I made my own discoveries. I asked Peg to talk about how relationships worked in such an isolated place.

"Holden is sort of connection on steroids. Every day offers the opportunity for conflict and opportunity for conflict resolution. At Holden, there's opportunities to experience conflict with each other just because of the tight quarters that we share. I mean, there is nowhere to go in Holden. You can go hiking, but you can't go very long, and eventually you have to come back because you need food and there's nowhere else to get it out here. We have a lot of places for personal growth and peace in between each other and ourselves."

"What about the mine work going on right now?" I asked.

"Mine remediation is really hard on the land. Things have to be blown up, and trees have to be moved and cut down, and there's bulldozers. Even though you know it's like the healing process and the patient is being worked on, it feels like there's a certain amount of violence happening to the land. How those things can come together is another opportunity for peace between the land and the people that live on it."

When you first arrive at Holden, your bus stops at the edge of the village for a safety briefing. You talk about fires and bears and signing out for hikes. Looking up the road, you can see the entire village gathered to welcome you, and when the bus finally rolls toward them and opens the doors, you are greeted with cheers, songs, and hugs from people you've never met before, a Holden tradition. Everyone is sent off this way too. It can feel a little overwhelming to a newcomer. Peg explained the significance.

"When I first got here, I didn't like saying goodbye, but then I started really paying attention to this whole coming and going in Holden, and I realized that it really imitates life. When you practice saying hello to everybody that gets off the bus and then likewise you take the time to say 'Thank you for being here, it was

great while you were here and now you're off to your next thing, and we're without you but we'll be OK,' there's just such a great daily reminder of our impermanence on the planet and in this place. Every day people leave us, people that we love. Just being aware of that on a daily basis is extraordinary because you realize how impermanent we are, and it makes you just so grateful for the time that you can spend together.

"If you can live in that kind of awareness, you can just live in a different sense of joy—that you're here with who you're here with today, and that is fantastic."

My dad had died just a few months earlier, and Peg's words resonated in that way as well. We try to hold on to what we love, but not everything is meant to last forever. Saying goodbye was a difficult but necessary skill.

Peg went on to talk about her and Chuck's conflict resolution work as well as their creative process as artists, including painting together on the same canvas, which she called *"an insane thing to do as an artist."*

"We had an opportunity to paint a very large painting, and we did not have time for either one of us to do it by ourselves. We painted it together, and what we found was, the painting that we created didn't look like what Chuck would paint, and it didn't look like what Peg would paint. It looked like a third thing, something that neither one of us could have come up with on our own. We had a moment of thinking, 'Oh my gosh, that's what it really means to us to have some sort of resolution.'

"In a way, that's what peace meant. It's not a compromise; it's a new idea. It's something totally different. When we direct here at Holden, we have Chuck's ideas about what we should be doing, and then we have Peg's ideas about what we should be doing. Usually, neither one of those is just the right thing. When we work together and we get all of our information and our stories out on the table and we mix them up and make a recipe, there's usually that third idea that is the most amazing thing.

"I think that's what has to happen on the planet. I think there have to be opportunities for us to come up with, not a left idea or a right idea. We can't be in our own little boats rowing around and just avoiding each other. That's not going to work. There's something there to be mined, to be discovered—about what you want to do, kind of, then you start working into it. It talks back to you, then something else happens that you didn't know was there. I love that."

As I spoke with Peg, fires of discontent smoldered in our country, and the Wolverine Creek Fire continued to burn just down the mountainside. That

afternoon, we all participated in an evacuation drill. The bell sounded. People met outside of the dining hall, accounted for one another, and loaded onto the buses. Smoke from the fire drifted up the valley and gave everyone a sense of urgency that underscored the need to be prepared.

The village was equipped with a heavy-duty sprinkler system that showered and soaked the village each morning and would be an important part of protecting the structures if the fire worked its way up the valley.

Overnight, the wind shifted, and the fire suddenly spread from 150 to 1,500 acres. At breakfast, we were told it was time to leave. Same drill as the day before, but this time the evacuation was real. It was actually the day we were planning to leave anyway, but now the rest of the village was coming with us. We loaded up and rode down the mountain in thick smoke toward the ferry dock.

I had known about Holden for years. I had fallen in love with the place before I had ever even seen it, and when I finally arrived, the sense of community and intentional living made it even better than I had imagined. And now, as we waited to board the ferry that would take us away, it felt like there was a very real chance that this special place would go up in flames.

It was hard to say goodbye.

In the end, the Wolverine Creek Fire burned more than seventy thousand acres. Thanks to the hard work of the hotshot crews, the industrial sprinkler systems, and perhaps a little divine intervention, the fire split and went around the village. The forest surrounding Holden burned, but the village was left standing, a sort of green oasis in a charred landscape.

The next year, we returned—exactly one year to the day of our evacuation. Black, charred stumps stood where forests had been before, all offset by brilliant purple fireweed, the first life to return to burned landscapes. It seems all things have seasons. Holden after the fire wasn't quite what we had left. It wasn't quite what I imagined it would be. It was a third thing. I had left expecting devastation, but I returned to find new life.

CHAPTER 29

WELCOME NEW IDEAS

The story of America is often told as a story of immigrants, of people who have come to this country to make it their home. There are exceptions, of course, and my conversations with Eugene Joe, Sheila Goldtooth, and later Myron Pourier underscored that fact. But it has become a familiar part of our national narrative that many of us come from somewhere else.

There are stories of relocation generations ago and others that are more recent. The conversation around immigration was becoming increasingly charged in our country. The issue was relevant nationwide but frequently focused on our 1,954-mile frontier with Mexico. The debate included all immigrants, but much of the most heated rhetoric centered specifically around undocumented immigrants from south of our border.

Since we've gathered these stories, our national conversation has become even more fraught as the Trump administration moved to deliver on campaign pledges to build a wall, as the Department of Homeland Security established policies to separate children from their families at the border, and as the number of asylum seekers allowed into our country was drastically cut.

Again I wanted to amplify the stories of individuals who could personify the complex issues surrounding immigration and offer a human dimension to the headlines we read every day. I started exploring what might be possible, and eventually, my various contacts led me to two very different stories from near Los Angeles, which was my final stop on the West Coast before turning toward home.

I met Cesar through a thread of requests that started with a civil rights attorney, led to a series of advocacy organizations, and ended with a text message

that simply read *"You can meet Cesar tomorrow morning at 9am"* and included an address in Riverview, California.

Cesar was a handsome young man, about my daughter's age. Dressed in jeans and a T-shirt, he was kind, soft-spoken, and slightly nervous. We met in the office of a community organizer, but it was a Saturday, and we were the only ones there.

Cesar's hometown in Mexico became increasingly dangerous due to drug violence, and when Cesar turned sixteen, his parents decided to send him to the United States. He made it across the border on foot during his second attempt, and he quietly recalled part of his journey:

"We talked to this person that could cross people over, so we went with that guy. We went to the state of Puebla, and then from there, me and a group of about thirty people took a bus to the frontier [of] Arizona to a place called Caborca, I believe.

"There, we tried to cross, but there was another group of about five people, and the lead people were saying that it wasn't safe because the travelers were smuggling drugs, and they kidnapped about fifteen other people and then they beat them up."

Cesar's story was matter-of-fact, relating the significant risk that immigrants are willing to face in order to reach their destination.

"We had decided not to cross at that moment, so we traveled to another place called Altar, which is the pit stop for immigrants. I have never seen a place like that in my life. I would see buses full of people just trying to cross. Pretty much the way it works there, they have everything for people trying to cross. They have backpacks of water, anything that you need just to try to cross."

As I reread Cesar's story today, I am reminded of a highly publicized trial in 2019 that tried Scott Warren from the faith-based organization No More Deaths for offering food, water, and shelter to two undocumented immigrants who were in distress after crossing the border and losing their supplies. The trial was part of a federal border crackdown that sought to criminalize humanitarian aid in an area that sees hundreds of immigrants die each year as they cross the harsh landscape. Warren was found not guilty of the charges.

"We stayed there for another week just trying to figure out when was the safest time to cross. The guy that was crossing us, he said that it would take more time for us to cross, which means more money, but if we wanted to, we could go to another guy that he knew. He said that he was reliable.

"We went to that person and he said, 'Yeah, I could get you across in forty-five minutes.' We went with him, and we walked about a day and a half, and we got to

this ditch where we were taking a break. Some of us were napping. The guy says, 'I'll go to the hill to look out, and I'll be back in thirty minutes.' He leaves and I was just laying on the ground, just resting. I see these two gentlemen walking towards us, and I didn't pay attention. I thought they were immigrants trying to cross us.

"When they got closer, I noticed they had covered their faces. As soon as they got to us, one of the guys aims a gun at me and tells me to turn, not to look at him, so I did. I turned, and he asked me if I had anything on me—drugs, money, whatever."

Cesar and his group lost all that they had but continued walking toward the border, and eventually they simply walked across. They reached a safe house where transportation had been arranged, and he was driven to San Bernardino, California, where some of his extended family lived. He started working with his uncle building houses and continues to work small jobs to make ends meet.

"I try to live a life as normal as possible, if I can say 'normal.' I don't think I'm weird or anything, but I just try not to think about me being deported, even though it's a constant fear every day when I'm out driving and I see a cop car—it crosses my mind. Then it's like, 'I might get deported.'

"I try to be a good standing citizen. I pay my tickets. I pay my taxes through an ITIN number because I don't have a social. I try to go to school, get a job, live a normal American life, hang out with my friends, maybe every now and then go out to eat, have a drink, talk to pretty girls, just try to be normal. I love the people. I love the cities even though there are some people that don't like us here. I try not to pay attention to those people."

I asked Cesar if he was nervous talking with me. Being recorded. Having his picture taken.

"I am somewhat scared. I am, but think it's important people put a face to the issue. We're not just numbers. We're just not eleven million people living here illegally. I'm a student. I'm a son. I'm a brother. I work for my community. I help around. They need to see that. They need to see that whenever they talk about undocumented people, undocumented immigrants, or whatever they want to call it—illegal immigrants—although I find that very offensive. Illegal—there's no such thing as an illegal human being."

According to the Pew Research Center, in 2018, there were nearly forty-five million people in the United States who were born in another country. Seventy-seven percent of the immigrants are documented, while about one-fourth of

them are undocumented. While the percentage of immigrants in our population has grown in the past fifty years to a current 13.7 percent, our historic peak was in the late 1800s, when 14.1 percent of our population was made up of immigrants, many of whom came from Ireland, Germany, England, and other European nations at that time. And although the rhetoric is loud, two-thirds of Americans feel that immigrants strengthen our national fabric through their hard work and talents, while just a quarter disagree.

"It's just that little bit harder for us because we're not allowed or permitted legally to work here in this country, but there's ways we can help. There's things we can do to change that. We don't ask for much, just the ability to work and be part of a productive society."

Like everyone in the project, Cesar offered his full name during our interview, but as we talked, it seemed prudent to use only his first name as we shared his story. I was grateful for the insights Cesar shared that day. He worked hard. He shared his story to help others understand what he and so many others have experienced. He had navigated dangerous terrain in his young life, and there was no reason to expose him to more.

I heard a very different story when I met Julissa Arce. She worked as an immigration rights advocate and was scheduled to speak at the University of Nebraska in Omaha (UNO) that fall, where I was scheduled to install one of my exhibits. The woman at UNO who coordinated both events connected us, and Julissa and I were able to meet at her home in Hollywood. She was born in Mexico and came to the United States with her parents when she was eleven. Three years later, her visa expired. She was just finishing a book about her journey called *My (Underground) American Dream* as we met at her apartment in West Hollywood, with her cat roaming around our feet.

"At fourteen years old, I was a freshman in high school and was worried about things that freshmen in high school worry about. I wasn't worried about getting deported. The first time I really realized that being undocumented was a problem, like a real problem, was when it was time to go to college. I thought that I had done all the things that I needed to do to go to a top school. I'd gotten really good grades. I was part of a bunch of clubs and had good recommendations from my teachers. I helped my family at the family business. I thought I did everything that I had to do.

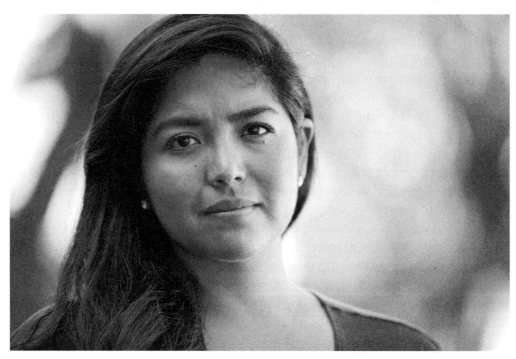

Julissa Arce

"Then I keep getting rejection letter after rejection letter because I was leaving one piece of credit information out, which was my social security number. That's when I was like, 'Oh, being undocumented is a real thing.' It's really going to affect my life, and I might not be able to go to college after all."

Julissa was living with her family in Texas, and in 2001, Texas became the first state to allow undocumented students to pay in-state tuition for public universities. Julissa was able to work hard and pay for her own education.

Julissa was offered an internship at Goldman Sachs, then a full-time job, and she eventually rose up to be a vice president, all while being undocumented. She received a green card when she married a US citizen. She told her story with confidence, perhaps a bit amazed herself at the turns her life had taken.

"If I was working as a waitress or as a dishwasher at a restaurant and I'm Hispanic and my English isn't very good, people are going to look at me twice. Because of the stereotypes that exist in this country, a woman who's working at Goldman Sachs, who graduated cum laude from a top-five business school in the nation—no one was ever going to look at me or my credentials and think twice about them. They were just going to take whatever I said at face value."

Julissa expressed her frustration with an immigration process that seemed broken.

"A lot of people just say, 'You should just have gotten in the back of the line.' Get in the back of the line. If there was a line that I could've waited [in], I would've been waiting in that line from the first minute that I became undocumented.

"There wasn't that line—I came here legally. I never crossed the border illegally, and the fact that I married a US citizen, I could adjust my status. For a lot of people, even if they marry a US citizen and even if they have US-citizen children, if they cross the border illegally, they cannot adjust their status under the current laws. There's no way for them to become documented.

"I fixed my status, got a green card, a real social security card, and kept going. It was such a relief to have this little piece of paper. In a lot of ways, I was free, but I always knew that I wanted to become a citizen."

She paused every once in a while and made eye contact with me, maybe wanting to be certain I was keeping up with the enormity of it all.

"Getting a green card allowed me to work, allowed me to come and go as I please. I still couldn't vote. I still felt like a foreigner in my own country. I had to wait five years from the time I became a resident to the time I could apply to

become a citizen. I guess I wasn't really expecting to feel different because I have felt American for a really long time, well before I ever got a piece of paper that said that I was.

"But I have to tell you that reciting the oath of allegiance in a courthouse in New York City and officially being recognized by my country was a pretty sweet thing."

Julissa was able to change her own status, but that wasn't enough. She wanted to advocate for others. So she left Wall Street and started sharing her story to try to shed some light on the real issues of immigration reform. As our conversation progressed, she spoke of the unfair accusations she heard leveled against undocumented immigrants.

"If there was unemployment in America, it must be because illegal aliens are taking the jobs of Americans. If there's violence in the country, it's because all the undocumented people in the country are criminals and rapists."

The advocate in Julissa sat up straight and leaned in. Her finance background infused her statements with relevant statistics. The storyteller in her wove a loud and clear narrative.

"It's really easy to place the blame on a group of people who don't have a voice, who don't have a say, who don't have representation, who never get to speak on national television. I'm a numbers person; I love economics, I love finance. I think all of these problems, the national debt, how is it possible that we can blame eleven million people for all those problems?

"However, politicians have been doing that every single year. You see it now in the political debate. Immigration is at the center of it, but it's not for the reasons that it should be at the center."

She paused and shook her head. Furrowed her brow.

"The reason immigration needs to be part of the national debate is because there are eleven million people who currently cannot live as full human beings. There are eleven million people who every day have to be scared of being separated from their families. Every day they have to be scared that if they're driving down the street and they get pulled over, they're going to get deported. I know what it's like to live in that fear.

"That's why it should be at the center of the conversation—it's a human rights issue."

CHAPTER 30

CHANGE IS POSSIBLE

Toward the end of this five-week road trip, I was getting tired. We made it to Vegas, and the next morning, I dropped Karen and Brenna off at the airport to fly home. I had about 1,500 miles and a few more interviews before I would be back in Minnesota myself. There was an appointment scheduled in St. George, Utah, and another on the Pine Ridge Reservation in South Dakota. I had time for more, but I was running out of energy. The idea of driving the rest of the trip alone suddenly weighed heavily. It had been a treat to have family on the trip, and while I usually welcomed the quiet of a long drive alone, the moment they stepped out of the truck, the silence just felt lonely.

I turned up the radio and rolled across the desert toward St. George as I considered how to use the rest of the trip well. Generally, if I had an open day, I enjoyed the puzzle of how to fill it. I embraced the last-minute scramble to see what gem might fall in my lap. But now—at the end of a long run—it felt more like a burden. I wasn't sure of my exact route or timing, so it was hard to focus my search for possible subjects.

My Coleman tent was in the bed of the truck, so I decided to allow myself a day to camp in one of our national parks to let the wilderness reinvigorate my weary soul. During a gas stop, I browsed the map and saw that I could easily work either Zion or Yellowstone into the route and still make it to Pine Ridge in time. A heat wave had settled over the Southwest. Temperatures had hovered in the triple digits for more than a week, and camping in a sauna was not appealing. The weather forecast predicted 107 degrees in Zion and 38 degrees in Yellowstone, so it was an easy choice. I had been sweating for weeks. The prospect of shivering for a day and a night sounded pretty good.

After recharging in the cool mountain air of Yellowstone, there was one last interview scheduled in South Dakota, and it deserved my full attention.

Myron Pourier is the great-great-grandson of Black Elk, also known as Heȟáka Sápa. Black Elk was a medicine man and a visionary of the Oglala Sioux born in 1863. He was related to the warrior Crazy Horse, and he was present for both the Battle of Little Bighorn and the Massacre at Wounded Knee. While Black Elk spoke of his vision of unity for all people, he also never lost sight of the dream of reinvigorating the traditional and spiritual practices of his people.

Myron lives on the Pine Ridge Reservation in South Dakota and has proudly served in the US military as well as on the tribal council of the Oglala Sioux.

Myron was working to change the name of Harney Peak, the highest mountain in the Black Hills of South Dakota, to Black Elk Peak. In 1896, the mountain, sacred to many Native Americans, was named by Europeans after General William S. Harney, who led an 1855 battle that resulted in the massacre of nearly one hundred Oglala Sioux men, women, and children.

When Black Elk was nine years old, he had a vision that he related later in life: *"I saw that the sacred hoop of my people was one of many hoops that made one circle, wide as daylight and as starlight, and in the center grew one mighty flowering tree to shelter all the children of one mother and one father. And I saw that it was holy."*

Late in the 1800s, Black Elk became involved in the Ghost Dance movement, which sought to use song and dance as ritual to rid the land of white settlers and restore the balance of Native life. But as it became clear that his people would inevitably lose their land, Black Elk turned to the spiritual realm to help his people find peace with their forced change.

The land around Porcupine, South Dakota, is sparsely populated. A part of the Pine Ridge Reservation, the annual household income is about half that of the national average. Myron had told me to call for specific directions when I got to the convenience store at Sharps Corner, a humble pole shed at the intersection of Highways 2 and 27 on the Big Foot Trail. My cell phone had no service, so I went inside, bought a soda, and asked if there was a pay phone. There wasn't. The woman behind the counter suggested I might do better by driving a little north toward the Thunder Valley Community Development Corporation. Parked on the side of the road, standing in the bed of my pickup, I found enough signal to call Myron, and he talked me in.

Myron lived in a double-wide trailer at the end of a dirt road under the broad South Dakota sky. He was waiting outside. We said hello, and he invited

me in to his kitchen table to set up for the interview. I asked about how he saw his relationship with his great-great-grandfather.

"My job as a descendant of Black Elk is to maintain a peaceful campaign for our cultural diversity, to unify people of all walks of life through a mutual understanding of who we are, and to respect one another through compassion, humility, and love."

It was clear that this connection lived large in Myron's life.

"We use a very powerful word when we finish praying: Mitákuye Oyás'iŋ. *Many people say it's like the word* amen, *but it's not. Its English translation is 'We are all related.' Through prayer, we're all related. Through all walks of life, we are related as one in unity."*

When I asked Myron to talk about some of the obstacles that prevented us from realizing that unity, he shifted the conversation to talk about trust.

"Right now, I don't think there's a group of Native Americans in the United States that trusts the US government or the Europeans. This is based on historical trauma and our treaties being broken continuously."

The Fort Laramie treaties of 1851 and 1868 set aside the Black Hills as territory for the Lakota people, but when gold was discovered in the Black Hills, those promises were broken.

"We had trillions of dollars in gold taken out of our Black Hills, stolen from us. We're the poorest county in the United States. Because we did not have the power and authority, they overwhelmed us and put us on these reservations and broke the treaties."

I had witnessed that distrust before. I had seen it in the eyes of people I encountered and was at a loss for how to rebuild it. Years before, I had passed through Wounded Knee, just south of Myron's home, and saw a government-issued sign marking the spot and relating the history of what had happened there on December 29, 1890.

In the late 1800s, the US military saw the growth of the Ghost Dance as a rising threat, and in retaliation, they arrested leaders like Sitting Bull. At Wounded Knee, they surrounded and attacked a settlement, killing more than two hundred men, women, and children.

My best guess was that the original posting on the sign had read "Battle of Wounded Knee," but someone had screwed a two-by-four over the word *Battle* and hand-lettered in red paint the word *Massacre* in its place. In my understanding of the events, *massacre* was the more appropriate word. I wondered

about the frustration of the people living in the neighborhood when they saw the sanitized language that a distant government used to describe their personal history and tragedy. It was a small act of resistance to customize the sign, but there was power in language and self-determination in the ability to tell your own story.

I drove past the same site on my way to Myron's place that morning and noticed a new sign where the old one had stood before. The official language at the top now read "Wounded Knee Massacre." I didn't know how the official correction had come about, but I took it as a positive—if small—change. Perhaps it was a step toward rebuilding trust. Perhaps it was a symbolic gesture toward bridging the gap. I asked Myron why names were important.

"How do we bridge that gap? We need to take our message to the federal government through peaceful prayer and through movements that bring us together in an honorable way."

And what would it mean to change the name of Harney Peak?

"It would be a big step for the government to rename this mountain Black Elk Peak. It will bring spiritual healing—not only for our people but for all walks of life. It's going to unite many people. It may even be a starting point for a whole new peaceful movement. I know I'm going to continue moving forward through cultural diversity. I welcome those that want to join me on this journey and spread the word to all walks of life. We don't know when we're going to leave this world. Nobody knows but the Creator. My thing is to move fast and move quick and spread the word in a peaceful way."

To change a name seemed like such a small thing to ask for given what the Oglala Sioux had experienced through generations. It seemed like such a small gesture for the federal government to make given their extensive history of broken promises. I could sense how important the request was and how the gesture could be a step toward building trust.

Our time went fast as we wrapped up the interview. Made the portrait. I thanked Myron for his time. I wished him well in his efforts to change the name of the mountain. And I said goodbye.

"The Sioux don't have a word for goodbye," he said. *"We say* doksha akeh, *'until we meet again.' I believe that if I don't see you again in this life, I'm going to see you in the next life.* Doksha akeh. *Until we meet again."*

Those were my grandfather's words. *Until we meet again.* Myron said it to me again as we stood by my truck in his yard, a stiff Dakota wind driving a fine

Myron Pourier

grit over the landscape. *Doksha akeh*. I wanted to remember those words in Myron's traditional language, and I asked if he would write them down for me. I grabbed a pen and an old McDonald's napkin out of my glove box, and he carefully wrote the words and their translation. The napkin is still in my glove box.

A year later, as our *American Stories* book went to press, Myron and those working with him realized success. On August 11, 2016, the Federal Board of Geographic Names voted 12–0 to officially change the name of Harney Peak to Black Elk Peak.

Things change. Not fast enough, but they do change.

CHAPTER 31

HOME

There is a Zulu adage that says, *"I see you. I hear you. And you matter."* It is one of the most powerful things we can say to another person, and stories have the ability to acknowledge and honor in that way. I've seen the impact over and over again.

Our first book—the one that contained stories from Minnesota—was self-published. As *A Peace of My Mind* grew and the scope expanded to a national platform, I was optimistic about finding a publisher for this new collection, *American Stories*. Again, the rejections piled up, and I became discouraged, but finally, it happened. I received an offer from a publisher.

It was a faith-based publisher, which seemed like a great fit because I am a faith-based person. But this publisher was from a more conservative tradition than mine. They said, *"We would love to publish your book if you would just remove the voices of the gay and lesbian people."*

I took a deep breath before responding and said, *"So you want me to take a project that is rooted in listening to the stories of others—whether you agree with them or not—and then remove the voices you disagree with?"*

And the editor said yes.

And I said no.

Creating peace does not mean backing away from your ideals. In fact, I am certain that it requires us to maintain and uphold them. But there are ways to stand firm in your convictions without lashing out.

We sparred around the details for a while. The editor suggested they do a trial edit and shape a couple of the stories they were concerned about. They thought perhaps we could find an edit we could both live with. I was highly skeptical, but I agreed to let them try.

It didn't work.

There was no way I would betray the trust these folks had put in me by sharing their stories and then turn around and erase a part of their story—erase a part of their identity. It simply wasn't my place to do that. So we self-published again.

On September 21, 2016—the International Day of Peace—the same team that helped me produce my first book held a local book release party to celebrate our second self-published book, *American Stories*.

The day after the release party, I was scheduled to talk about the project with a group of fifth-grade students. My exhibit was installed in their school atrium, and I visited each classroom to introduce the artwork, encourage empathy, and answer questions about the project.

One fifth-grade girl raised her hand when it was time for questions in her classroom.

"Have you ever talked to someone from a family where there is a mom and a dad but they are the same thing?" she asked.

I paused to make sure I had heard her correctly.

"Can you repeat your question?" I asked, and she did. I thought I understood what she meant, but I wasn't certain.

"Do you mean a family with gay or lesbian parents?" I asked, and she said yes.

"I have absolutely talked with people like that—Laura Patey's story is the second story in my book. She's married to another woman, and together they raised two sons."

"OK," she said. *"Thank you."*

And after pausing for just a moment, she added, *"Because I have two moms."*

I learned later that it was the first time that girl has spoken publicly about her two moms at school. Maybe there was something about seeing herself reflected in the series that created a space where she felt secure opening up.

I wondered what it would have been like to say to that young girl, *"Sure, we talked to people like that, but we didn't include their stories in the book."*

A small group of Somali girls gathered around the exhibit panel of Imani Jafaar Mohamad, who wore a hijab in her portrait, and you could hear the young girls saying, *"Look, she is like us!"*

A woman experiencing domestic violence shared how she found comfort, strength, and encouragement after reading the story of Amy Robinson, who survived and thrived after leaving an abusive relationship.

A church for people in recovery used the story of Michael Reid as a resource, drawing on his journey of a decade-long heroin addiction and then coming clean as an inspiration on their own path to sobriety.

A Black woman who taught in a predominantly white school district thanked me for speaking at their MLK assembly and helping to amplify some of the issues she had been speaking about for years.

I see you. I hear you. And you matter.

At the end of the day, *A Peace of My Mind* is not a project about diversity, even though there are elements of diversity present in it. It's not about faith, although there is faith in it. *A Peace of My Mind* is not about substance abuse, environmental sustainability, domestic violence, immigration, gender identity, or politics. It's not even a project about peace. It's simply an exploration of what it means to be human and how we can live better together.

I set out to find answers to the meaning of peace and learn about peace for others. What I found instead was a little more peace for myself.

I have been inspired by the people who choose not to hate when hate could have come easily. I have been encouraged by stories of forgiveness in unforgivable circumstances. It was these transformative stories that drew me in and propelled me ever forward. I recognized that the people who had found a way to bridge divides and build connections had chosen to do so. They didn't possess any special skills or magical powers. They had simply made the commitment to do the hard work of staying at the table. They had rejected the temptation of scapegoating and vilification and instead elected patience, dialogue, and relationship.

If we want to get better, we have to be brave. We have to make ourselves vulnerable and start those difficult conversations however and wherever we can. We have to go outside of our comfort zone and expose ourselves to new ideas. At first, we're not going to be good at it. We have not exercised those muscles, and it will feel unnatural. But the second time you do it, it might be easier. You will have learned things, and it won't feel so unfamiliar. By the time you have navigated a dozen conversations, you will start to find your footing. And it's OK to practice. In fact, it's required that we practice, and in the process, we will get better. I hope along the way, we can have some grace with each other when we make mistakes.

Perhaps the most common question I am asked by students is *"Which story is your favorite?"* It's a hard question to answer, and it feels a little bit like being asked to choose your favorite child. Some days you can do that. And some days the answer changes.

I've spent years trying to answer the question of which story is my favorite. The answer changes based on what resonates with my own life at the moment. It changes based on the day's headlines and the people I'm with. There is wisdom, beauty, courage, and joy in each of the people I have encountered, and each story is powerful in its own way. But after trying to answer that question in so many ways, I've finally come to understand the truth:

My favorite interview is the next one.

ACKNOWLEDGMENTS

An expanding definition of *we*.

I often use the word *we* when I talk about my multimedia arts project, *A Peace of My Mind*, and people ask, *"Who is the 'we' you are referring to? Who is on your team?"*

Like many things in life, the answer is complicated. I'll give you the simple answer first. It's just me. I'm the photographer. I'm the interviewer. I'm the speaker. I'm the bookkeeper. I'm the IT guy and the custodian. I've always been a small shop, and I am much better at doing things myself than I am at delegating. So *A Peace of My Mind*—technically—is John Noltner.

But now I'll offer the bigger, fuller, and truer answer and the reason why I use the word *we* so often when I speak about the work. I never could have done this alone. It's true that I came up with the notion and I've done much of the work, but I have been encouraged and supported in so many ways that I can only see the project as a collective effort.

A Peace of My Mind was possible only because my family gave me the room and encouragement to pursue it. Thirty years ago, Karen and I were married in a small church in a classic, small-town Wisconsin wedding. We had a reception in the church hall next door, meals prepared by the ladies' guild, and an open bar staffed by a family friend. Since that day, we have met our challenges with a determination to make it through life together, even if we couldn't always see a clear path forward. In our marriage, I have found a partner who is willing to accept risk and give me the space to explore the ideas that don't play out and also the ones that do. Our son, Jordan, and our daughter, Brenna, were both entering their teen years as I started *A Peace of My Mind*, and even as life became busy, I like to believe that they understood that they were the top priority. We fit travel, interviews, and editing in between teacher conferences, show choir performances, and family outings, even when that meant long nights in my basement office after everyone else had gone to bed.

I don't like to calculate the hours I've put into this project, but I know I could have mowed the lawn, weeded the garden, made the bed, painted the house, and walked the dog more often if I hadn't been busy editing the next story. I know I could have made more money had I spent the same amount of time working at McDonald's instead, but from the start, my family encouraged me and nudged me forward. I hope that in exchange, they saw someone who pursued their dream and continued pushing on even when slowed down by obstacles and frustrations. We are on the long road, and sometimes we have to keep pressing forward on the difficult days toward that end goal. I hope they've seen and learned from that. My family is a big part of the *we*.

A Peace of My Mind is a collection of other people's stories. I've come to see myself as a curator of sorts. Like an art curator gathers beautiful paintings into a collection, I gather stories. And this project would not exist if these hundreds of kind and thoughtful people had not lent their voices, stories, and wisdom to the collection. I am grateful to each and every one of them, and they are a part of the *we*.

Before we even began our interview, I asked each person to sign a release form saying they were willing to be a part of *A Peace of My Mind*. They consented to adding their story to the larger body of work. But they wouldn't get to choose the photo we used, and they wouldn't get to edit the story. For the first two years, I wasn't even certain what to tell them about how the stories might be used. I had a vague notion that I would try to use them for good, but I did not know what that would look like. Basically, the release form said that they trusted me, and for some reason, they agreed and signed.

I took that trust seriously. These stories were at times deeply personal. We talked about difficult issues. If there is such a thing as privilege—and I'm quite certain there is—I am the poster child for it. White, middle-aged guy from the suburbs, college educated, heterosexual, cisgender, married, with 2.0 kids and a dog. So I found myself flush with privilege, and I was often sharing the stories of those who did not experience that same privilege. It was important to me that I honored each story and allowed each person's voice to come through while reducing my own filter in the process.

I agonized over the editing, maybe more than I needed to. But when I would post a story on *A Peace of My Mind*'s website, I would send a link to the person I had interviewed along with a note that said, *"Let me know if I've missed the mark*

on anything." I wore it as a badge of honor that their response was always one of two things: *"That's exactly what I was trying to say"* or *"You made me sound smarter than I thought I was that day."*

The goal was not to hear my voice in those stories. The goal was to amplify theirs, and each person who shared their voice became a part of the *we*.

I came to appreciate the Q&A sessions after my talks. People posed interesting questions and helped me think of *A Peace of My Mind* in new ways and clarify the direction it should move next. People challenged me when they didn't see themselves reflected in the stories. Early on, a fifth-grader pointed out that there weren't many young people in the collection. An Ojibwa woman observed that there were no Native American voices, and the mother of a child with a disability wondered why that voice wasn't represented. It's hard for a project like this to be a perfect mirror of who we are as a society, but there are ways it can be better. So when I heard these comments or questions, I used them to help make the project stronger and invite new voices in. Each person along the way who helped me recognize and challenge my own blind spots became a part of the *we*.

A Peace of My Mind has moved forward through grants, crowdfunding, sponsorships, gifts, and volunteers. People have opened their checkbooks to shepherd things along and make it all possible. Each of those generous souls is a part of the *we*.

So many friends have patiently listened to me talk about the project for a decade now. Through their conversations, they have served as sounding boards, helping shape the project and make it what it is today. Wade Barry rode with me in the truck for a travel assignment as I worked through some of the initial concepts for the project. Teresa Scalzo published some of the early stories in the *Carleton College Voice* as we were finding our footing. Chris Bohnhoff propped me up when I was ready to quit. Barry Yeoman offered connections as we explored the possibilities of a nationwide series. Our small group at church offered a testing ground for building conversations around the stories. They all offered wise counsel and poked holes in my fledgling theories, forcing me to think hard about what the project would become, and they are all a part of the *we*.

I've had a few interns along the way who have helped with some of the heavy lifting—transcribing interviews, developing discussion questions, finding

interview subjects, researching email lists, and installing exhibits. Mia Jackman, Bailey Sutter, and Nick Theisen are a part of the *we*.

I have partnered with creative souls along the way who have added their skills and insights to the journey. Jonathan Hankin designed our first exhibit. Barbara Koster has designed others as well as our two award-winning books of stories. Teresa Scalzo has edited text. Greg Bura of Conscious Campus has booked engagements. Carolyn Williams-Noren has written my newsletter for years now. Amy Tomczyk has offered a steady hand and voice while managing the logistics of my sometimes-frenzied public-engagement schedule. Heatherlyn, the Roe Family Singers, and Neal Hagberg have graced public events with their thoughtful music. They are all a part of the *we*.

People have invited *A Peace of My Mind* into their homes, schools, places of worship, conferences, and communities. If my vision of public programming was going to make an impact, I needed venues to convene the people. They are a part of the *we*.

A Peace of My Mind is the umbrella project under which I do my storytelling work these days. Our first two books and our traveling exhibits have focused on telling other people's stories. After a decade of this work, I realized I also had something to say, born out of the experience of encountering all of these amazing people and hearing their stories. Each individual story opened my eyes further, challenged my previous thinking, and enriched my understanding of the world. That personal journey of discovery was my reason for writing the project's newest book—the one that you hold in your hands—*Portraits of Peace*.

Many people read early drafts of *Portraits of Peace* and helped craft it into the book you have just finished. I am grateful to Jeff Rennicke, Andy Tix, Jen Beck Seymour, Nick Theisen, and Joan Posch for pointing out where the early versions fell short and needed more work. I am grateful for my acquisitions editor, Lisa Kloskin, who saw promise in the concept and brought the title into the Broadleaf Books family, and for my editor, Diedre Hammons, who offered her wisdom and perspective in the final edits, challenging me to dig a little deeper and be a little braver in sharing my own journey in the hopes that we might encourage you to do the same. They are all a part of the *we*.

Of course, the risk of calling out specific names is that you will leave out others who deserve much gratitude. There are literally hundreds, if not thousands, of people who have left their imprint on this project and on my heart.

Please know that I see you. I hear you. And you matter. *A Peace of My Mind* has grown to be the project it is today because of you.

It's satisfying to stand in front of a few hundred people and share the stories from the project. It's great when they applaud and cheer at the end. But I can't think of this project without thinking of the rich and varied community effort that made it possible. *We* is the only word that makes sense.